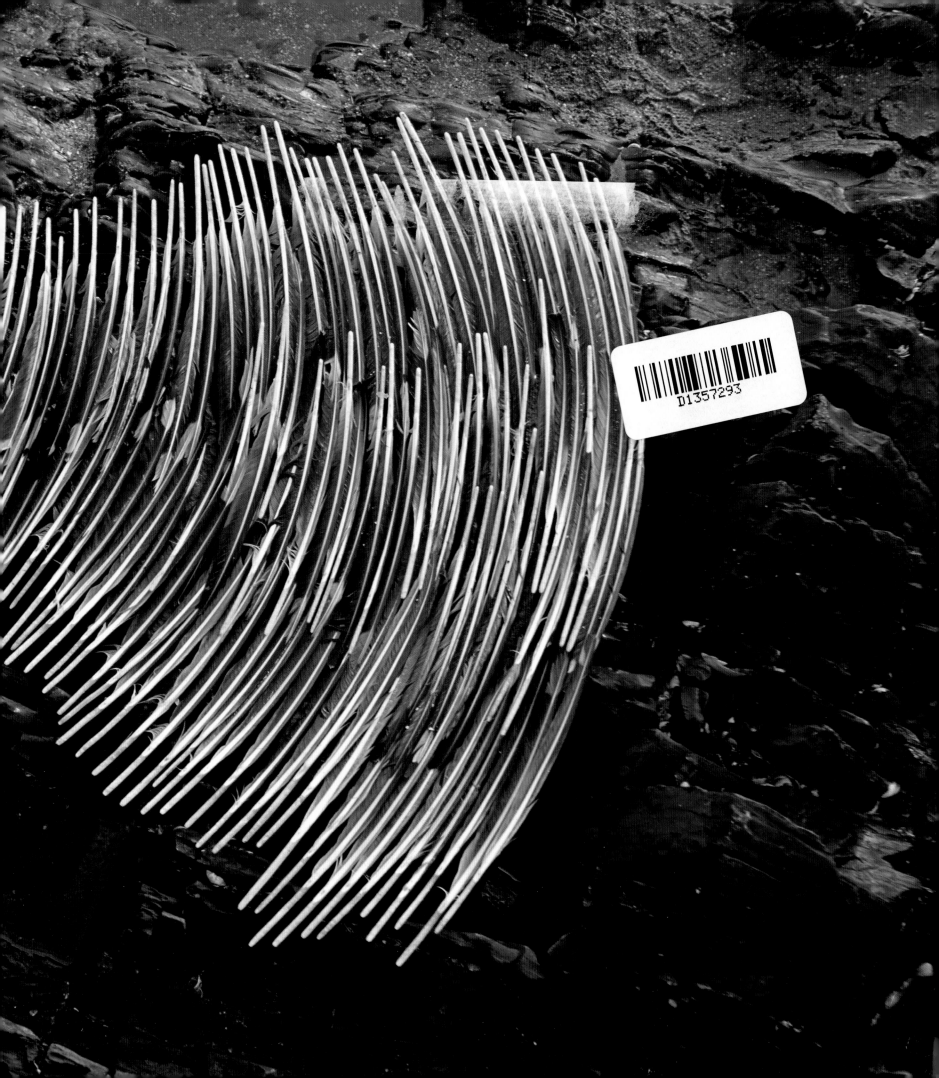

PASSAGE

FOR JAMIE, HOLLY, ANNA AND THOMAS

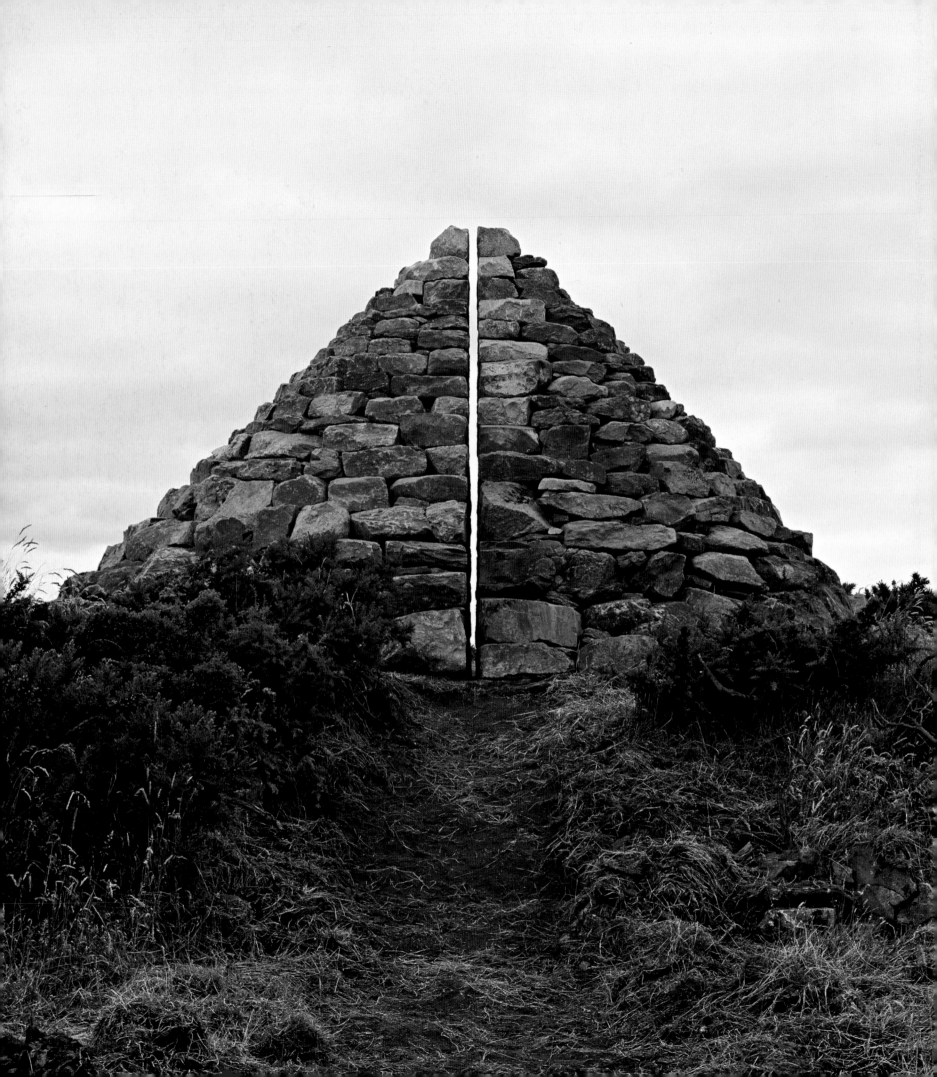

PASSAGE

Andy Goldsworthy

Thames & Hudson

Endpapers

Seagull feathers

laid over a river of stone

before incoming tide

SANDYHILLS, DUMFRIESSHIRE

4 NOVEMBER 2002

Title spread

Logie Cairn

ELLON, ABERDEENSHIRE

1999-2000

First published in Great Britain in 2004 by
Thames & Hudson Ltd, 181A High Holborn, London WC1V 7QX

www.thamesandhudson.com

British Library Cataloguing-in-Publication Data
A catalogue record for this book is available from the British Library

Produced by Jill Hollis and Ian Cameron
Cameron & Hollis, PO Box 1, Moffat, Dumfriesshire DG10 9SU, Scotland

Set in Stone Sans by Cameron & Hollis, Moffat
Colour reproduction by Studio Fasoli, Verona
Printed in Italy by Artegrafica, Verona

Andy Goldsworthy is represented by:
Haines Gallery, San Francisco
Michael Hue-Williams Fine Art, London
Galerie Lelong, New York and Paris
Galerie S65, Aalst, Belgium
Springer und Winckler, Berlin

ISBN 0-500-51191-8
Printed and bound in Italy

CONTENTS

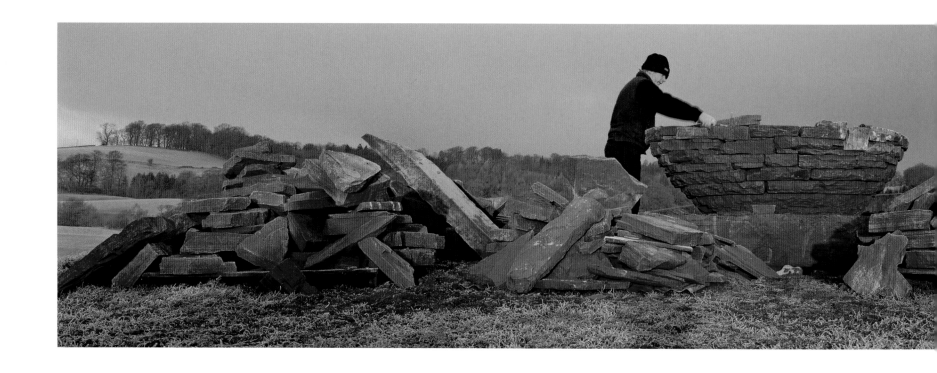

PENPONT CAIRN

23 December 1999

Stone has been delivered to Penpont from Locharbriggs Quarry, including one six-ton block which will be dug in for the base – to be placed in 1999 and built upon in 2000. I like the idea of one year supporting and giving foundation to the next as an expression of continuity and connection between the two centuries.

Surprisingly, the large stone was slowly but easily manoeuvred up the hill by a driver with an excavator. I decided to bed the stone half in and half out of the ground. This will raise the cairn by about a foot, so that when viewed from the road, the bottom will appear to be sitting directly on the hilltop – a joining of two rounded forms. I will decide later whether to build the ground up to the base or to leave the stone proud.

I have been very anxious about this sculpture and have given enormous thought to its making. I feel self-conscious about working so prominently in my home place. I will see the resulting sculpture whenever I leave and return to the village. My children will grow up with it. These associations can become rich and beautiful, but if the sculpture does not work then I shall have to live with that. Most artists have to deal at some time with bad reactions from the public, that is normal, but home is where I am most exposed.

I have surprised myself by choosing such a prominent site. I tried to talk myself out of it, but somewhere along the process the self-conscious Andy Goldsworthy was replaced by Andy Goldsworthy the artist whose purpose is to make the strongest possible sculpture. It is an honour and responsibility to have been asked by the village to make a work and I must do all that I can to respond as well as I am able.

1 January 2000

The first stone of the cairn was prepared a few days ago, ready to be laid today. Because of the softness of sandstone, I decided to make the first layer a carved single slab, rather than making it up of several pieces. This will give the cairn a strong beginning.

The foundation stone had been laid slightly off the horizontal. I am not overly concerned about getting everything level, but would have preferred it a little flatter. Today's stone was tapered and so corrected the tilt of the foundation stone, giving me a more or less level base to work on.

My friend Wallace Gibson and my assistant Andrew McKinna helped. Several people arrived; at one point there must have been around thirty people watching, which could have been off-putting, but on this occasion I enjoyed the setting of this first stone being witnessed. Children carved their names on the top surface of the stone, which will be covered as we build upwards.

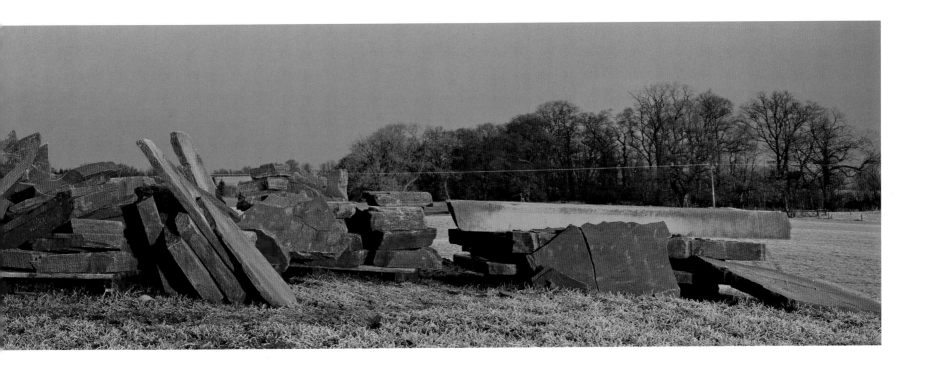

5 January 2000

Went to the quarry to pick out more stone and returned to Penpont to await its delivery. I began cutting up the large blocks of stone already on site – cleaving each block along its grain into slices, which can then be broken up into more manageable pieces.

The field is very soft, and the tractor carrying stone dug in badly. I loathe doing this to a field and I am fortunate that it belongs to Jim and David Kirkpatrick who I know well and who have shown tremendous tolerance. They cannot imagine how helpful it is for me to work with people who, although not exactly happy to have their field driven over, are not too angry either.

6 January 2000

Today we began work in earnest. It was a beautiful, calm, sunny, warm winter day. What a contrast to yesterday's wind and rain! It was a joy to be outside. The first hour was difficult. Sandstone, although an easy stone to work, is very hard to make into the shape of a cairn. It is only now, after making many of these cairns, that I have enough understanding of the form and construction to be able to work on such a scale with soft stone. The problem is that every stone has to be well supported or it will break, and it is not possible to use many very thin stones for levelling lest they crumble under the weight of the stone above.

The beginning is always slow. This is the belly of the cairn. I have never made a cairn in such a critical location. The base will be so exposed against the sky when seen from the road and as you walk up the hill towards it.

We are continuing to have problems getting stone up to the site. The tractor dug in very badly today which will make it difficult to bring in the heavy through stones that need to be here shortly.

7 January 2000

What a contrast in the weather to yesterday's: windy, dark and overcast. Fortunately the rain held off until around midday, but once it came it was heavy and driving. Worked most of the morning on the cairn; the afternoon was spent splitting the big blocks into slices, dropping them as they separated from the main rock, so that they landed heavily, breaking against the ground. I have to leave for Paris tomorrow and wanted to make a stockpile that my assistant, Andrew, could get to the site in my absence.

I am almost at the widest point of the cairn and, although I am not entirely happy with its appearance from certain viewpoints, overall it has a good shape. The dialogue between the rounded belly of the cone and the rounded hill is very strong. The cairn is beginning to have a presence. It is only in the course of the making that I will discover whether the scale is right for the place. There is some way to go before I know for sure, but at this stage, it looks promising.

8-12 January 2000

I am in Paris to attend the premier of *La Danse du Temps*, a collaboration with the choreographer, Régine Chopinot. I made the backdrop for the dance. I decided at short notice to do an exhibition of photographs of related works in a gallery at the Hôtel Scribe. I was told that it was a good place and it certainly is different. In its own way it is an interesting space for certain works, but it is not the right place for my work. The gallery has shiny, black walls and a glossy, grey marble floor. The other area is the hotel lobby. I never envisaged my work being placed next to gilded angels with lights. It has all been a bit tense, and I feel somewhat sickened by the prospect of having my work here.

What a contrast to the cairn, the thought of which gives me the strength to get through what is becoming a very difficult exhibition. I remember the

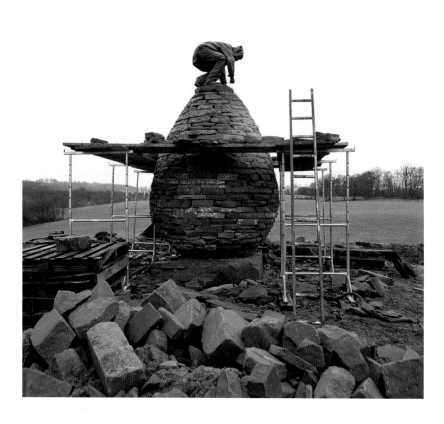

The form grows; good, long through stones extending from one side to the other are being put in place at every course to give strength. I don't think I have made a cairn as tight as this before. I have had to carve level many of the stones so that each has a good contact with the next. As far as I can tell there are no loose stones whatsoever.

The light today was fantastic. I have never made a cairn in a place so open, not just to the view, but to the rising and setting sun. Today has been such a relief after working for the last two months in wild, wet, cold conditions.

We're having problems with getting the tractor up to the site; it is sinking more and more deeply. We have had to come up by a different route, which is spreading our mess even more, and I am not happy about that.

22 January 2000

The cairn is taking on its character, and although it is too soon to be certain, I feel a welling up of excitement at how good the form is. I live, work, sleep and breathe this piece at the moment. Stones laid in the day are turned over in my mind in the evening.

The weather has been astonishing – warm and calm this morning, brilliantly sunny, becoming overcast and cooler later on this afternoon, but still a great day.

It is strange to talk of such hard and heavy work as enjoyable, but the making of this sculpture is the closest I have been with a large stone work to being able to say this. This is due mainly to it being where I live. I go to work as farmers and others are also going to work. I am doing my job as they do theirs. Although the making of a sculpture is obviously out of the ordinary, this particular work has a wonderful sense of the normal and everyday about it.

I see my son's bus taking him to school in nearby Thornhill every morning and see its return in the evening. People that I know and several that I don't know have made visits during the cairn's construction. After school, my children come to see how the cairn has progressed. There are the almost daily visits by David and Jim Kirkpatrick, the farmers on whose land I am working, which has added pleasure and interest to the making. Today, the manager of a local tractor company came and has said he will lend us a front loader for no charge.

Earlier, Neil Mackay, who first suggested that I make a work for the village to mark the millenium, met with David and Jim Kirkpatrick and Andrew Wootton from the Buccleuch Estates to discuss access and the making of a gate, so that people can get to the cairn easily.

This weekend I must go to Spain for a site visit, stopping off in London on the way back, so will not be able to continue work until next Wednesday. It is frustrating, having to break off like this. Perhaps I will see more clearly after a break – as I did after Paris.

This week has been good.

stones on the hill, I can still feel them in my hands, shaping the belly of the cairn. I think of the stones that I will lay on my return.

To some extent my work at home has always functioned in this way, but the situation here has brought the relationship into sharp focus. Every stone that I place on a sculpture contains some of my own energy: the lifting, the cutting, the placing. Part of me stays with the stone, just as part of the stone stays with me.

13 January 2000

I returned from Paris last night and have one day before a visit from Dr Terry Friedman who will write for a future publication.

It was a beautiful, frosty, cold, calm, sunny morning. The light on the wet, deep red stones of the cairn was quite beautiful. Being away might have interrupted my concentration and feeling for the cairn, but that distance has allowed me to see more clearly what I have made so far.

There are irregularities within the shape that I find disturbing. The cairns are made by eye. I use a tape measure, just to keep within the limitations of the width that I feel is stable in proportion to the base. I always attempt to make the perfect cone but fail. A tension develops between what I want and what is emerging. This tension is important to the feeling of the piece.

18 January 2000

Finally able to get back to work. Great weather – warm, dry, sunny – I even had my jacket and jumper off at one point, which is incredible for January.

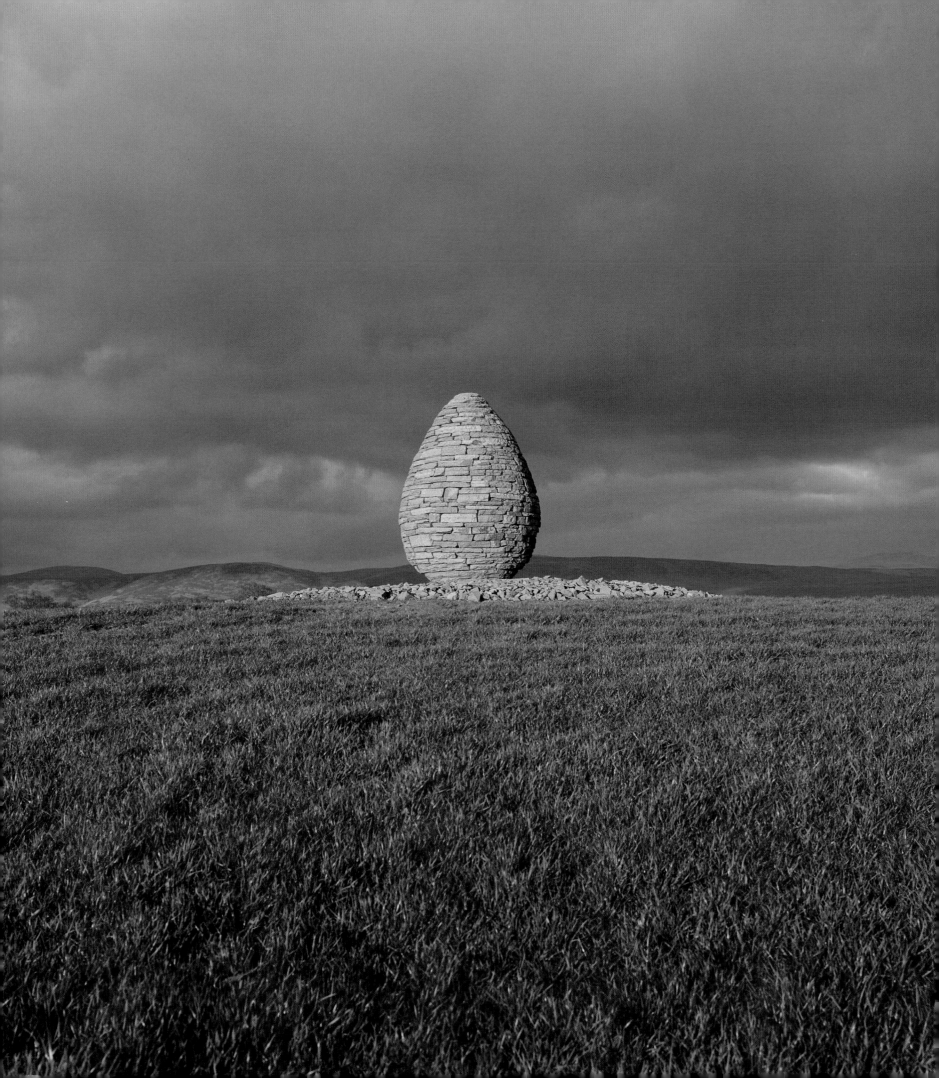

26 January 2000

I'm tired after a trip to Madrid and London to make site visits for possible future sculptures. I arrived back late last night, after my flight had been diverted because of fog at Glasgow. I have missed some beautiful dry days. There has been an extraordinary spell of dry weather during the making of this cairn, which will become part of the memory of its making. This has given its construction a calm, clear and at times sociable quality – people are more willing to venture out and spend time talking in fine weather. It is good that its making has been witnessed in this way.

I left for Madrid early last Sunday morning. It was dark, but with a lightening sky. As I passed the cairn, I could see its silhouette. It has been a long time since I made a sculpture with such a strong outline.

To see the cairn against the sky as dawn breaks is so beautiful as it changes from a dark, mysterious, silhouette to a brilliantly illuminated three-dimensional object when the sun rises.

Today the work was slow, because I was feeling tired. Work becomes more difficult as the form contracts, giving less room for manoeuvre. I try to keep my nerve, slow down and not become frustrated at the lack of progress.

It is a critical moment when the cairn is drawn to a peak. I can feel the energy welling up as I draw in the form – the apex not unlike the growth tip of a plant, where the plant is most alive and active. How this is resolved will affect dramatically the cairn's character.

There is a possibility that I may finish tomorrow, or at least get very close to completion. I will then work on the pile of rubble that I have decided to lay around the cairn. This will protect it from cattle, but also root it to the place.

The ground was frozen hard early this morning so I took the opportunity to get rubble stone on site so that the grass is not damaged further.

27 January 2000

Almost complete. It has been slower than expected towards the end, as it always is. It will be the tallest cairn of this form that I have made.

Now that the cairn is reaching its full height, irregularities are more fully revealed. I finally have the unsettling feeling that the form has not turned out as I wanted it – yet again. This happens with each cairn. I set myself an almost impossible task: to make the perfect form by eye and hand. This is probably the best-shaped cairn I have made, but it still falls well short of perfection. I now have to get to know the final form, which in some ways is a stranger to me.

I know from past experience that the same irregularities that I so dislike now will become the qualities I enjoy most later.

28 January 2000

The cairn is finished. The last stone was placed just after lunchtime. The end took quite a long while to resolve. I had to go to my workshop to deal with some things, leaving my assistant Andrew to clear up and take down the scaffolding.

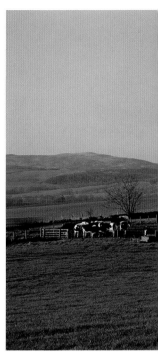

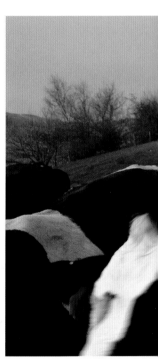

On my return I saw the cairn without obstructions. It is difficult to describe my feelings. It is far more impressive than I thought it would be. For a work so prominently sited I was anxious that it might be too imposing and appear as if it were shouting for attention in a 'look at me' kind of way. In this instance, however, I am delighted that it should have a strong presence. Standing on the brow of the hill, it appears almost to float. Even I wondered momentarily what is holding it up!

As you walk up to the sculpture it changes so much; I like the many different ways in which it can be seen. Of course the form is not perfect, but it has to be the best cairn that I have made so far.

A farmer stopped and when he asked what it was, I explained my ideas of it being a guardian or a sentinel to the village. I knew by the tone of my own voice that I was unable to explain fully what the sculpture is about. The farmer stayed for some time and the conversation went from farming to quarries; to things taken away from the land and things given to it; to the standing stones and landmarks in the area and of how his young daughter will have the memory of having seen the work being made. Any explanation I can give inevitably falls short of describing the work fully and in many ways it is better described by conversations I had with this man.

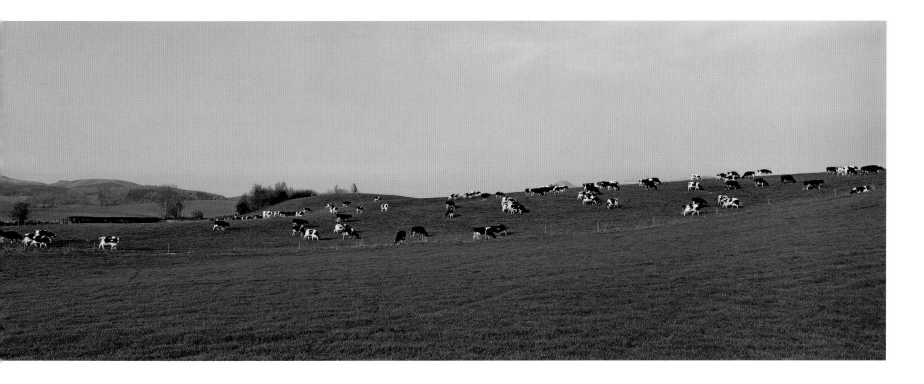

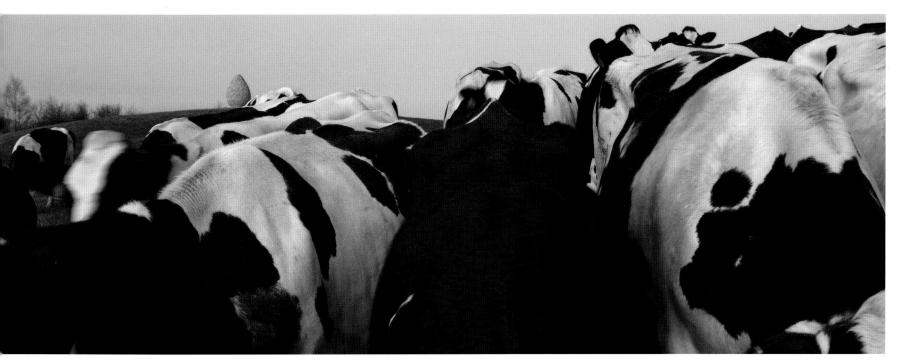

The sculpture is at the beginning of its existence and, as with any new life, there is a sense of fragility. I don't know if it will be accepted or rejected, loved or hated. I have never made a sculpture (except for those around my own home) that I will live with, day after day, as I will with this one. Perhaps it can be seen as an indication of my own strong attachment to this place.

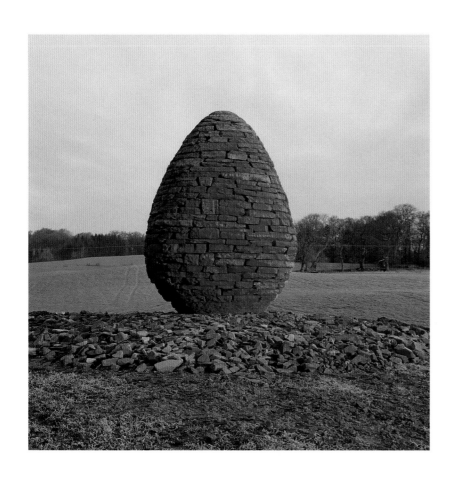

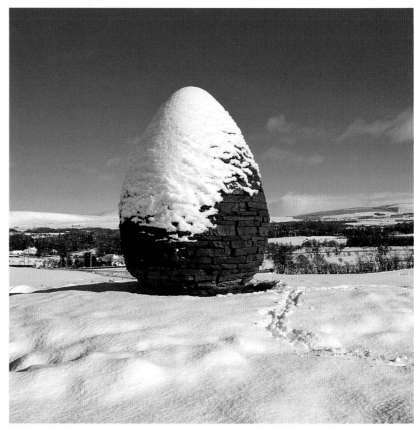

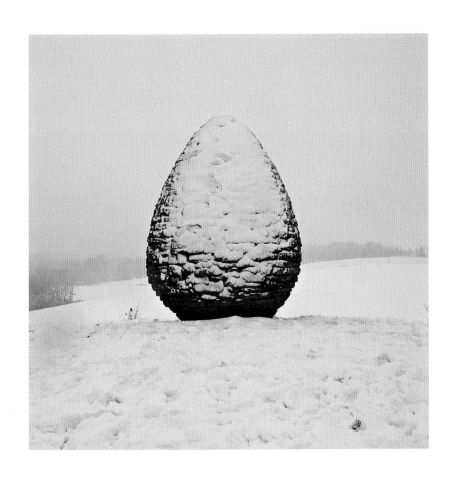

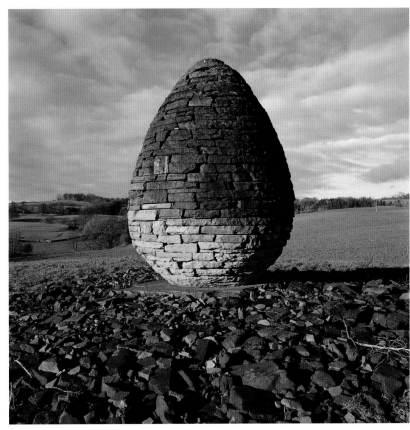

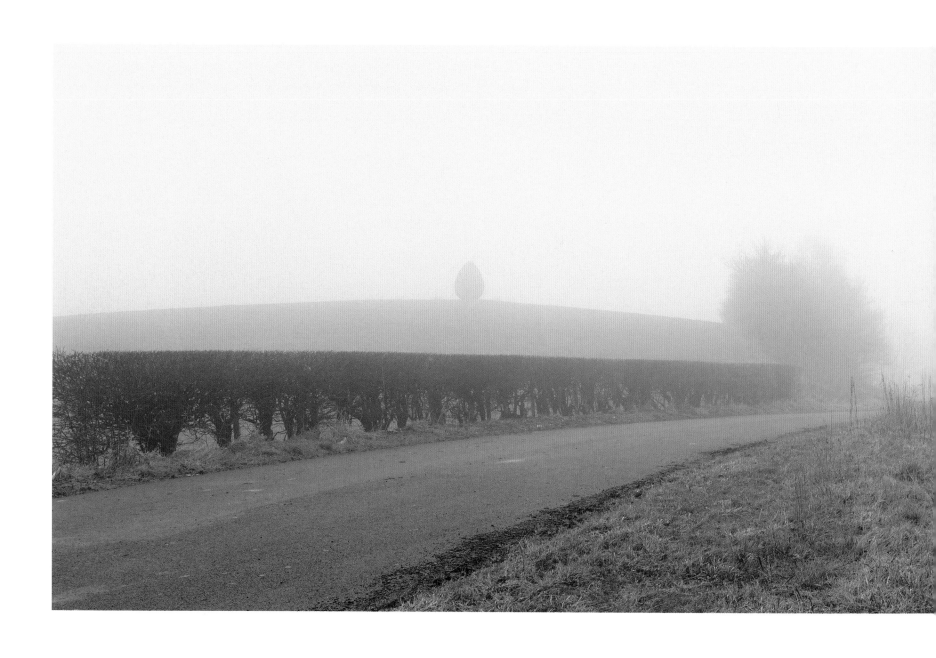

RIVER

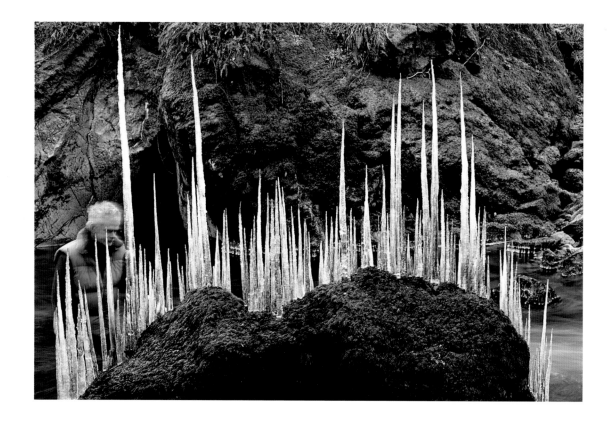

Cold to begin with
temperature rising and falling
throughout the day
at times unable to freeze icicles to stone
had to finish around mid afternoon
when a wind picked up
and the frost disappeared
heavy overnight rain
river in spate the following morning

for Sue

SCAUR WATER, DUMFRIESSHIRE
31 DECEMBER 2003

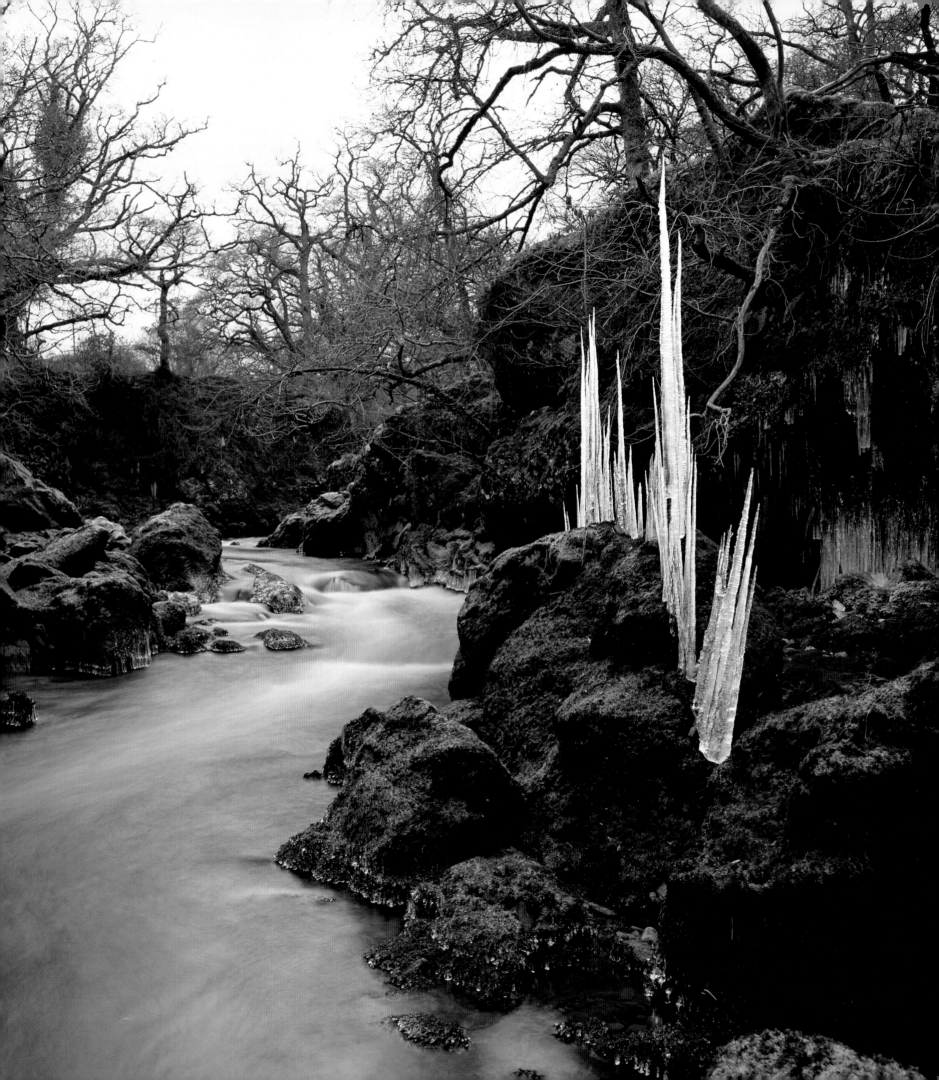

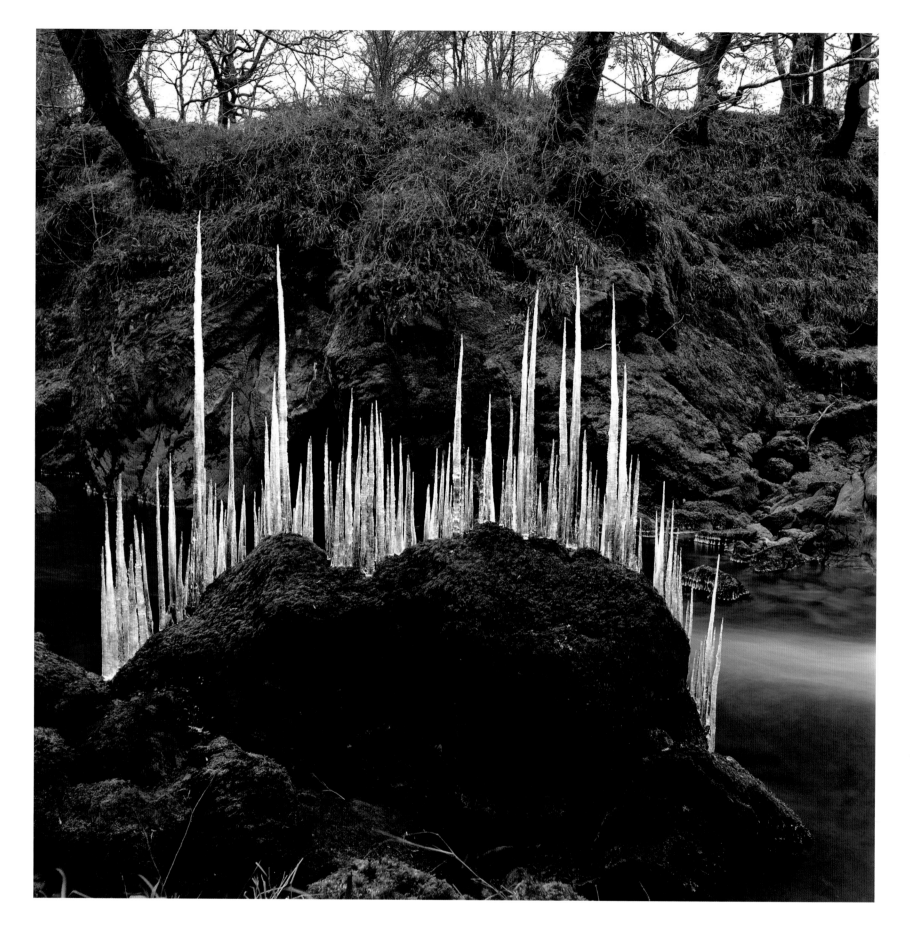

31 DECEMBER 2003

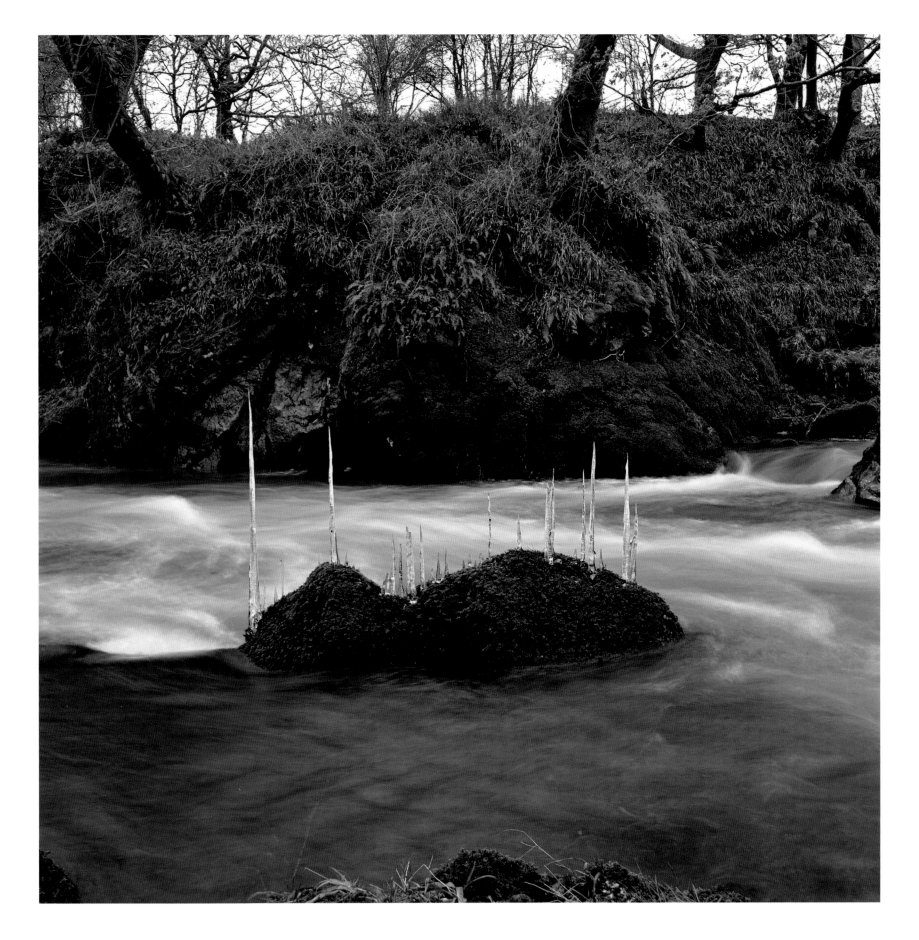

1 JANUARY 2004

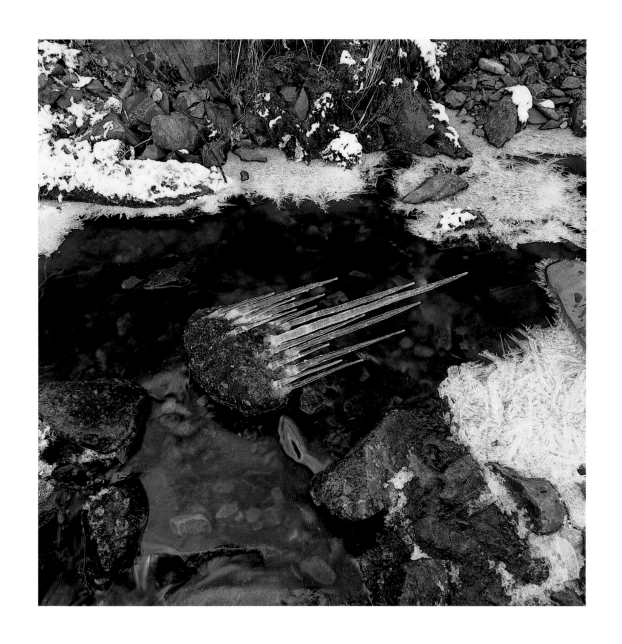

Icicles

frozen to river stone

freezing temperatures overnight

returned the following morning

STONEWOOD, DUMFRIESSHIRE

2 & 3 MARCH 2001

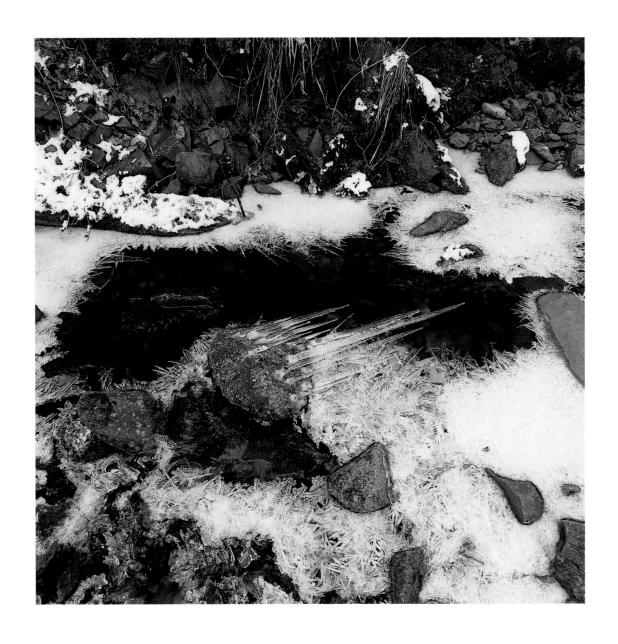

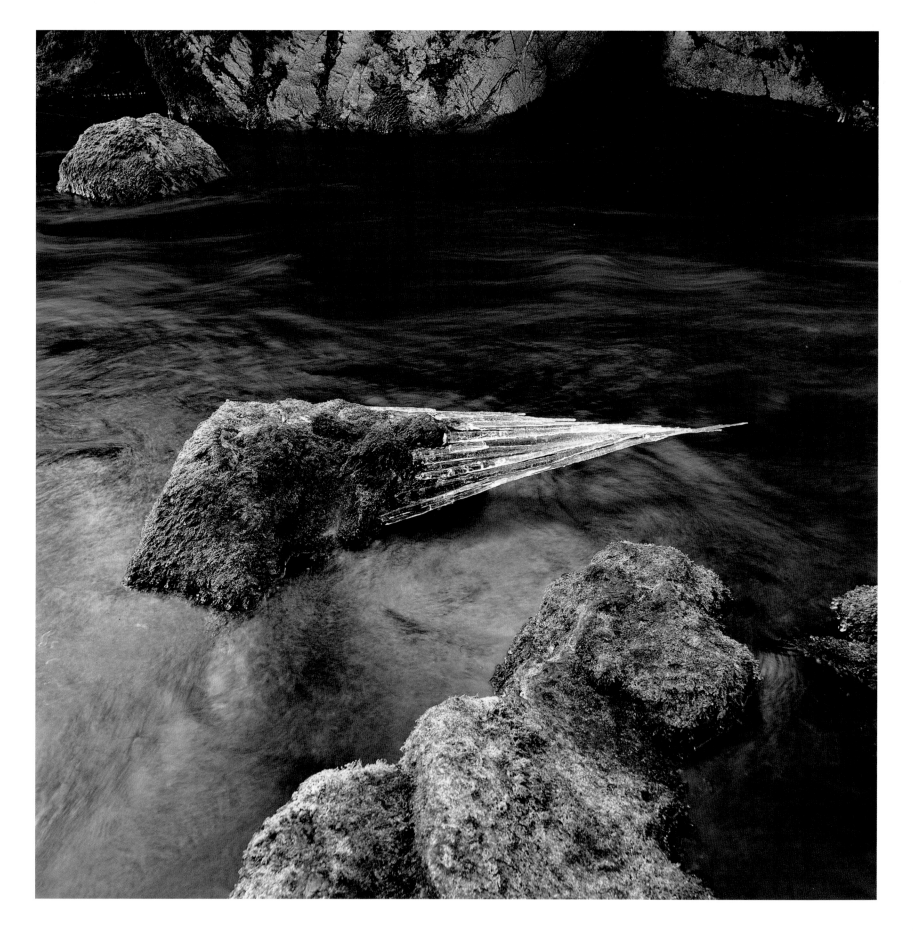

Two icicle spires

frozen to stone

SCAUR WATER, DUMFRIESSHIRE

30 DECEMBER 2003 (above) & 5 JANUARY 2003 (opposite)

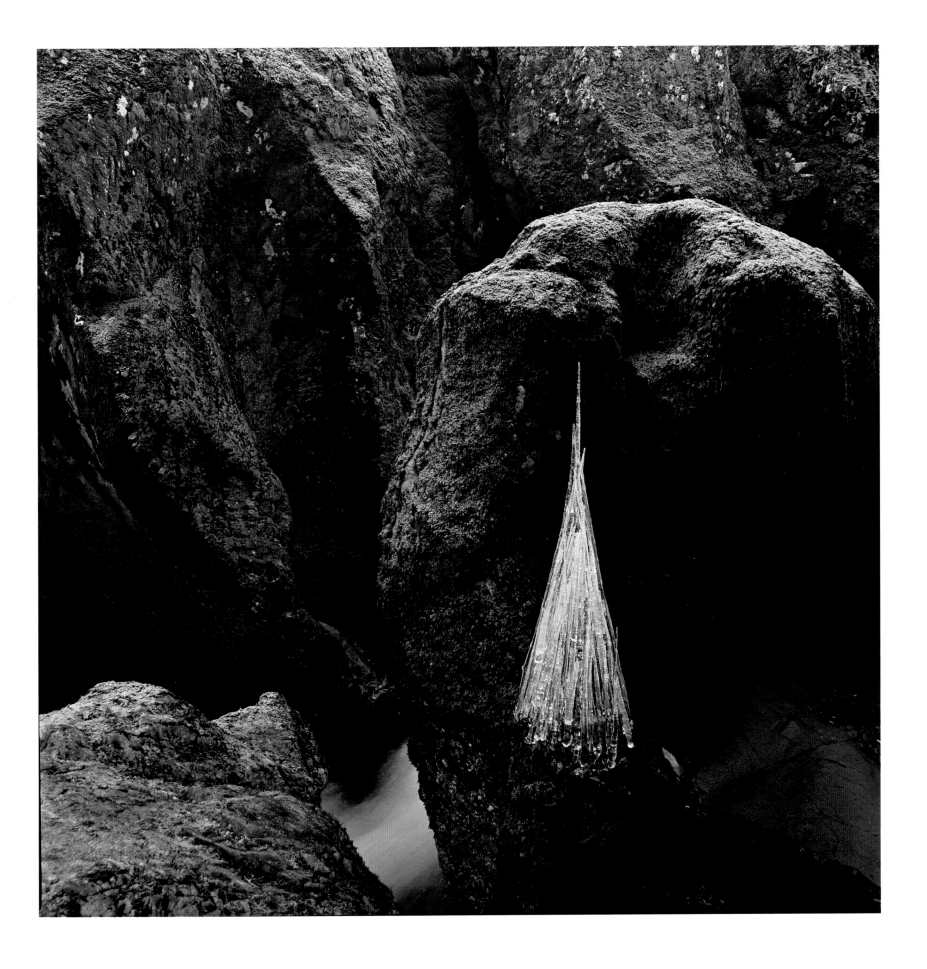

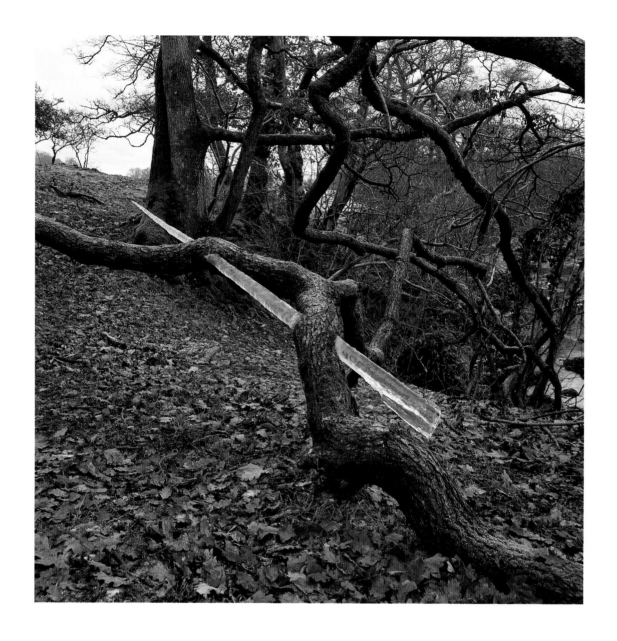

Fallen oak branch
frozen reconstructed icicle

SCAUR WATER, DUMFRIESSHIRE
1 JANUARY 2002

Opposite
Thin ice lifted from nearby pool
frozen to river rocks
melting as the sun rose

SCAUR WATER, DUMFRIESSHIRE
FEBRUARY 2004

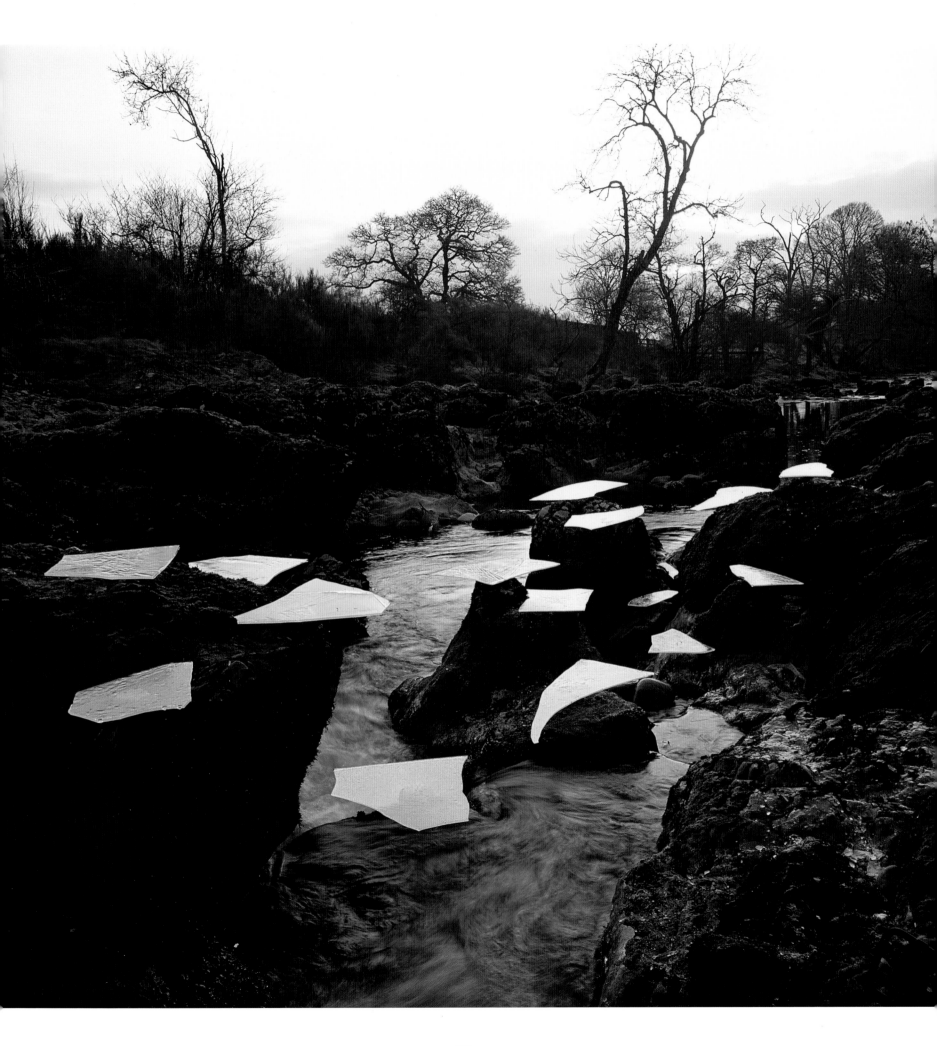

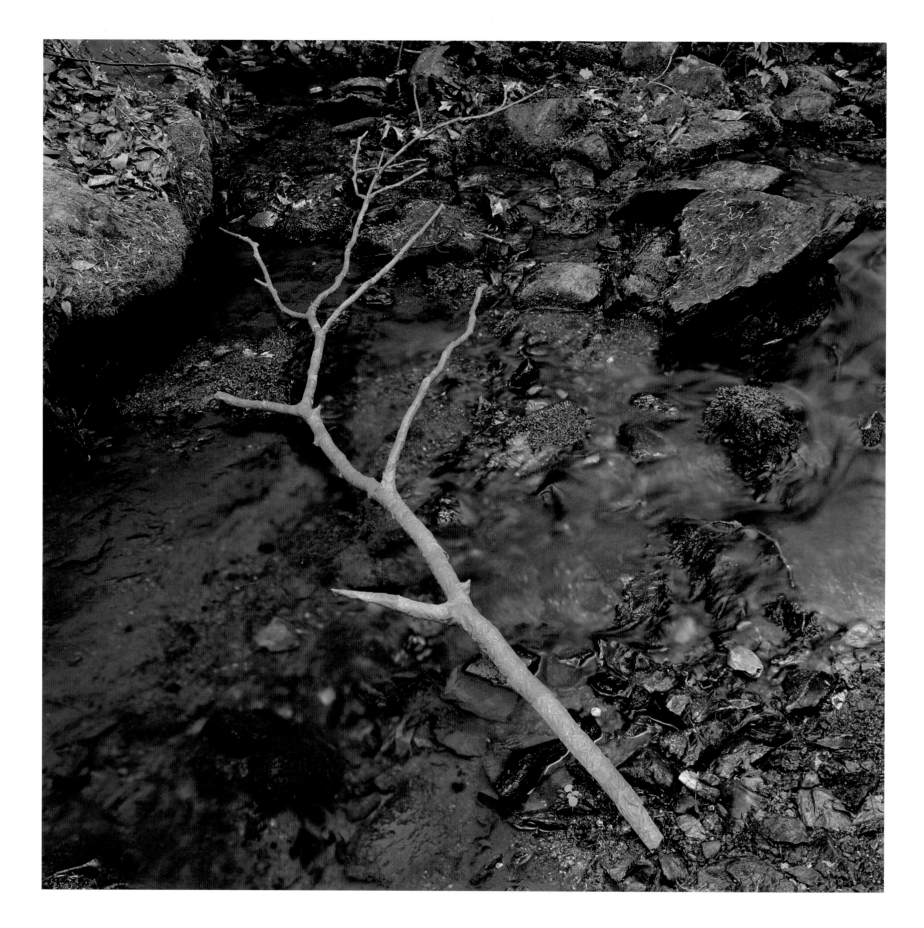

Young, supple, fresh green leaves

dipped in water

wrapped around a branch

BIRCH HILL FARM, MASSACHUSETTS

MAY 2001

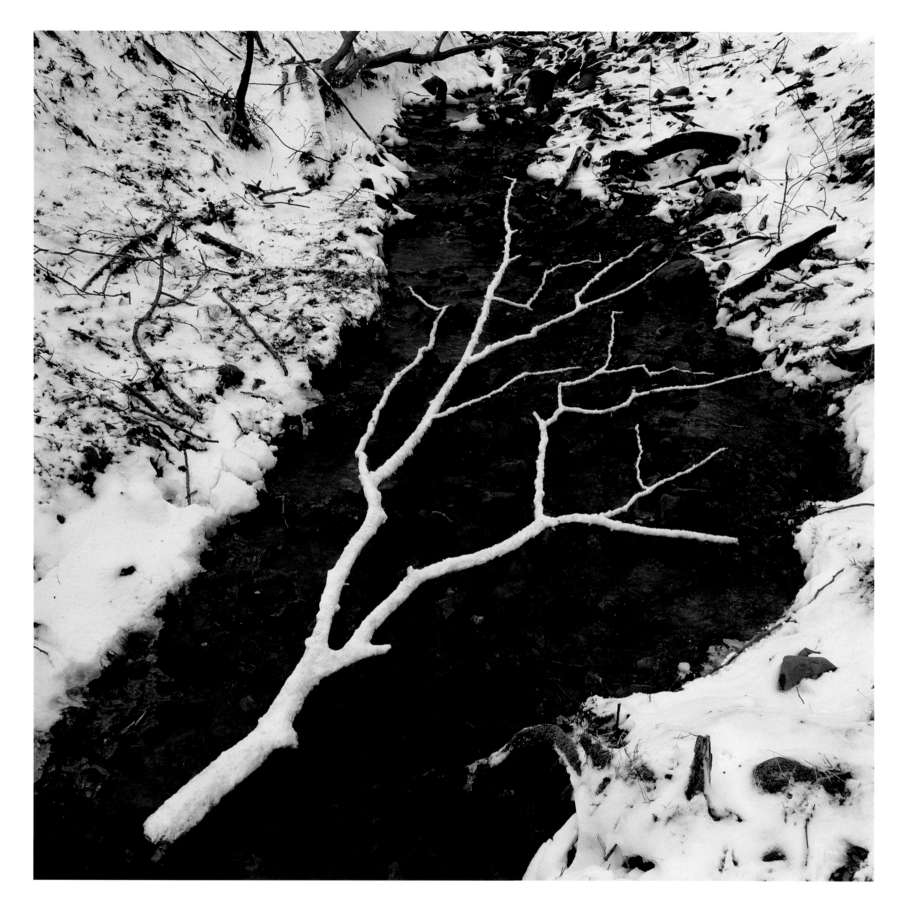

Branch made wet
powdery snow thrown over it

TOWNHEAD BURN, DUMFRIESSHIRE

MARCH 2001

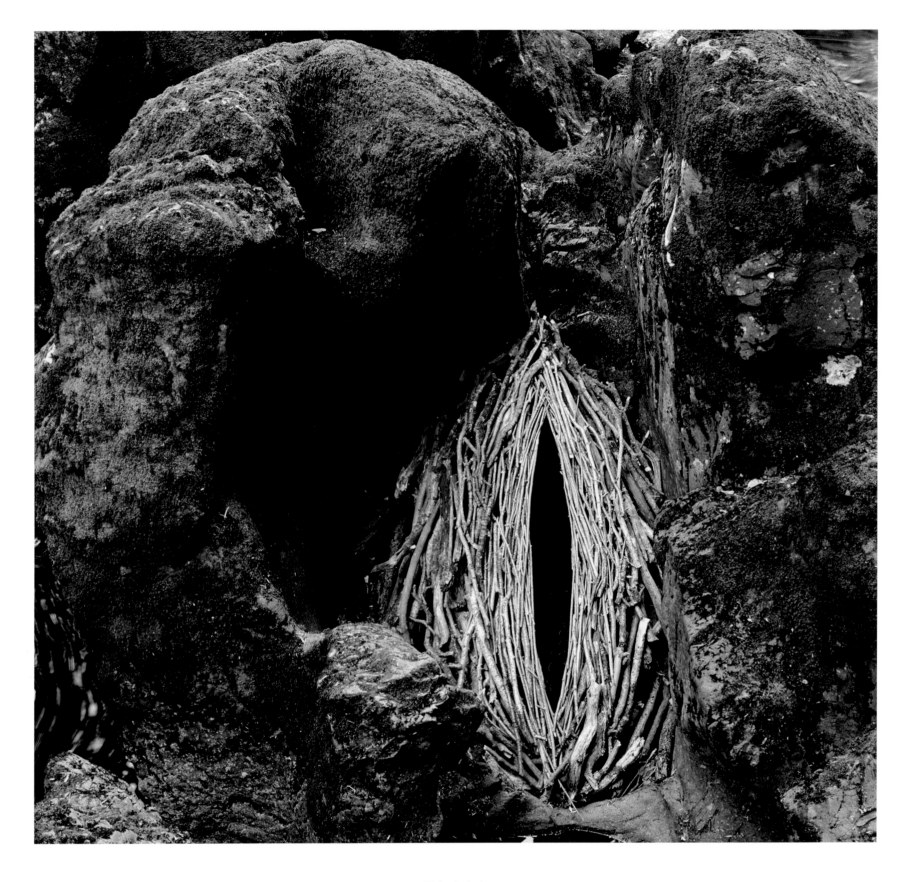

Sticks stacked

leaving a hole within a hole

SCAUR WATER, DUMFRIESSHIRE

12 JULY 1992

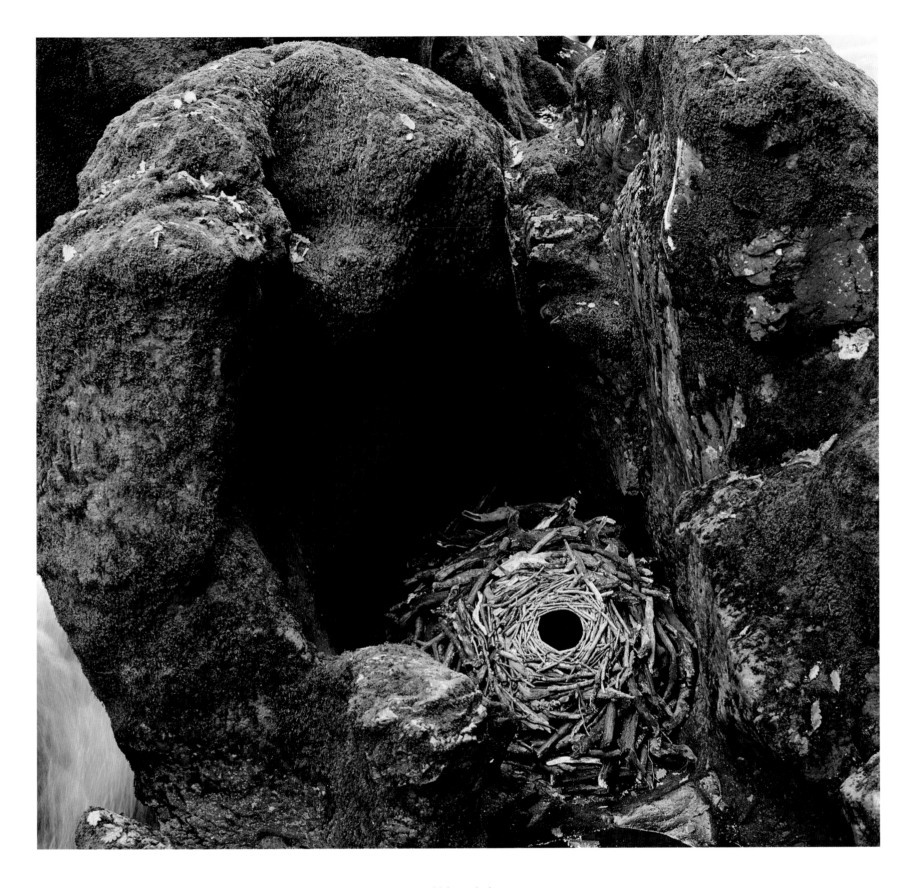

Sticks stacked

heavy rain

river rising

SCAUR WATER, DUMFRIESSHIRE

14 OCTOBER 1991

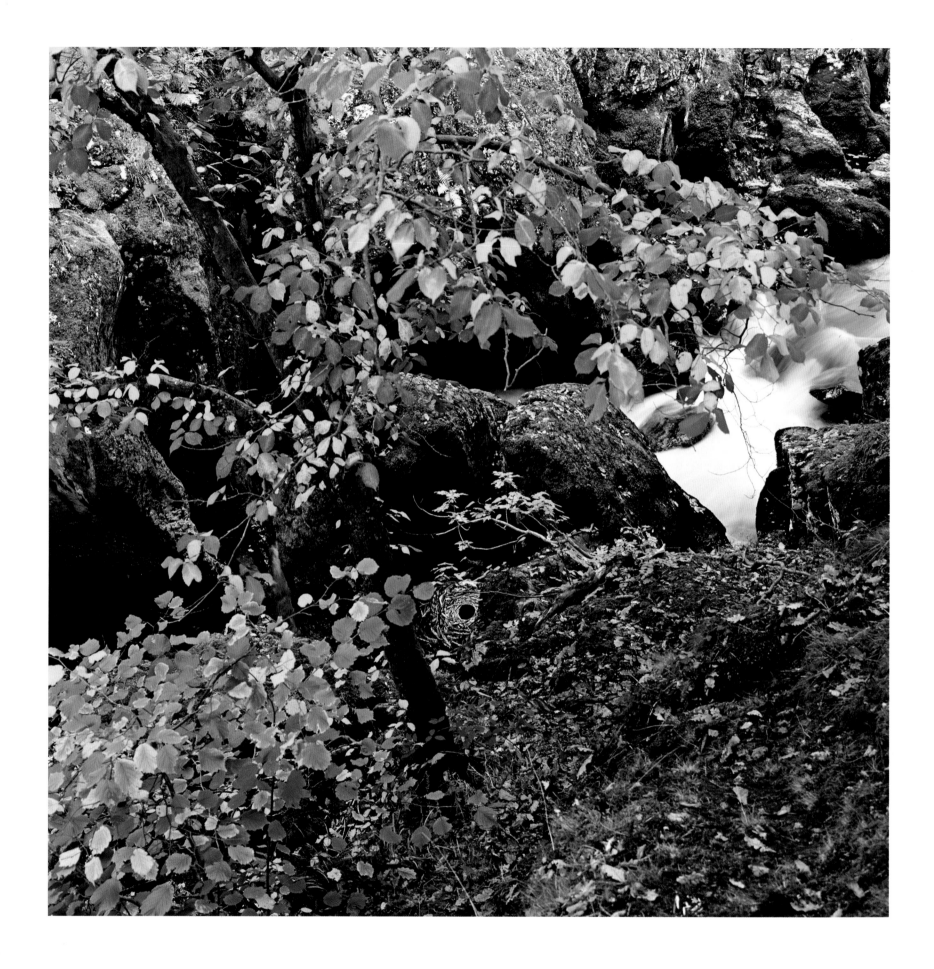

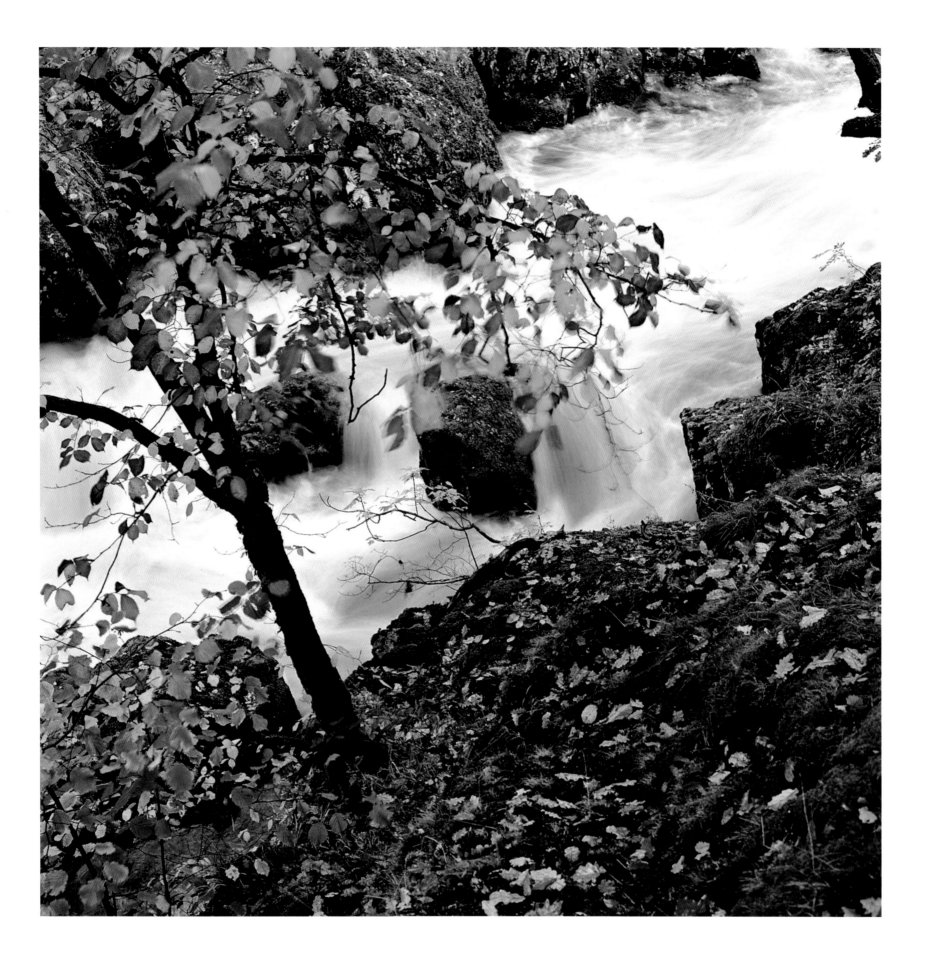

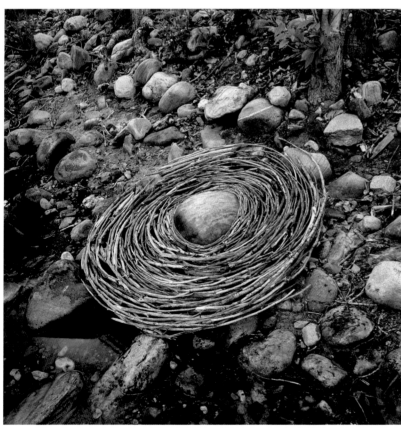

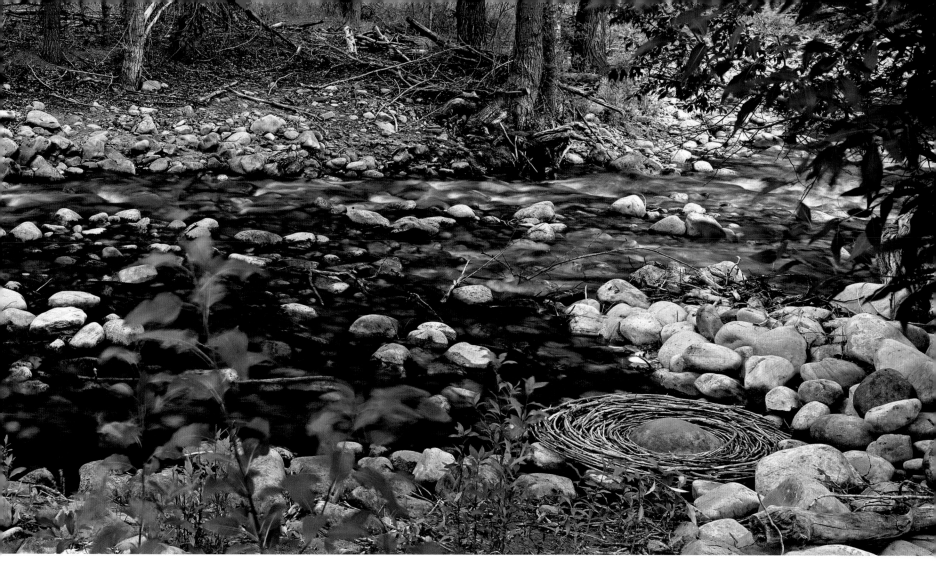

Two river stones
worked around
with curved sticks

SUN VALLEY, IDAHO
28-29 JULY 2001

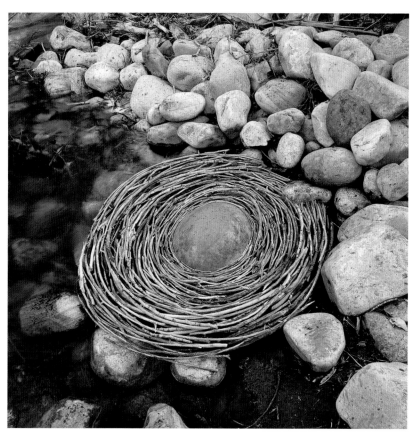

Hogweed stalks
split open
to reveal the white inside
held together with thorns
in a line along a fallen elm branch

TOWNHEAD BURN, DUMFRIESSHIRE
25 DECEMBER 2002

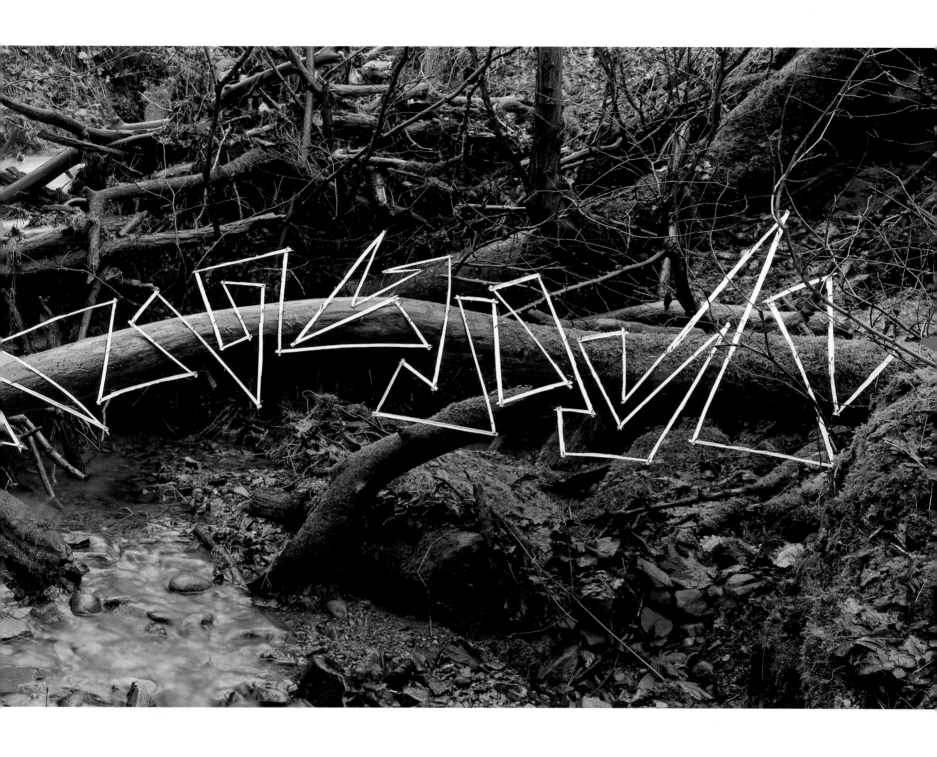

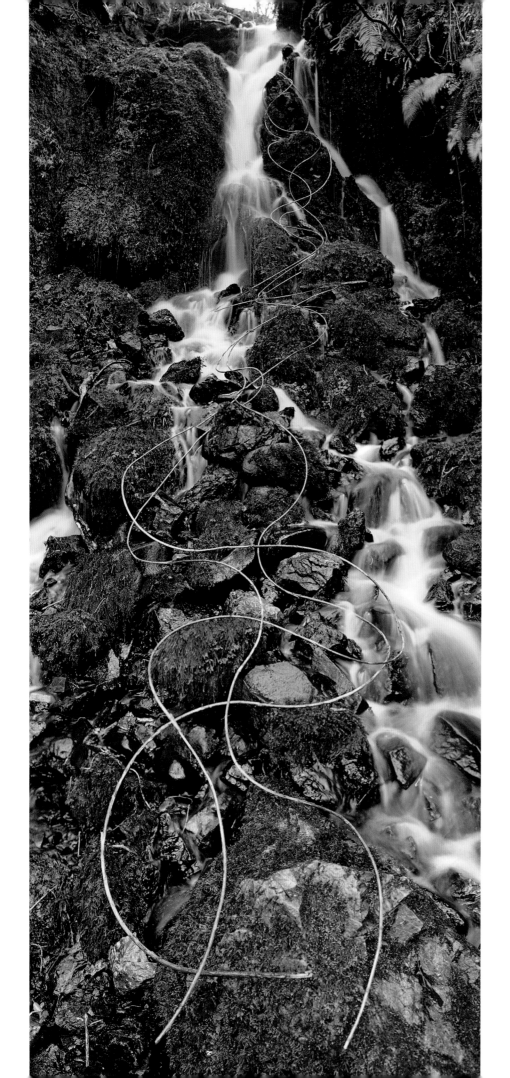

Rosebay willowherb stalks
bent by the wind as they grew
drawing a waterfall

SCAUR WATER, DUMFRIESSHIRE

7 JULY 1992

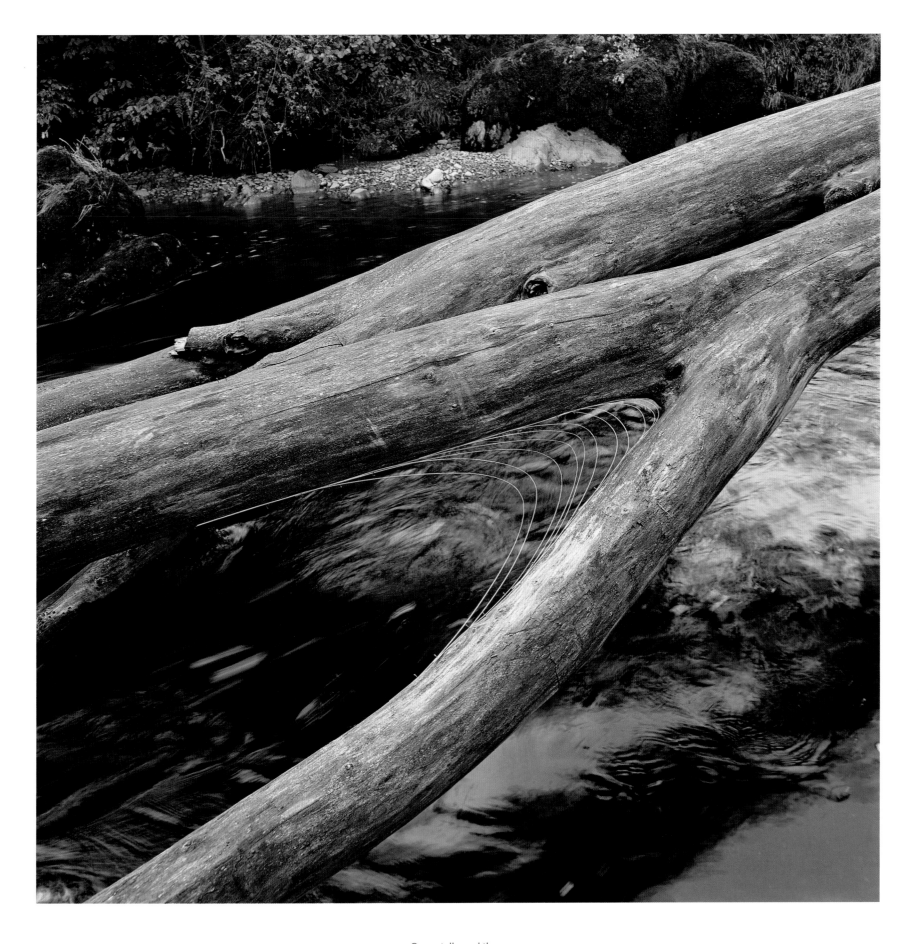

Grass stalks and thorns

worked into a fork in a dead elm

SCAUR WATER, DUMFRIESSHIRE

9 SEPTEMBER 2002

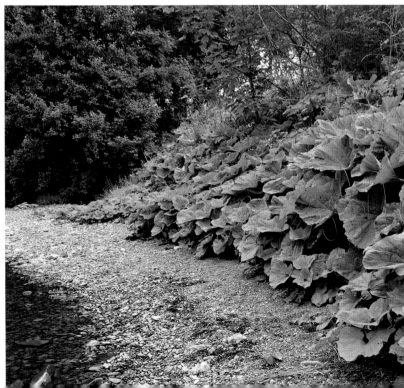

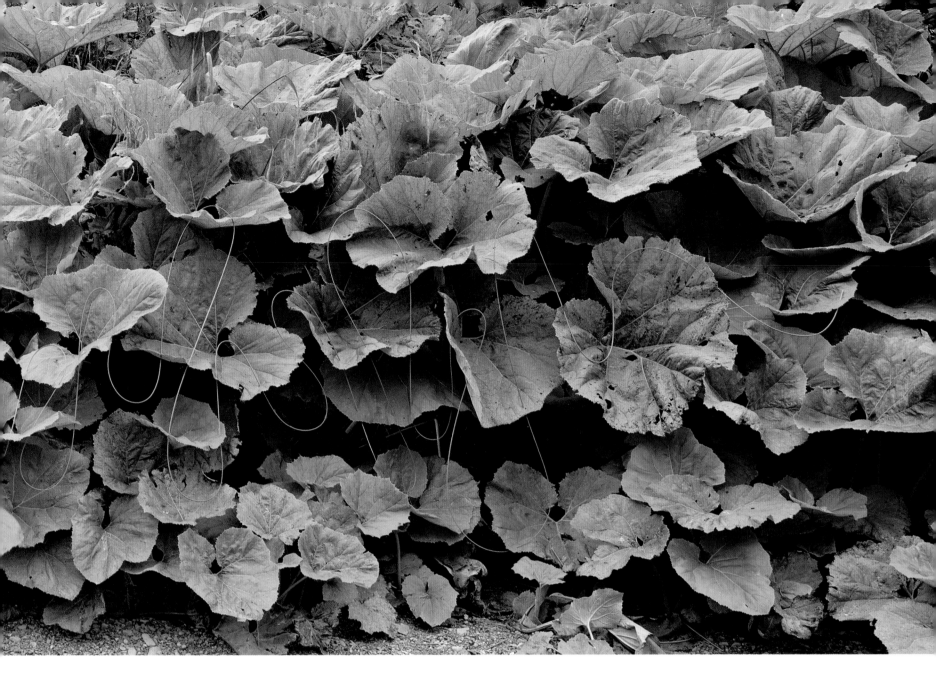

Rush line drawing
through butterbur

SCAUR WATER, DUMFRIESSHIRE

20 AUGUST 1999

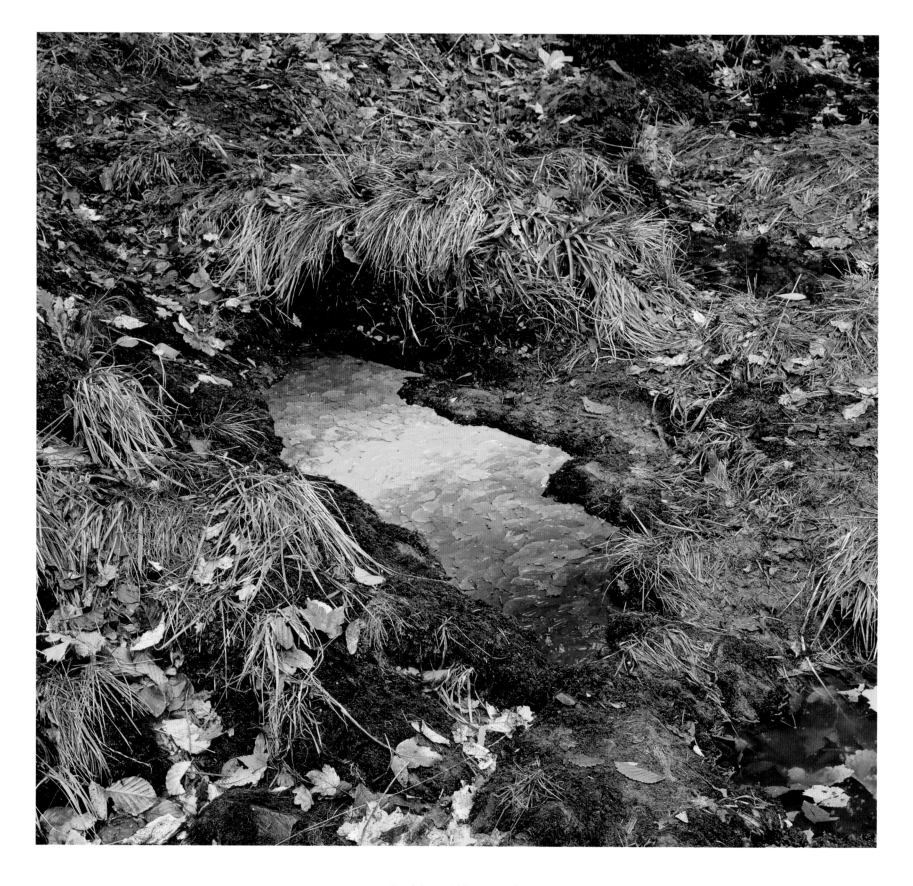

Beech leaves laid over a pool
rained overnight
river rose
washing the leaves downstream

SCAUR WATER, DUMFRIESSHIRE

30 OCTOBER 1999

TIDES

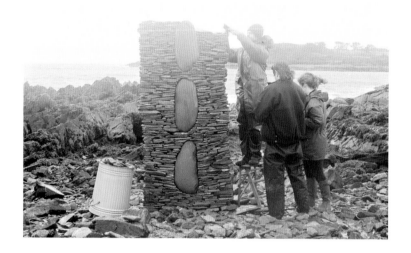

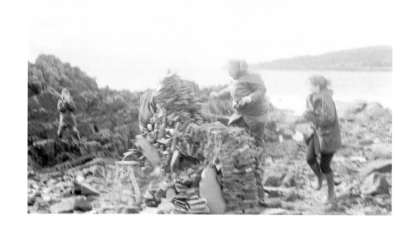

Stone stack

made quickly

ahead of the incoming tide

hoped for a collapse into the sea

fell when almost complete

but untouched by the sea

returned and rebuilt it the following day

making it stronger

photographed over several days

but didn't see it fall

CARRICK BAY, DUMFRIESSHIRE

17 OCTOBER 1996

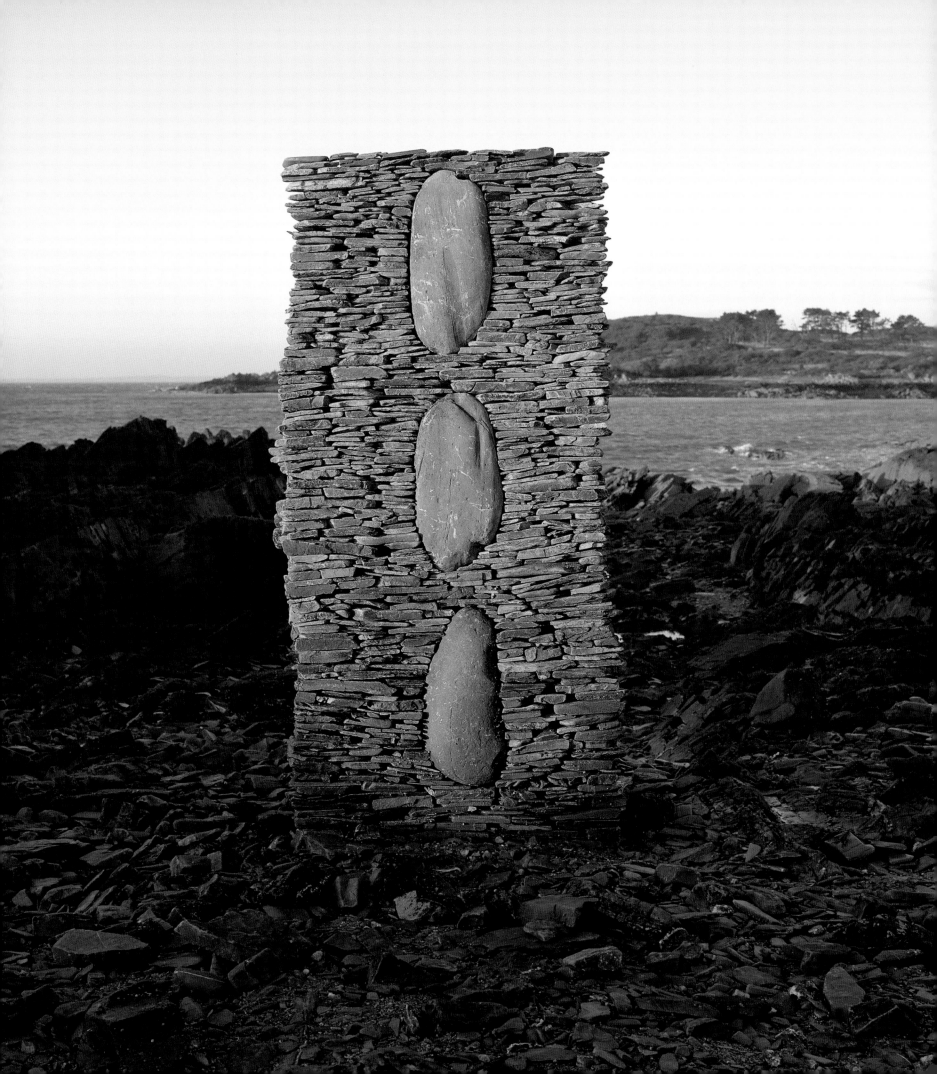

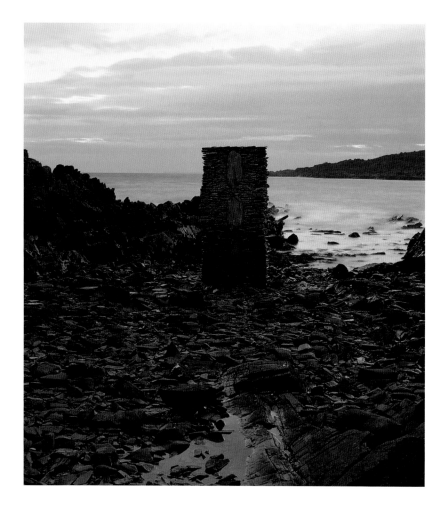

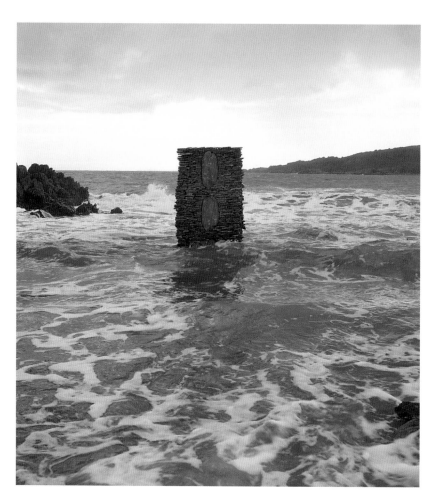

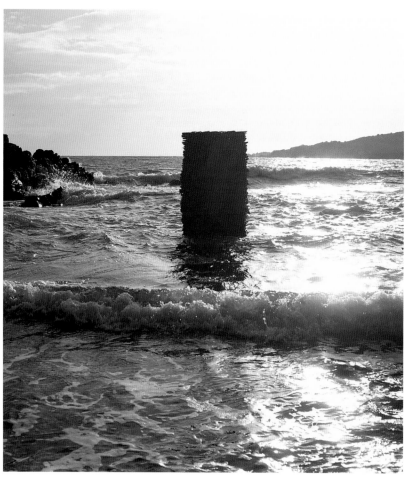

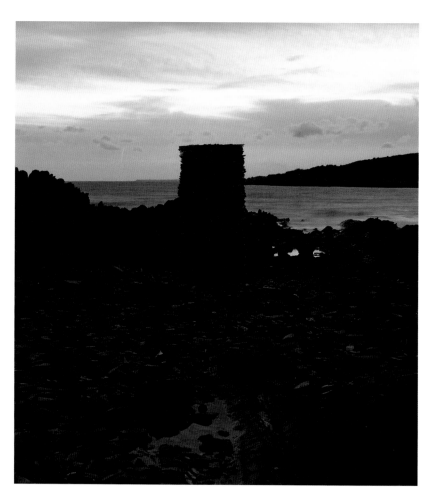

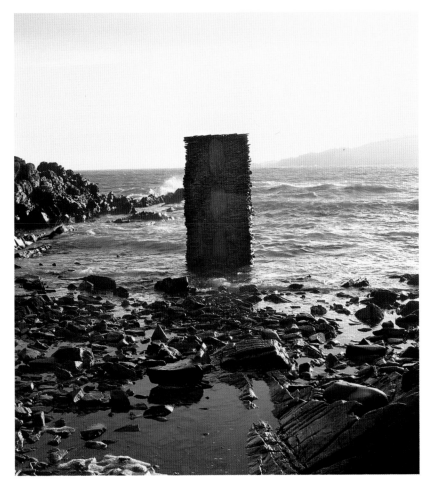
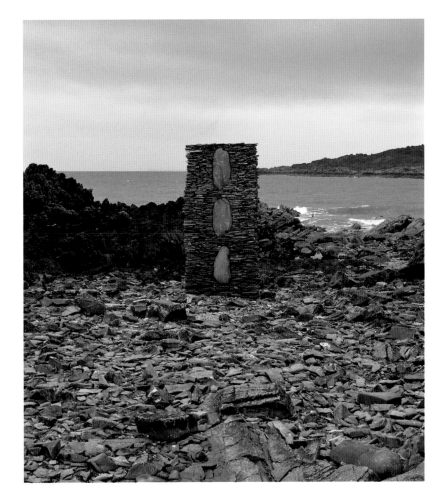
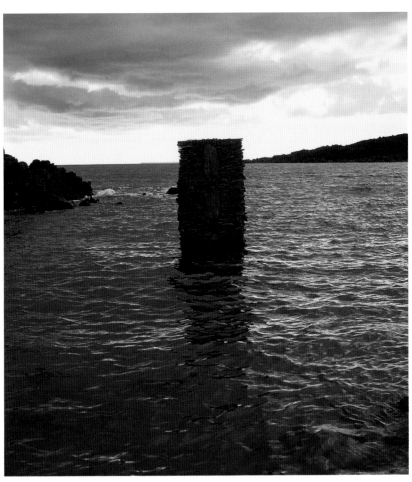
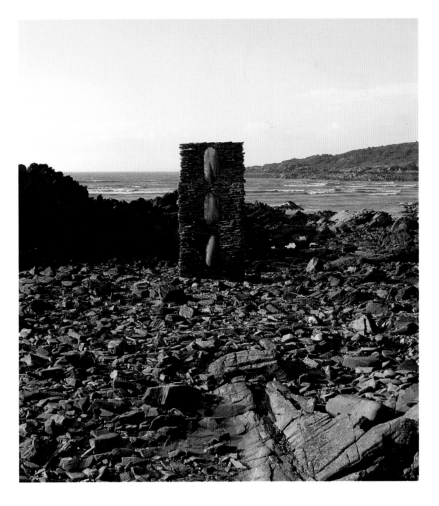

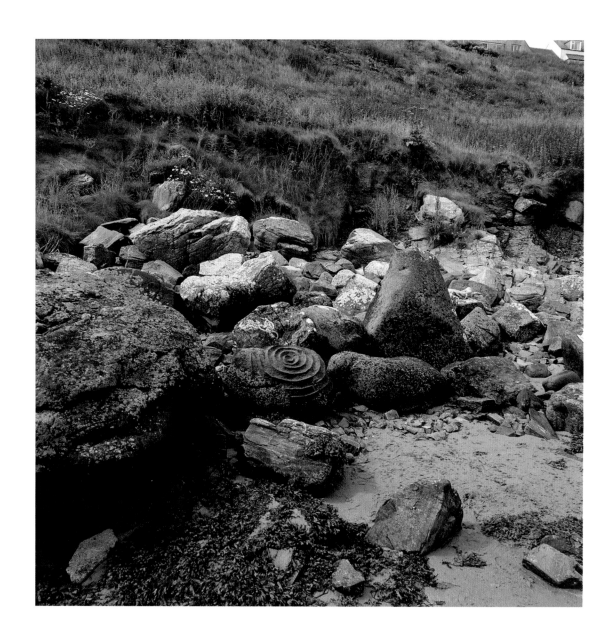

Sand stone

each work washed away

by the tide

before another was made

COLLIESTON, ABERDEENSHIRE

31 JULY 2000

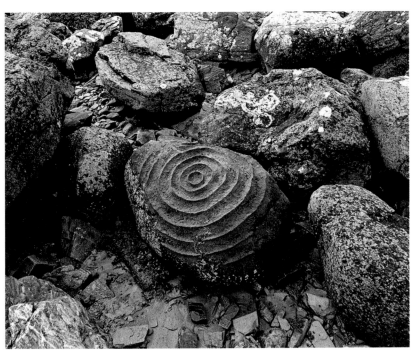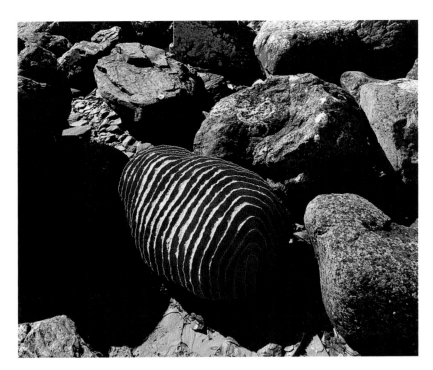
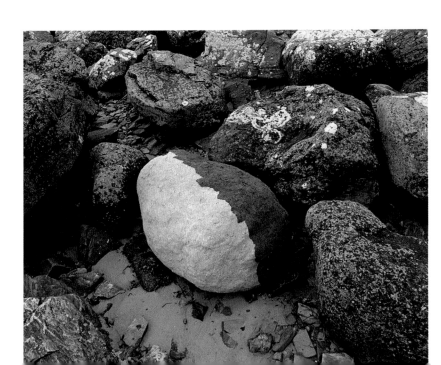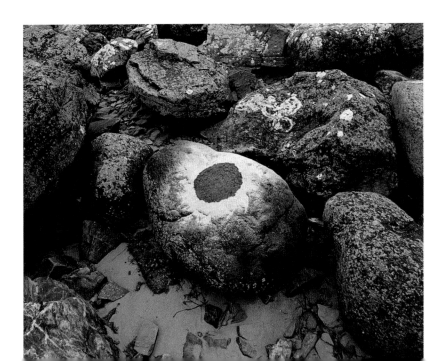

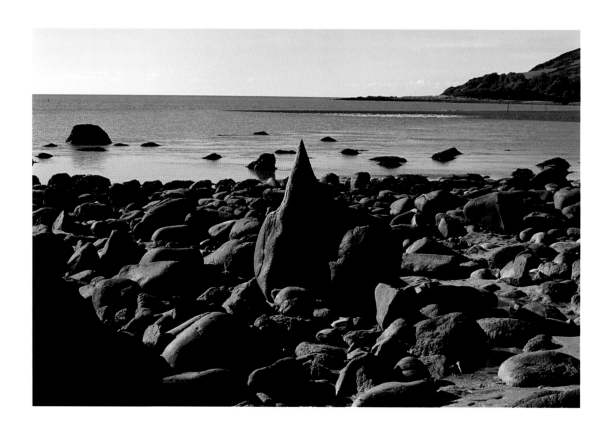

Sand worked around a rock

SANDYHILLS, DUMFRIESSHIRE

5 OCTOBER 2002 (this page) & 2 NOVEMBER 2002 (opposite)

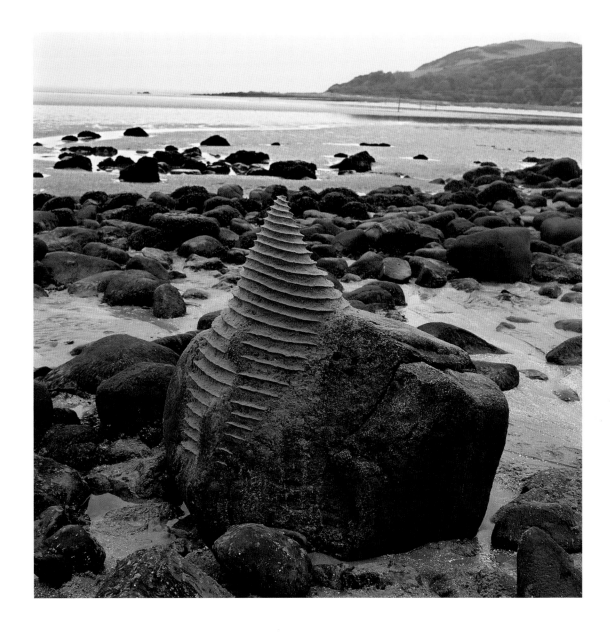

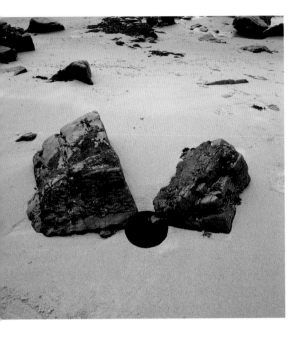
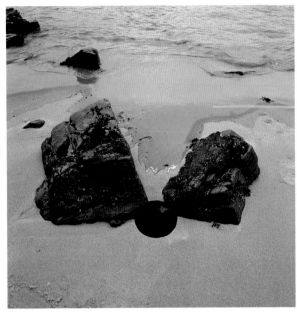
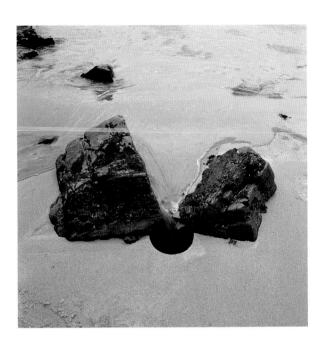
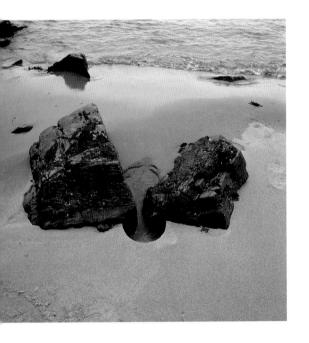
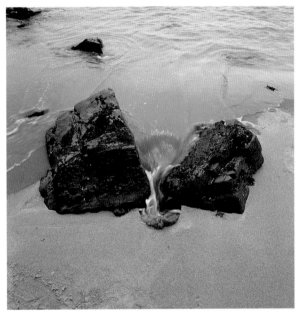
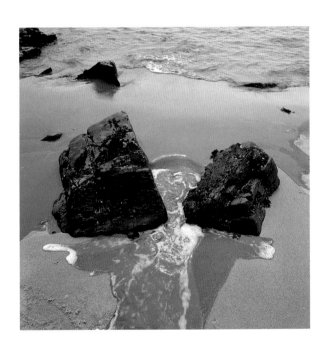

Two stones

hole

incoming tide

COLLIESTON, ABERDEENSHIRE

30 JULY 2000

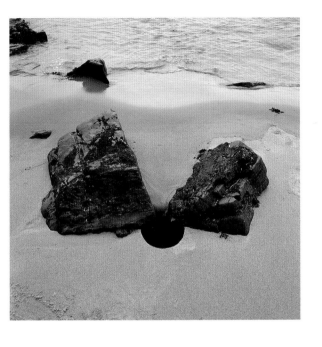
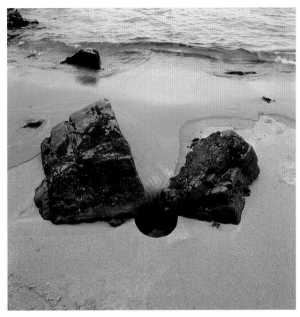
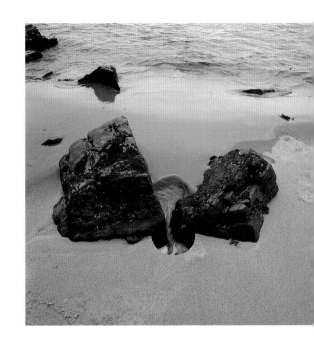
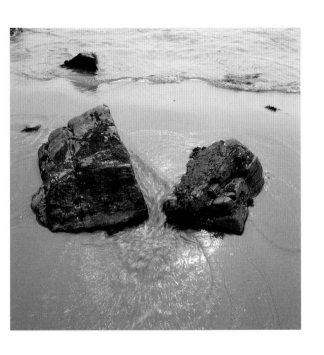
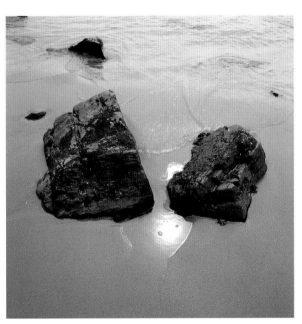
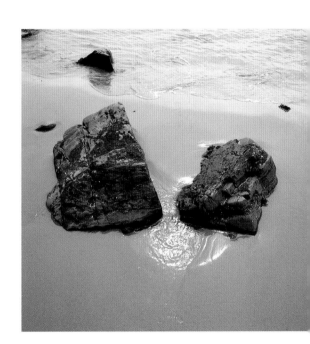

STONE HOUSES

Initial proposal drawing for *Stone Houses* using branches, 2003

Stone gathering at Glenluce Bay, Dumfriesshire, February 2004

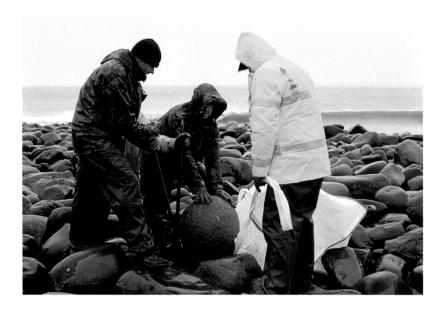

Since 1993 Andy Goldsworthy has created a number of works of an ephemeral or temporal nature in New York City's Central Park – an important source of inspiration whenever the artist has visited the city. *Stone Houses*, a monumental piece of a more enduring nature, was made at the invitation of The Metropolitan Museum of Art as its Iris and B. Gerald Cantor Roof Garden sculpture installation from May through October 2004. It is the first time that a work of art has been constructed especially for the site and the first time that the artist has created a work above Central Park's tree line. Goldsworthy found the Museum's Roof Garden a spectacular site to make a sculpture but one that presented many challenges. How could he relate the work to the place and have it belong there, with what he referred to as the 'easily overwhelming' dramatic and vast scale? How could he avoid engaging in a futile competition with the surroundings or treating them merely as a backdrop? How could he build on a large scale, given the weight restrictions of the site? Goldsworthy responded with proposal drawings of two stacked columns of balanced stones, each surrounded by a monumental dome of wood elements. The proposal ultimately became *Stone Houses*, a work that the artist feels 'commands the space' while also offering a counterpoint of view, inviting the visitor to peer into its interior realm. The sculpture echoes both the horizontality and the verticality of the surrounding urban architecture, and employs materials native to the park: wood and stone. The artist views Central Park as a landscape of wood (trees) surrounded by stone (the park's enclosing stone wall and the buildings beyond); conversely, *Stone Houses* is made of stone surrounded by wood, with stone the more fragile and precarious partner, 'just as trees often hold together and protect the landscape in which they grow'.

The granite stones were collected from the beach at Glenluce Bay in southern Scotland. Permission to do so was secured from the British Crown, the local council, a Scottish nature organization, and a group of farmers (one with ownership rights to a section of beach between the tides and a spear's throw). In fierce winter weather conditions, the granite boulders were airlifted by helicopter from the beach in the first step of their journey to America. The wood for the two domes is northern white cedar split rails from New England, the color of which will evolve over time from yellow to silvery white in response to the elements. These components of the sculpture – stone and wood – were gleaned from settings that Goldsworthy has a strong familiarity with and respect for: the beach (where, venturing out of the typical studio cubicle, he first began making sculpture as an art student) and the rural/agricultural landscape (where he worked as a farm laborer from the age of thirteen).

The two tapering pillars of balanced granite stones are thirteen feet (4 meters) and thirteen feet eight inches (4.17 meters) in height. Reminiscent of Brancusi's *Endless Column*, they are by far the tallest stone towers Goldsworthy has created. The stones decrease in weight as they ascend – from one-and-a-half tons to two ounces – and evoke the sea, having been

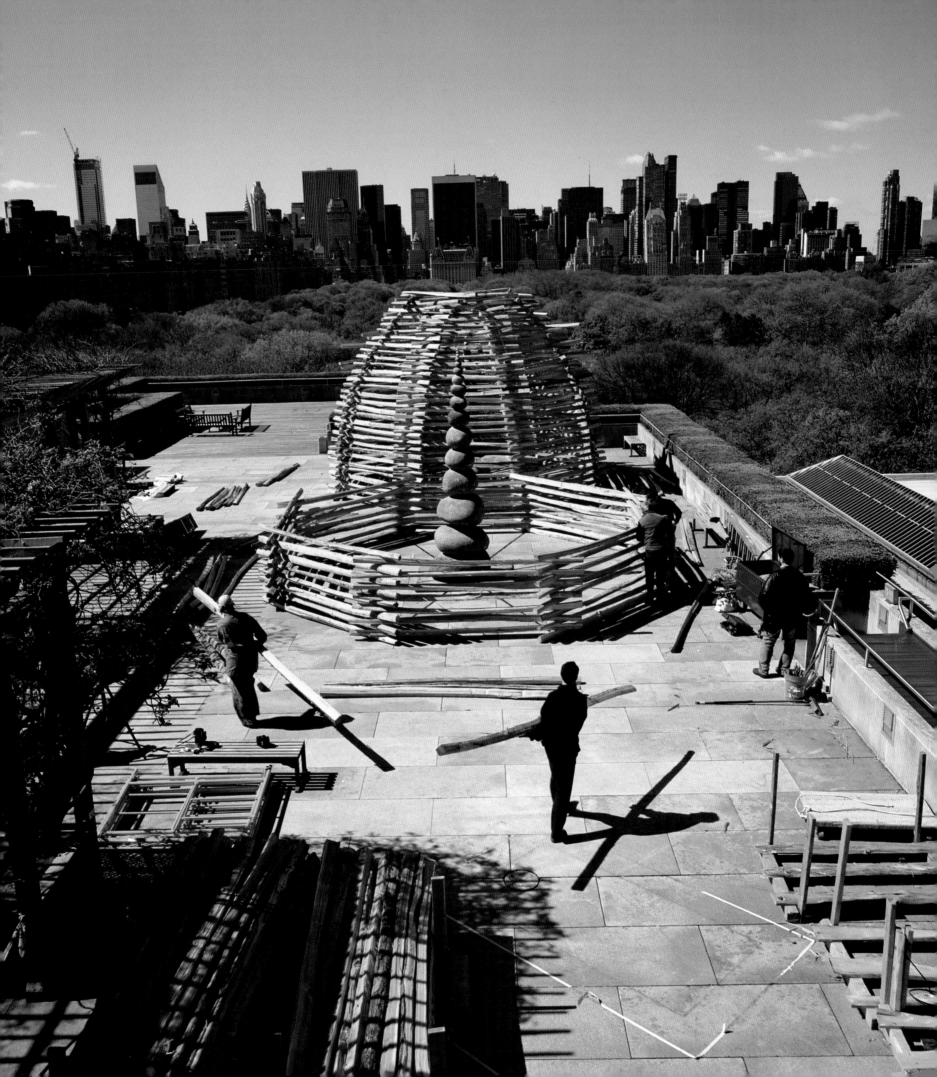

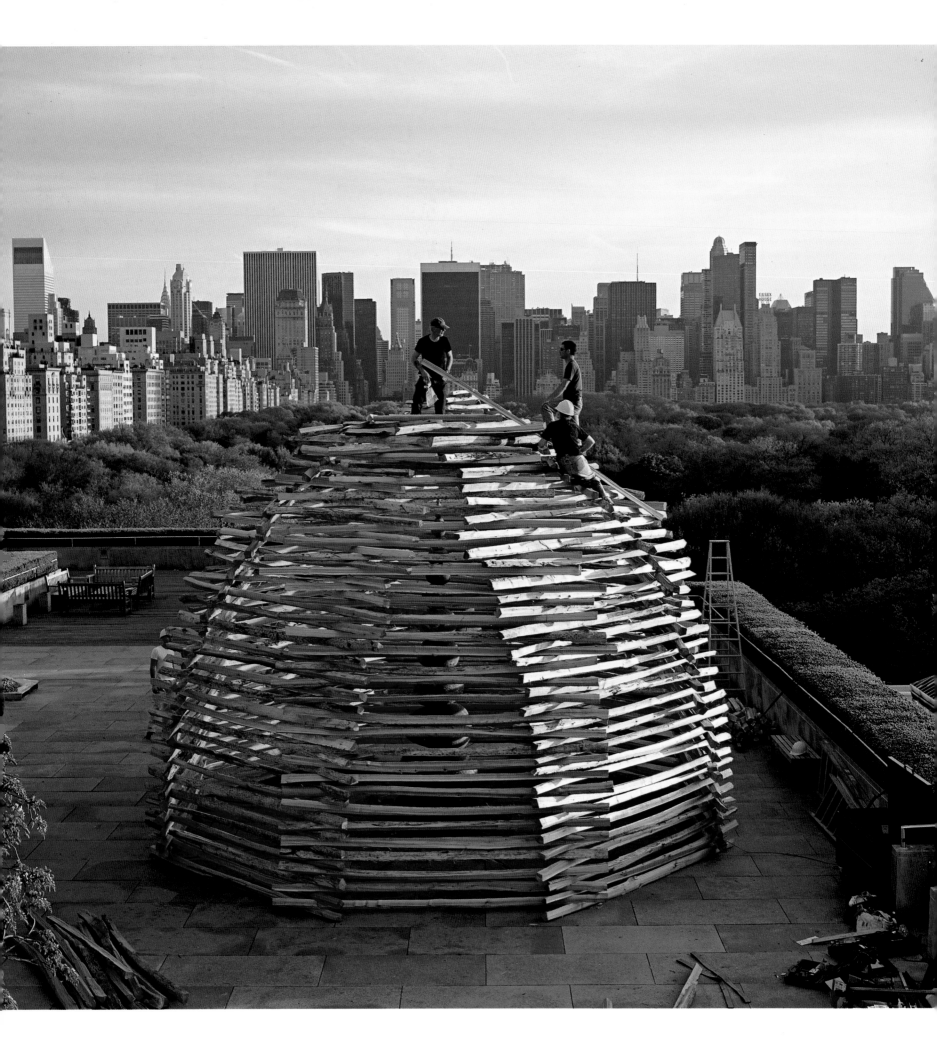

individually shaped by it and marked by it with red algae and barnacles. As he stacked them, Goldsworthy carved a shallow cavity in the top surface of each stone and then set one upon another, finding the perfect balance point between them. Each tower is surrounded by an octagonal dome of wood rails eighteen feet (5.5 meters) in height and twenty-four feet (7.3 meters) in diameter, with eight pronounced vertical ribs and, at the summit, an octagonal oculus three feet (90 centimeters) in diameter. Working with split rails for the first time, Goldsworthy constructed the wood domes by placing rail upon rail, creating strong natural joints that resulted in a secure, stable structure. Crushed granite made from former Metropolitan Museum Roof Garden paving slabs has been scattered within each dome, uniting the American granite roof terrace with the Scottish granite boulders.

The sculpture, of seemingly effortless simplicity and elemental beauty, power, and mystery, is firmly rooted in the setting, with stone that has journeyed from Scotland now sheltered by American wood. The stone columns appear fluid and ripe with energy as they rise skyward in an organic chain toward the domes' oculi, perhaps emblematic of life, each stone spawning a smaller one. The work includes a number of predominant themes that weave through Goldsworthy's oeuvre: the cross-cultural connection with his home in Scotland; the emphasis on stone as a living material, as seeds that nurture growth; the importance of the tradition of farming, evoked by the fencing rails; and the unpredictabilities, uncertainties, and unknowns of nature. Counterbalances resonate within the sculpture: a monumental, precisely constructed shelter, geometric in shape on the one hand, with delicate and balanced forms suggestive of the precariousness and vulnerability of nature on the other.

Following six months at the Metropolitan Museum, Goldsworthy envisions the long-term placement of *Stone Houses* in a rural setting of open fields.

Anne L. Strauss

Assistant Curator
Department of Nineteenth-Century, Modern and Contemporary Art
The Metropolitan Museum of Art

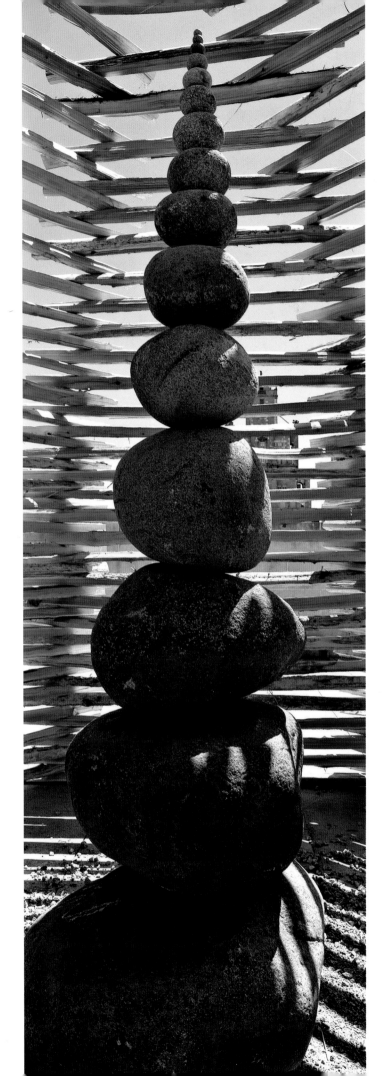

Scottish stones
collected from Glenluce Bay
a shallow depression carved into the top of each stone
into which the next stone was placed
to make two tapered columns
the top four or five small stones
fixed to prevent them from being blown off by the wind
enclosed in white cedar split rails
the top few again fixed against the wind

ROOF GARDEN, THE METROPOLITAN MUSEUM OF ART, NEW YORK

MAY–OCTOBER 2004

GARDEN OF STONES

On a sultry morning in early August, the sculptor Andy Goldsworthy stood in a quarry in Stony Creek, Connecticut, watching the heart being burned out of a ten-ton granite boulder. Eighteen of these tawny-gray brutes, varying between three and fifteen tons, are to be scattered around a space measuring a hundred and twenty feet by thirty-five on the second-story roof terrace of the new extension of the Museum of Jewish Heritage, in Battery Park City. The hollowed rocks will then be filled with soil, and, on September 16th, Holocaust survivors will plant a dwarf chestnut-oak sapling in each one, creating a memorial Garden of Stones.

Ten feet away from Goldsworthy, the stonecutter, Ed Monti (who is the son of an Italian immigrant quarryman), stood on an upended milk crate, draped in a yellow safety coat, his head masked by a black welder's helmet, pointing a six-foot shoulder-mounted lance at the half-eaten core of the lichen-webbed rock. From the nozzle of the lance a propane-ignited mixture of kerosene and oxygen hit the stone at around four thousand degrees Fahrenheit, generating a jet-engine roar. Sprays of sparks erupted about Monti's cowled head as the granite slowly yielded to his gouging flame. It can take twenty-two hours of this relentless attack to turn the largest boulders into scooped eggs.

Amid the din, Goldsworthy, a wiry Englishman in his forties with a habitually frank and friendly expression, observed the burning intently. The rock surrenders to the fire, he said, because fire created it in the first place. But fire cleans as well as sculpts. Shooting flames at granite not only reenacts primordial geology but converts the incinerations of genocide into the flames of sanctification.

Monti, a short, stocky man in his seventies, with a creased, nut-brown face, was unconcerned with these grand meditations. After about half an hour of concentrated fire, he descended from the milk crate and emerged from the helmet, haloed by clouds of steam produced by the cooling spray he runs at the same time as the fire-lance. He is more at home fashioning birdbaths and big neoclassical fountains, one of which was standing behind Goldsworthy's boulders like a duchess stranded in low company. Monti, who drives to the quarry every day from Quincy, south of Boston, made no secret of the fact that the job is more perseverance than pleasure, since kerosene flames got inside his mask and red-hot splinters of flying rock sometimes burned through his protective clothing. Goldsworthy, too, who has been often scarred, frozen, and lacerated while making his strenuously wrought pieces, showed off fresh burn marks acquired on the job. 'Dangerous work – can get nasty', Monti said in his flat Massachusetts accent, with a rueful smile. Jacob Ehrenberg, Goldsworthy's imperturbable young project

manager, has had to deal with operatic Monti specials: tantrums over pay; impromptu walkouts. But on this morning Monti went at it with a will, looking, with his helm and spear, decidedly archaic, like a warrior on an Attic vase.

During a break from the burning, Goldsworthy, Ehrenberg, and I peered into the opened belly of the rock. The interior was speckled gray, with shreds of stone flaking away from the walls or pulverized into a granular silica, like sand on a beach, some of the grains glassily fused. John Ruskin's feverishly beautiful passages on 'Compact Crystallines', in *Modern Painters* came to mind, in which he describes the glitter of granite as looking 'somewhat like that of a coarse piece of freshly broken loaf sugar'.

The cavity is conical, a form that much preoccupies Goldsworthy, who often declares a debt to Brancusi. Monti was working from the opened base and down the narrowing funnel. Once hollowed, the rocks are inverted, so that the saplings can sit at the neck of the boulder, atop their bed of earth. The disproportion between the hefty stones and the tiny, six-inch plants may risk looking absurd, but it will at least preclude any possibility of the stones' resembling the oversized planters commonplace in corporate atriums. Instead, a mysterious hatching will be inaugurated: the sprig from the rock.

The growth process of the sprouting menhirs, standing between the Hudson and Ground Zero, will not, however, be risk-free. Tom Whitlow, a Cornell plant ecologist whom Goldsworthy consulted, warned that if the growing tree should press against its unyielding stone girdle it could crush the living cambium immediately beneath the bark. In that case, the root system would atrophy and die. But unlike many contemporary artists, fretful about their posterity, Goldsworthy incorporates the indeterminate outcomes of natural processes into most of his work. Sculptures created from found materials like ice and thorns, driftwood, and even bleached kangaroo bones all presuppose that artistic design will yield to the cycles of time and climate, whether over an hour or a decade.

Sometimes misread as a placid pastoralist, Goldsworthy is in fact a dramaturge of nature's temper, often fickle, often foul. A recent, very beautiful film of his work, *Rivers and Tides: Andy Goldsworthy Working with Time*, must be one of the few documentaries in which an artist is seen enduring, repeatedly, the collapse of his own creation, as he attempts to build a cone of dark seashore stones. The idea, a dream of every seven-year-old sandcastle engineer, was that the cone should stand sentinel, almost submerged in the high tide, yet survive intact to reappear as the water receded. (After multiple failures, he finally pulls it off.) Similarly, Goldsworthy relishes the embattled growth of his dwarf chestnut oaks, contending with the jack-hammer shaking of downtown construction, the judder of helicopter rotors

on the riverbank, sudden gusts of estuarine winds, and the murky air of lower Manhattan. The plants' fight for survival against the odds is meant as an emblem of the Jewish experience they memorialize. 'The trees I wanted couldn't be decorative,' he says. 'They needed to be tough little S.O.B.s.'

On August 22nd, three weeks before the inauguration of the Garden of Stones, the last boulders were hoisted into their positions on the museum roof, and it was already apparent that Goldsworthy's sculpture would be one of the most powerful monuments in a city still struggling to find visual expressions for the tug between the perishable and the imperishable.

'Land art' – the genre in which Goldsworthy works – began in the nineteen-sixties, as an attack on the embalming of raw nature by the aesthetics of landscape. Of all the genres of painting, landscape, with its window view of the world, its dependence on the illusion of depth, was arguably the one furthest from two-dimensional abstraction. Even flattened out, its pastoral lyricism was at the opposite pole from the street-smart edginess that agitated New York Abstract Expressionism. But some sort of modernist encounter with nature was still possible. The founders of American land art – Robert Smithson, Nancy Holt, and Michael Heizer – aimed for an engagement with the outdoors that would break from the confinement of the rectangular frame; from freestanding sculpture that used a park or a landscape as an ornamental setting; and, above all, from the decorum of the gallery or the apartment wall. Instead of being a decorative placebo for urban angst, land art would, if anything, aggravate it, by frankly displaying what had become of the natural world in the age of industrial junk. The scenery – whether desert wilderness or the parking lots recorded in Smithson's *Monuments of Passaic* – would, photographically, at least, call the shots.

Land art was to be landscape's comeuppance. The place would own the beholder, not the other way around, since to experience Smithson's *Spiral Jetty*, at the Great Salt Lake, or the earthworks that Heizer cut into the desert one had to travel a very long way from Madison Avenue. What was left for the dealers to display and sell was nothing more than the secondhand trace of the authentic work out there in the wilderess: a photographic or cartographic record. Galleries dutifully filled up with lists, journal pages, rambling manifestos on entropy, and studiously amateurish photographs. The unreproducibility of the original epiphany was precisely the point.

The response of British land artists to all these Big Sky-Bad Boy backhoe heroics was creative understatement laced with a smidgin of polite distaste. Trucking through the desert and shifting the dirt was fine for a country with millions of acres of unpopulated wilderness, but Britain was the opposite kind of place. Not an inch of its crowded landscape was unmarked by human occupation. So its land art needed to be practiced as though Wordsworth were still with us: it had to be respectful of ancient rights of way, reverently self-effacing. In 1967, Richard Long created *A Line Made by Walking* – a photograph of the darkened trail made by his tromping back and forth over the grass. The integrity of the piece assumed that Long's line would be temporary and that, by the time most viewers saw the record, the bruising inflicted on the landscape would have been naturally repaired. Instead of nature brushworked into art, British land art proposed a brush with nature, its materials discovered rather than appropriated. Although nature, however fleeting the visitation, cannot, of course, take its own likeness, and although Long's austere images were necessarily framed and staged, they rapidly acquired canonical status.

In the late nineteen-seventies, Andy Goldsworthy, then a student at Preston Polytechnic, in Lancaster, went to hear a 'lecture' by Long that turned out to be a slide show accompanied only by county-and-Western music. Resolutely mute, when asked if he would mind answering questions, Long replied that yes he would. But Goldsworthy, who had worked off and on as a farm labourer just outside Leeds since he was thirteen, and already knew the work of Smithson, Christo and Dennis Oppenheim, was already making his own temporary constructions of stone against the sweeping arc of the Lancashire coast. Long's calculatedly laconic, anti-urbane gestures may have struck a chord, but Goldsworthy himself needed no tutorials about the need to cut loose from the drawing cubicle and get to the land. He was already his own master.

Immediately, he encountered land art's Catch-22: the need for a record. The record might be photographic, or it could consist of allusions to the real thing – circles of slate laid on the floor, for example. But as soon as the stones entered the gallery space, not to mention the inventory of dealers and the collections of patrons, they lost the flinty integrity that came with their 'on site' isolation. Even the Zen-Puritan Long understood that his gnomic trails – map coordinates, numeric and textual itineraries – were too arid to hold the viewer's interest, and he took to bringing into the gallery shorthand versions of his original experience. Whenever possible, the floor rather than the wall – the conventional plane of display – was to be used, or, if the walls were covered, it was with exhibitions of thinly laid-on mud, not paint. The idea was to rough up museum manners by importing the raw fabric of outside work. Even so, when land art surrendered to the wine-and-cheese gallery opening, it had, by its purest lights, surrendered.

Goldsworthy, however, believes – as a matter of historical fact and his own individual taste – that the social and the natural are not mutually exclusive. Making a virtue of a dilemma, he co-opts gallery space as a collaborator in natural process: covering the floor with clay taken from a construction site on the grounds and letting it harden and split into craquelure, outside and inside joined in an unhappy marriage; bringing in giant snowballs, stained with the natural dirt or dye of their origins, and allowing the melt to make an image on large sheets of paper, a visual history of self-dissolution.

Alternatively, he makes the suburbs do unsurburban things, obliging them to remember the harder rural history over which they have been comfortably laid. A road-facing stone wall, built for a Westchester client, has embedded at its center a huge boulder that looks like an invader from glacial prehistory; another wall has a fallen tree trunk laid horizontally within the stones, guaranteeing, at some point, the wall's collapse. Goldsworthy is drawn to social landscapes. Not for him the epic remoteness of Michael Heizer excavating a cut in the Nevada desert, or the solitary, imperially guilt-burdened peregrinations of Richard Long in the Andes or the Himalayas. Goldsworthy welcomes collaborations with wallers and shepherds (including neighbors in Dumfriesshire, in southern Scotland), pulling into his art the densely packed memories of human and animal occupation, limned through old hedges, cart tracks, and sheepfolds.

One of Goldsworthy's most spectacular and popular works is *The Storm King Wall*, built in 1997-98 for the Storm King sculpture park, in the Hudson Valley. It was made possible by an encounter with the debris of an old drystone wall, overrun, like most such walls in the valley, with second-growth

forest when farming was abandoned. In contrast to most of the contemporary sculptures at Storm King, which are simply set in the landscape, Goldsworthy's is of it. His snaking, 2,278-foot drystone line was built by wallers imported from the North of England, where curved walls are called 'crinkle-crankle'. It reverses expectations in that the stones appear to move, while the stands of maple, shagbark hickory, and oak through which it travels resist their encroachment. (With time, root systems and wall foundations will conduct a pushing and shoving match.) Emerging from the woods, the line descends giddily into a pond and seems to resurface before climbing the far bank and getting itself straightened out, American fashion, as it heads directly for the perimeter highway.

But there is *Wall*, the book, as well as wall, the work: one in a series of large-format volumes packed with dazzling photographs documenting Goldsworthy's ephemeral works. There are pools dyed blood red with pigment rubbed from on-site iron-oxide rocks; translucent arches of ice destined to self-destruct in the winter sun; rocks smeared with peat to coal black; thrown clouds of sand or snow, photographed at the sprayed arc of their ascent; coronas of bracken stalks fastened with thorns and hung from trees; delicate strings of pale-green rush threaded about a mossy trunk. These high-color glossy images are the antithesis of the self-consciously primitive, grainy prints favored by the founders of land art, and they have been taken by Goldsworthy's critics to be evidence that he is, at heart, an ornamentalist, a glamorist of nature who has made the mistake, serious in a contemporary artist, of hunting beauty. 'Fiddling around with nature' was one such verdict. While Goldsworthy concedes that the books may have contributed to misunderstanding, he does not apologize for working with color, using it to load his work with emblematic and poetic allusion. A drape of autumnal elm leaves about a rock documents, through the belying brilliance of its yellow, the doom of the diseased species of tree; a line of fleece laid atop a Dumfriesshire drystone wall evokes a sorry history, when the entire rural populations were cleared to make way for sheep.

Goldsworthy's work has been widely exhibited and praised on three continents, but it has yet to be acquired by the Tate Collection, the pantheon of British modernism. The omission is predictable, for the work's peculiar virtues – its moral intensity; its Ruskinian devotion to work and craft; its scientific curiosity; its intelligent engagement with the long history of land use; its keen instinct for the baroque hyperbole of the natural world (all those mottlings and juttings and peelings and stainings) – are precisely what is least likely to recommend it to the contemporary canon. Yet it could be argued that Goldsworthy's work is at least as conceptually rich as Smithson's; his compressions of space and water as metaphysically suggestive as the sculpture of Anish Kapoor; his use of found materials as inflected with past use and future alteration as the wood pieces of his friend David Nash; and his meditations on decay, mortality, and generation as smart as Damien Hirst's.

But the connoisseurs of decomposition are overwhelmingly urban, and walls generally capture their interest only when scrawled with graffiti. Goldsworthy, too, plays in the junk yards of the world, but his are strewn with the rubble of the eons, not last night's Chinese take-away. And then he is obstinately indifferent to cool, impervious to the laconic game-playing required for certification in conceptual subtlety. He has never made a secret of valuing clarity over irony and northern plainness over metropolitan chic.

When, in the late 'eighties, his former dealer, Fabian Carlsson, offered him a long-term contract on condition that he move to London, the price was too high.

What is he doing, then, in downtown Manhattan? The commission from the Museum of Jewish Heritage (in collaboration with the Public Art Fund) is in essence an attempt to realize a natural process of catastrophe and redemption. No one encountering the stone garden will think it the work of a decorative artist. It is, instead, an encounter with the elemental. The benches are made of granite.

This is not to say that Goldsworthy wants the boulders to look as though they had just dropped in from the cosmos. The white scuff marks he has left on them testify to their many migrations: from fields near Barre, Vermont, where Goldsworthy and Ehrenberg discovered them, to the Connecticut quarry where they were hollowed, and thence to a Brooklyn holding yard, from which, finally, they were moved to Battery Park City and crane-lifted, gingerly, onto the roof of the museum. The fact that the stones had long ago been cleared from their original geological site by farmers needing agricultural land was a plus for Goldsworthy, though he had to convince one incensed member of a local commune that he was not uprooting the rocks from an ancestral resting place. But wandering stones seem right for a Jewish memorial garden, especially one that faces outward across the broad slate-green river to merciful stopping places: Ellis Island and the Statue of Liberty. Goldsworthy, who has himself travelled a great deal in the making of his work, felt the weight of impending repose as the last boulders were moved onto the roof.

Much was still to be done. The concrete plinths on which the boulders are settled needed to be covered, along with the rest of the garden bed, with the gold-brown gravel that Goldsworthy had chosen to set off his gray monoliths. A watering system for the trees had to be installed and tested. The garden space is contained on two sides by five-foot walls made of granite panels. Atop one wall is a planter running the length of the space which is to be filled with flowers and shrubs, and Goldsworthy worries that this will prettify the meditative austerity of the site. Worse still, as rock No. 15 is lowered to the roof terrace, Goldworthy learned that a corner jutting over the garden, and in the view of anyone looking toward the harbor, might be covered by a trellis. The coming of creepers does not make him happy. But for the moment the work seems wonderfully well done, a poignant metaphysical conceit strongly realized, the crush and mass of history penetrated by the germination of hope.

The derrick men, led by their athletic crew boss, J.B. Jones, from Blakely, Georgia, sporting a nifty head scarf and with more graceful moves than Alvin Ailey, have got into the spirit of the thing. As one of the last of the boulders drifts, seemingly weightless, onto its receiving plinth, J.B. talks the rock down, shouting, 'Whoa! Treat the *lady* nice and easy', and yells to Goldsworthy as the titan settles, 'You like? You *like*?' He does.

Simon Schama

first published in *The New Yorker*,
22 September 2003

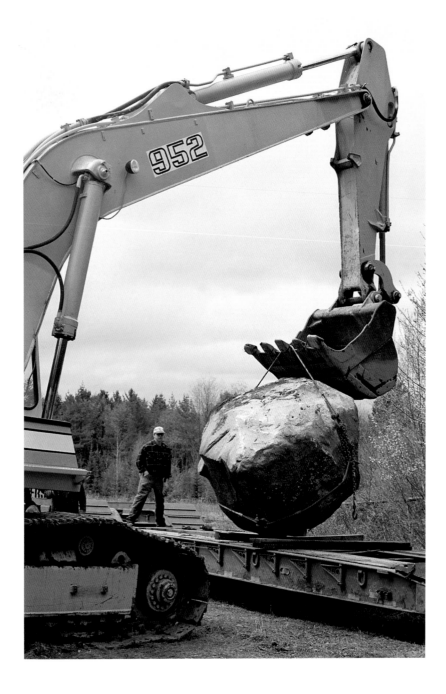

11 May 2003

Yesterday was spent looking for stones. Jacob has found an area near Barre with many good boulders. Today we will lift three of them, which will be sent to various places to be worked upon in the hope of finding the best way to hollow them out.

Each stone will be weighed as it is lifted and will determine the physical limits of the sculpture. We have already made rough calculations, but actual measurement is essential. I have to find a balance between the size of the stones and the ability of the roof garden to support them.

It is unusual for me to make a sculpture away from the place where it will eventually go. The site, however, still exerts a control over the making.

It is always interesting when idea meets material. Until now I have been able to choose stones from my mind which I have then represented in drawings, models and computerised images. On site I used round tables instead of stones to give an idea of placement and number.

A boulder, however, is not a table, and the reality of being in the woods and fields, where I have found some great stones, has changed the way I am thinking about the group. Seeing them together outside, I now feel that my original idea of stones of roughly equal size is too uniform.

I initially needed to give the tree as much root space as possible; the tree would not be viable in a boulder of less than a certain size because it could not be hollowed out enough to contain sufficient soil. The possibility, however, of a combination of dwarf trees and a layer of soil covering the entire roof below the stones has removed the need for all the stones to be large.

There is energy within a group of stone of various sizes. It becomes a family rather than an army. Smaller stones will take up less space in the garden which in turn might allow the number of eighteen to be achieved – a significant association for this particular place. (Each letter in the Hebrew has a numerical value, and those that make up 'chai', the Hebrew word for life, add up to eighteen, so this number has always had special connotations). My primary aim is for the number of stones to feel right. I must not force a number into the garden that makes it feel overcrowded.

It will be interesting to see how adaptable the Museum, architect, engineers and everyone else involved will be as the idea develops and changes.

12 May 2003

Lifting the stones at Maple Hill yesterday attracted the attention of a couple of people who live nearby, one of whom ended up spending most of the day helping. I don't think he knew anything about my work. He grew up on a nearby farm which could be a possible source for more stones.

The atmosphere was good and I was able to mark up the stones to indicate where they should be hollowed out.

I was hoping to move onto a nearby farm which is now a community-run school where I had seen good stones. At midday I was told by its director that we could have some of them. We moved the tracked machine up to the largest and most perfectly shaped stone that I have found so far.

MUSEUM OF JEWISH HERITAGE, NEW YORK

My idea for the garden at the Museum of Jewish Heritage in New York was accepted in September 2002. Jacob Ehrenberg was enlisted as project manager and in December we went in search of stones, starting just north of New York and going as far as Vermont. There was snow was on the ground and we were able to locate only one possible stone at Barre, Vermont. This was important because we needed to experiment with various methods of hollowing out.

The particularly severe winter prevented any more searching until May the following year. This placed enormous pressure on the making of the sculpture, which had to be installed by fall 2003.

The following extracts are from a diary that I kept intermittently during the process of finding and working the stones.

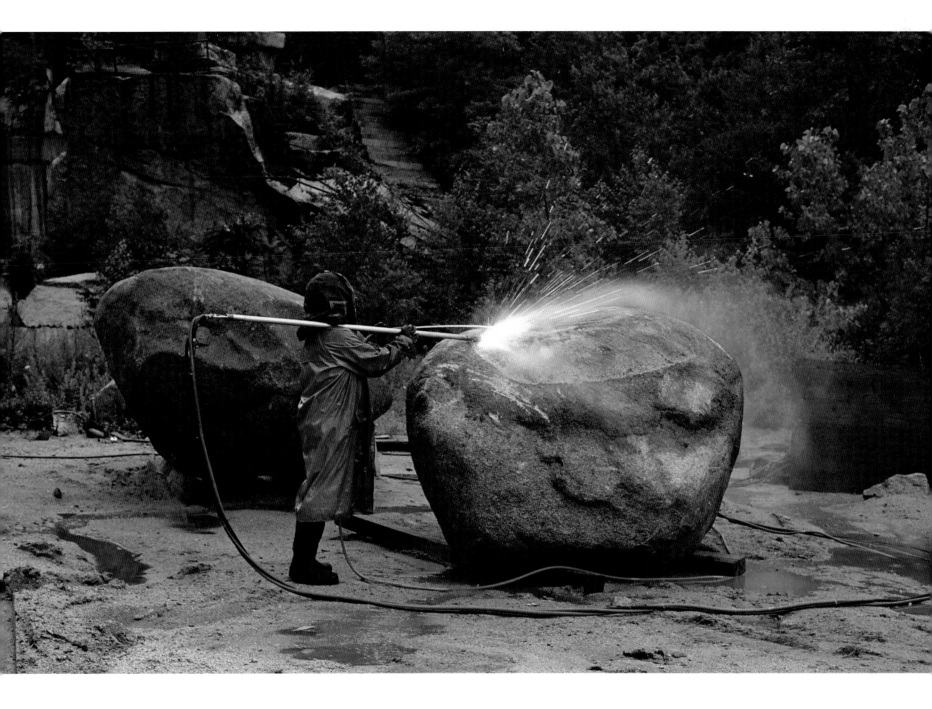

The machine operator, Todd, was uncertain as to whether it would be possible to carry the stone across the field, which had been softened by the rain, without the machine digging into ground. It was decided that the stone should be weighed before a decision was made. As it was being strapped up, a member of the local community came up to express her anger at the taking of the stones.

I have great sympathy for anyone caring about stone, but sometimes the level of protectiveness is suffocatingly precious. The stones have come from areas cleared for farms and homes. I prefer to take them from places like this rather than from where they have become rooted in woods. These glacial boulders have had a long and, at times, violent past – both natural and man-made. Granite originated in fire at the earth's core and rose to the surface, where it has been split, carried and worn down by glaciers. Farmers pulled out whatever they could to make fields, blasting those that they couldn't

remove. When bulldozers arrived, the big stones were pushed to the edges of the fields intact, and this is the kind of boulder that I am lifting. Without machines these stones would not be there. Underlying the pastoral calm and beauty of a field is the destructive or creative violence (depending upon how you look at it) of stones and trees being ripped out to make farmland.

My working of the stones is a continuation of the journey these stones have made so far. They have a history of movement, struggle and change – appropriate associations, I hope, for a Holocaust memorial garden.

The stone was lifted as I was trying to explain this to the angry woman and I had to break off to see how heavy it was. To my dismay it weighed in at fourteen and a half tons. Ten tons has been talked of as the maximum weight, but it has been unclear whether exceptions could be made in certain areas of the garden, and whether, if some of the stones were smaller than anticipated, others could be larger.

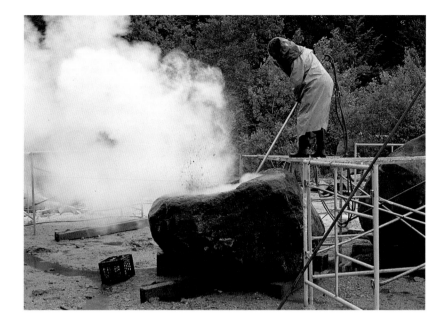

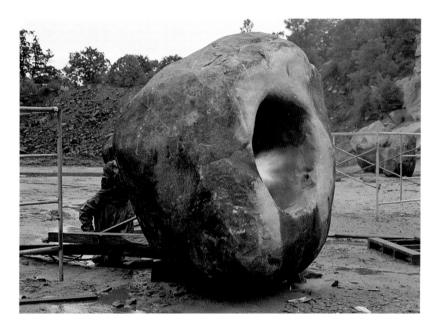

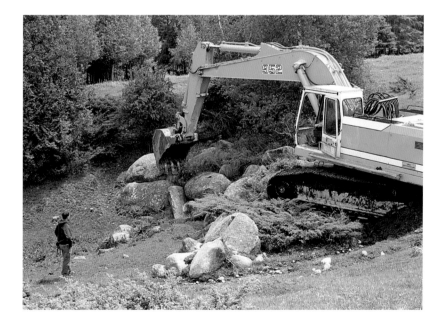

I rang the engineer to ask his opinion. I think he was dragged out of a meeting to be asked yet again for a response to a question he couldn't really answer. He angrily said that if I told him the weights of all the stones, he could tell me if and where they could go. My problem is that I don't want to go as far as lifting and carving the stones only to find that I cannot use them.

In addition to the angry woman and a reluctant machine operator I now had an angry engineer. I took the stone.

Today Jacob and I drove for four hours from Barrie to Branford, Connecticut, where one stone was delivered to Ed Monti. Ed carves granite with a cutting torch. The stone was put in position and marked up for cutting, and I left to go to New England Stone, Rhode Island, who have large premises with facilities for working granite and have agreed to experiment with various ways of hollowing out the boulders.

The drive took about an hour and a half. When we arrived, it turned out that the person we had been dealing with and hoped to meet, Tony Ramos, was on his way to Brazil. We were shown round by his manager, Don, who knew nothing about what we were doing and will need time to think it through.

We decided to go back to Branford to see how Monti was doing. On the way I caught a glimpse of what seemed to be a sand quarry in which there was an enormous number of boulders. We were on the freeway so had to get off the next exit to get back to the place I had seen.

Eventually we found it. The quarry appears to have closed recently to make way for development. It was eerie to go into a huge expanse of sand and find the most amazing quantity of round granite boulders. Had I seen this place at the beginning I would have been ecstatic.

The stones were exactly what I had in mind when I first made the proposal. Now I am not so sure. I have grown to like the raw rounded boulders from Vermont. The surface of these stones is highly textured and speckled and might be too much in surroundings that are already textually rich. This, added to their perfect roundness, could make the stones feel manufactured rather than found.

I do not think that a mixture of the two types would work either: it could reduce the sense of solidarity within the group.

The social and agricultural associations of the Vermont stones gives them more resonance. The tree will struggle to grow out of stone; a farmer struggled to remove that stone from a field – both tree and farmer driven by the need for food.

It took about five hours to drive from Rhode Island and NLB Mickledon, the company in New Jersey where work will take place on another boulder. NLB specialise in the use of water under high pressure to cut materials. The technology is now used primarily to cut steel but was originally designed for granite.

We stopped off at Branford to see how Monti had got on. He had not started on the stone, but everything was in place to begin tomorrow.

A long day.

15 May 2003

We have been at NLB for two days experimenting with high-pressure water as a means to cut the boulder. The process is technologically complex but in fact erodes stone in a way it always has been – by wind and water.

I don't know as yet how viable this method will be, but it could be extremely useful in getting to the more difficult areas inside the stone The people there were extremely helpful, and the process works, but the hiring of the pump makes it expensive.

16 May 2003

Went to see how Monti was progressing. The stone had been hollowed out to a depth of about fourteen inches which was a little disheartening considering how much still needs to be removed.

Richard Griggs from the Public Art Fund joined us at the quarry. I wanted to see Monti at work so we stayed at the quarry for the morning.

Monti said that the stone had become easier to burn the deeper he got, but nothing had prepared me for the speed at which he was now hollowing out the stone. Monti is in his seventies and seeing him climbing up onto a plank supported by unstable wooden ladders, whilst carrying the ignited torch, was somewhat unnerving.

The process is extraordinary. The noise was intense. Great clouds of steam rose out of the stone as Monti poured water on to the rock to cool it down as he burnt. Fragments of molten rock flew off from time to time, and the torch made the part that was being worked on glow yellow.

It seems a raw and violent way to work stone. Granite, however, can be melted because it originated in fire. The process taps the latent energy within the rock and is much more sympathetic to the nature of granite than the clinical cut of a saw.

In the afternoon we returned to New England Stone to see what Tony Ramos had managed to do. Unfortunately nothing had happened which was very disappointing.

We returned to Monti who had spent much of his time having the stone turned over into a position which would allow him to core drill a small hole through its middle. This hole will mark the place where the tree will eventually be planted.

29 May 2003

I visited the Museum two days ago to give an update on progress. The site is developing and although I have concerns about surrounding plantings and the lighting, it is looking good.

The following day I went to Stony Creek quarry to offload more stones for Monti to burn. It was good to see them as a group. One stone is more or less finished. That evening we decided to go to Boston and visit the Arnold Arboretum to see a dwarf oak that is known to grow there.

It was with great anticipation that I arrived at the arboretum this morning. I called in at the reception to find out where the trees were and was given a map indicating where they were growing. I also explained what I was doing and asked if there was anyone available to give any information on the tree.

There were many small oaks in the area indicated on the map. Most of the trees are labelled. I saw several that would have been acceptable-looking trees, but turned out not to be dwarf oaks. I then saw a small oak that was exactly what I wanted. It is the image that I had in my mind when thinking of the garden. It had a wonderful character without being contorted. It was about twelve feet high with a stout trunk. I couldn't, however, find any identification. Just then one of the arboretum staff who had heard I was around came by and confirmed that the tree was *Quercus prinoides*.

There were several growing in the area, which revealed that this species can grow in a variety of ways, both single and multi-stemmed. The trees had been planted in 1884 and were therefore 119 years old.

This was a great moment as it has confirmed that this is the tree I would like for the museum.

The director, Peter Del Tredici, kindly took me on a tour of the garden and enthusiastically showed me other trees that might be of interest. It was a wonderful morning and gave me the same feeling as when I found the stones – what had been, until then, an idea only in words, diagrams and photographs had become living material.

31 May 2003

I am back in Vermont to find more stones.

Yesterday was very intense. Jacob took me to a recently cleared area of land with many boulders pushed to the side. There were several good stones, and I selected a number of them before leaving to go to Maple Hill School where I had agreed to give a talk.

The school had given me some stones on my last visit and they had asked me to talk to the kids. The audience, however, contained various other people, some of whom we had met during our search for stones. All the stones have come from a small area near Barre. The people who live there feel associated with the sculpture because of the stones, and I like the idea that people from here can go to New York and find stones that they are connected to.

The stones would not have had the same social connection had they been collected over a wide area. My aim is to realise the final sculpture at Battery Park, but how the sculpture is made and the journey of both the idea and material are also important. That all the stones have come from one small place gives this part of the story greater meaning.

After the talk we resumed our search for more stones. Jacob had found another farm with boulders. I felt that I had enough from the first location so was not expecting too much, but it still seemed worth going to look. The farmer took us around and showed us some stones which were even better than those I had found earlier on. Not only were they better shaped and free of flaws, but they had turned a similar colour to the ones already collected and so would allow the group to be fairly uniform. The stones from the first location I had looked at this morning were freshly pulled and not as weathered.

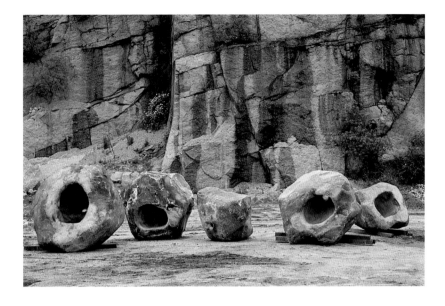

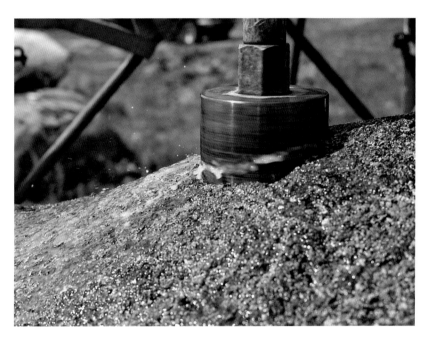

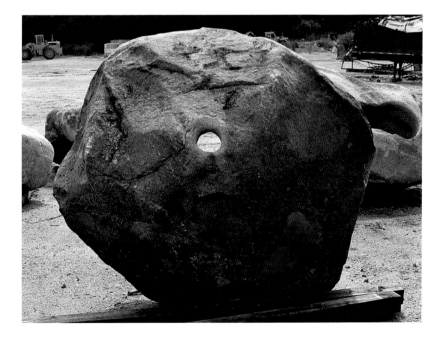

I also liked the fact that the stones had come out of a farmed landscape. The farmer had no love for the stones at all – which is not surprising. He had started by being dismissive about all the stones and couldn't see any difference between them, but gradually he understood what I was after and began to point out good stones to look at.

Our big problem today was trying to figure out how best to proceed with the hollowing out. Tony Ramos has not produced an acceptable solution and there are too many stones for Monti to do alone so we need another process on the go if I am to finish the work on time. The only other method has been coring, which although it removes a substantial amount of stone, is not a complete solution. I have been impressed by the willingness of Pat Foran who does the coring, to engage physically with the stone, and feel that after the coring he might perhaps be able to cut out more out with a hand saw.

We went to meet the owner of Vermont Concrete Cutting, John Anderson, at his works in Barre and arranged for the remaining stones to be delivered to him on Tuesday.

Today I went to the river. I made a work with fresh, vivid green maple leaves – laid on a pool alongside the river. It took me a while to find something to make and I first experimented by laying leaves on stones.

I then laid the leaves on a pool, wondering if they could support a line of sticks. I half expected the leaves to break up and sink but to my surprise they not only supported the sticks but in return the sticks held the leaves together. I tried a line but changed to a flattened branch on top of the leaves. It was a small but interesting work, of a kind that I have desperately needed to make but which has been understandably overtaken by the demands of the substantial Museum of Jewish Heritage project.

In the afternoon I returned to the farm with the stones to make a final selection. Barry Maclaren, the farmer, is being very helpful and took us around his fields in search of more stones. It is interesting to get to know him a little, to hear his views and to see the land from his perspective. He sees the stones very differently to me. To him they represent obstacles and broken machinery.

I have found all the stones that I need and on Monday we will lift them. I hope that the ground dries out – it is very wet and muddy at present.

2 June 2003

The lifting of the stones has gone very smoothly. Everything worked on time with a great combination of crews from the machine operator to the haulage people.

The Maclaren family came out to watch – father and sons. They have been good company. I like being amongst people who farm. I don't necessarily agree with everything that they do, but I feel an affinity with their connection with the land.

We have some relatively small stones which I hope will give greater variety to the group and also reduce weight on the roof and allow me to reach the number eighteen.

I have twenty stones in all – two spare in case one or two go wrong. I might try to take all of them to New York to give flexibility during the installation.

It feels good to have one part of the project finished. We can now concentrate on the next stage, which is the hollowing out of the stones.

22 June 2003

I returned to the States last Thursday, arriving late afternoon. About half an hour after my arrival I received a call from Jacob who said that after a disagreement over finances, Monti had left the site saying he would do no more work on the stones.

This news was not unexpected as Monti has been difficult to deal with at times. It did however put me in the very awkward position of having to find an alternative method to hollow out the stones.

Fortunately on my last visit nine stones had been kept at Barre to be cored out with drills. I hoped that this would speed the process along, with Monti either finishing them off or possibly finding some way of cutting out stone with blades and chisel after the core had been removed. The difficulty lies in expanding the hole inside the stone. This appeared now to be my only option.

The hacking, cutting and hammering of stone is reminiscent of mining. It is a very brutal, physical process in which human will is set against the stone. Each process has its own energy which brings a different dimension to the story of the sculpture's construction. But working a fire-formed stone with fire is the process that I like most and I was very disappointed at the prospect of losing Monti's involvement. I was therefore delighted that the following morning he returned to work.

There are now seven completed stones. To my horror, however, the largest and most beautiful of them all has developed a hairline crack on one side. There is still plenty of stone left but it is not a good sign – especially with the as yet unknown effects of soil expansion and contraction through freezing and thawing.

When going over the potential problems with the project the possibilities seemed clear – the stone would either be intact or not. I never expected something in between. There is a fantastic tension in this stone which could still be interesting even if it did split apart. I still don't know what to do and I am considering putting an internal metal brace across the crack as insurance. I would prefer not to do this and may accept the crack as evidence of another level of vulnerability and tension within the sculpture. This project is proving to be the most stressful and time-consuming that I have ever been involved in, and the crack has become the focus for all that tension.

23 June 2003

I am back in Vermont to see how the coring is going. Unfortunately only one core five inches in diameter and about twelve inches deep has been drilled. This part of the trip would have been a waste of time were it not for the opportunity it gave to find a couple more spare stones as possible replacements. I had not expected a large one to crack and consequently had only smaller stones in reserve.

The range of sizes is important. The larger stones are particularly significant and take on the role of guardians or leaders in the group without which the sculpture would be the weaker. I remembered a stone that I had not lifted previously because it was too big – around fourteen to fifteen tons I think. These are the most difficult to find and I was pleased to have one to hand.

The only problem was that in order pick it up we would have to cross someone's garden, and the lawn would inevitably be damaged in the process. Fortunately the owner was not too put out and agreed to our having the stone.

Apart from the friction at Maple Hill I have been astonished by how amenable people have been. I know the payment of thirty dollars a ton helps, but feel that stones have been given in the spirit of helping somebody out together with a curiosity about where they are going and what they will be used for.

2 August 2003

I am on my way back to New York. During the past month work on the stones has been carried out under the supervision of my assistant and project manager Jacob Ehrenberg. I left the remaining stones clearly marked as to where they should be hollowed.

Work has gone well and most of the stones are now finished. Another financial disagreement with Monti caused him yet again to leave the site. I think he will return, but it is not a good time for this to happen. Over the next week I need to approve the work done so far, have the bases flattened to make sure each stone sits well, check those stones with cracks and oversee the hollowing of two replacements. I could do without any other problems.

Jacob has run this extremely difficult project with patience, commitment, understanding and honesty. I trust him completely both in terms of making the right decisions for the sculpture and the way in which the project is run. I am also very grateful to Monti for his ability to work the stones but at times he has been harder to deal with than the granite itself and I feel for Jacob who has had to bear the responsibility for seeing the project through on the ground.

The trees have been selected and are currently at Cornell University under the care of Professor Tom Whitlow and one of his students Miriam Pinsker. Miriam's grandfather is a Holocaust survivor.

The trees are young and small – about six inches (15 centimetres) high. I do not want an instant garden. Amongst the mass of stone the tiny trees will appear as fragile, vulnerable, flickers of life – an expression of hope for the future. The stones are not mere containers. The partnership between tree and stone will be stronger for the tree having grown from the stone, rather than being stuck into it. Trees draw and articulate the space in which they grow and the union between tree and stone has to develop over time.

5 August 2003

It was interesting to see all the stones stood on their side or turned upside down with their hollowed out chambers visible and the holes penetrating

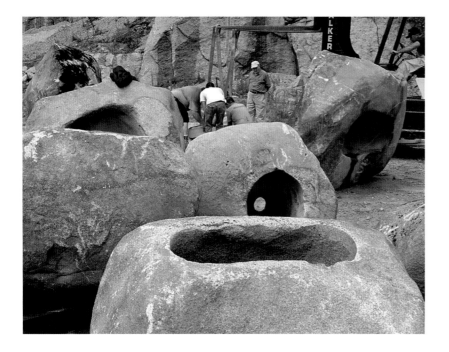

suspicious and is something that I would rigorously avoid. Neither Hepworth nor Stonehenge has directly informed the sculpture, but it makes me think of indirect influences or possibly more universal recurring connections that happen when dealing with a similar source.

The riggers were at the quarry to move the stones and see how each stone would fit the concrete rings that are necessary to spread the load.

The way of handling the stones changed dramatically – they are no longer stones and have become sculptures. I have always asked that the stones be treated carefully but consciously attempted to avoid being precious. I am not interested in a pristine surface. The process of lifting and working the stones has left score marks and scratches which are evidence of the latest journey the stones have been on, just as the stones were once marked by the glaciers or more recently by farmers' chains. These marks will fade over time. I do not want instantly aged stones just as I don't want instant mature trees. I like the lichen and surface of the stones but acknowledge that this will slowly change as they adapt to their new surroundings.

6 August 2003

The site felt more organised today. The riggers seemed more comfortable in lifting and moving the stones. All the bases have been flattened by Monti so that each stone should sit well. I hate taking off any stone that reduces the height and so have tried to keep the trimming to a minimum. I want to change the external appearance of each stone as little as possible.

21 August 2003

The stones have been installed this week. We started on Monday.

It has been a tense, difficult and at times frustrating process. As the week has progressed, however, there has been a growing sense of energy as the space filled with stones. I expected to feel some uncertainty about the placement of individual stones and the overall relationships. This is the moment when idea and form meet the space – the test of whether the sculpture will work in the garden. I have been braced for the shock of finally seeing the stones on site.

In the event it was as I expected. I did not wish any stone or the spacing between stones to have been different. The changes during the past few months have, I feel, led me to the right number, scale and placement. I am almost suspicious of how confident I feel and have never previously left a sculpture without feeling some sense of regret or uncertainty – perhaps this is yet to come, after all the sculpture is not yet complete.

I like the way the sculpture works with the lines of building and the way the garden is cradled by it. I am also enjoying the fact that the garden is on the second floor. If it had been at ground level in the park it would not have had the same intensity, nor would it have had the same connection to the sea. The elevated position makes the viewer less aware of the strip of land between the museum and the water. The visual rhythm and flow of the rounded stones reflect the movement of the sea. This will hopefully also be picked up by the pattern of footprints and pathways that will be made in the gravel covering the garden surface.

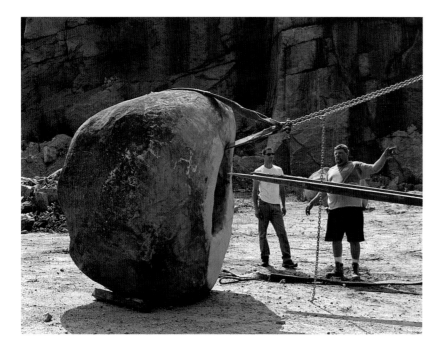

from one side to another. All this will eventually be hidden and is not intended to be seen but the external quality and feeling of a sculpture is affected by what is inside and the way it was made.

It felt as if I had entered a Moore landscape. Two weeks ago I took friends to see Moore's *King and Queen* which is close to where I live. The rounded form of the bodies and the hole for the eye of the Queen came to mind today. Last week I was in Cornwall and saw a Barbara Hepworth exhibition at The Tate at St Ives in which there was a strong group of large rounded blocks of wood that had been carved internally to make holes and cavities which reminded me of those that I have made in the granite boulders.

On the way back from Cornwall I saw Stonehenge from a distance and the image kept recurring today as I moved around the stones. Any sculpture that bears similarities to Stonehenge would normally make me very

I am concerned about the proposed planting around the perimeter of the garden. Whilst I am sympathetic to the intention of softening the building, I am concerned that it will detract from the sense of barrenness that I want surrounding the trees growing out of the stones. The clarity of the building's lines and profile will also be compromised.

We had a large and enjoyable crew to work with – the enthusiastic exclamations from 'JB', one of the stone setters, of 'you like?' when a stone was placed or 'gentle like a lady' as each stone was lowered, will remain with me.

18 September 2003

This week saw the planting of the trees. I don't know what I expected, but nothing prepared me for the intensity of the experience. An artist makes things that become a focus for feelings and emotions – some personal, some public, some intended and some not.

At best a work of art releases unpredictable energy that is a shock to both artist and viewer – I do not mean shock in conventional sense but an emotional tremor that articulates a feeling which has been in search of form.

The planting was done by groups of people, some of them families that included Holocaust survivors and their children. My mother and Sherry Mallin (who is also as a mother to me) planted a tree together.

The trees had less of a root ball than anticipated, which meant that the hole had to be partially filled before the tree was given to the stone. There was the feeling of a well-rehearsed ritual in the passing around of the trowels as each member put soil into the hole.

The act of filling the stones recalled that of burial. One Holocaust survivor said as she filled the stone that she had spent two years in Auschwitz, and lost six members of her family to the gas chambers, and that now she had a place to bury them.

Each stone became a tomb upon which a tree was then planted – a poignant mixture of life and death.

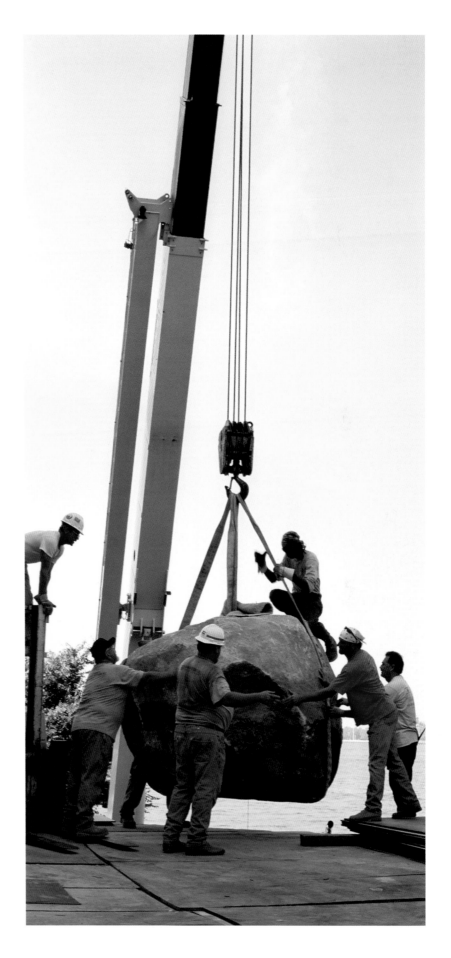

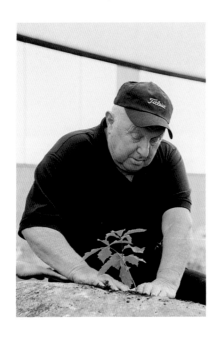

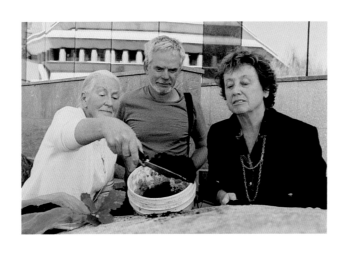

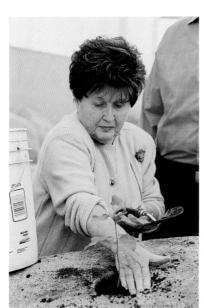

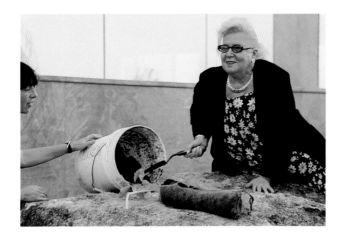

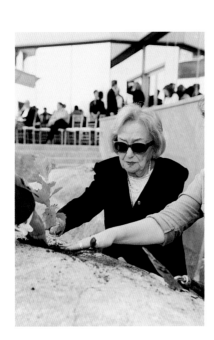

Planting of oak saplings

MUSEUM OF JEWISH HERITAGE, NEW YORK

16 SEPTEMBER 2003

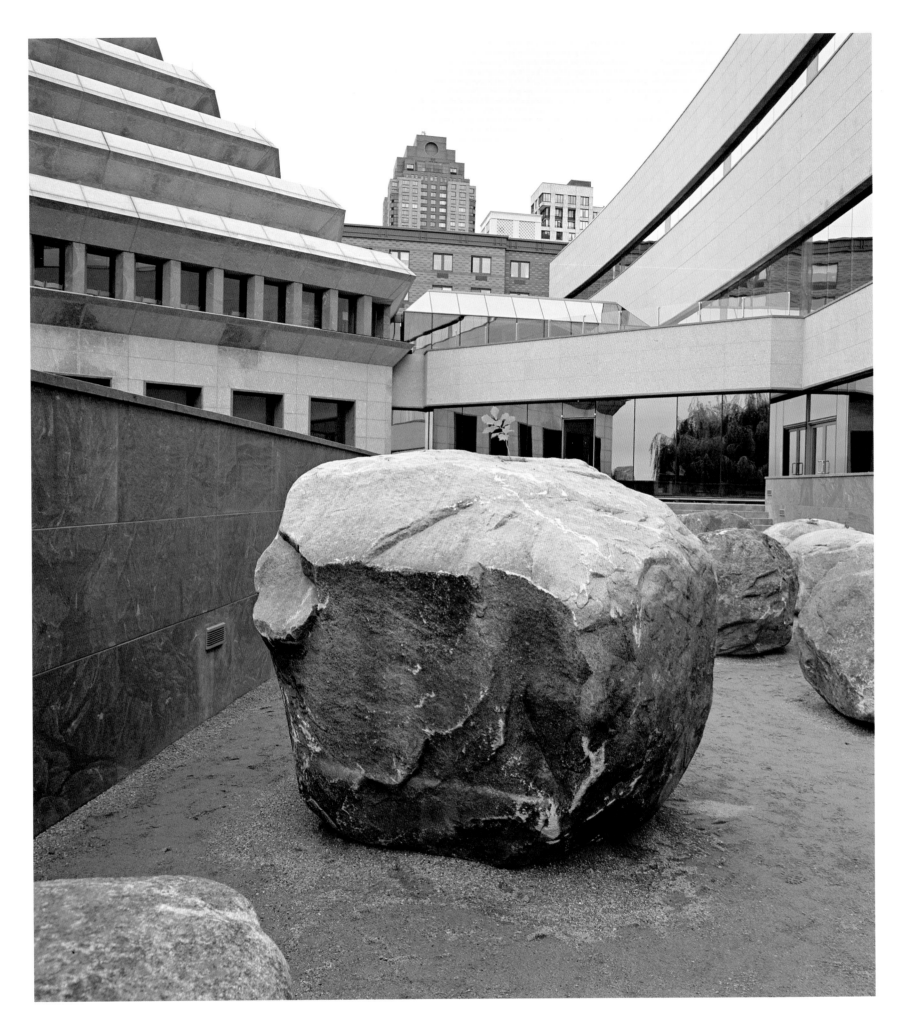

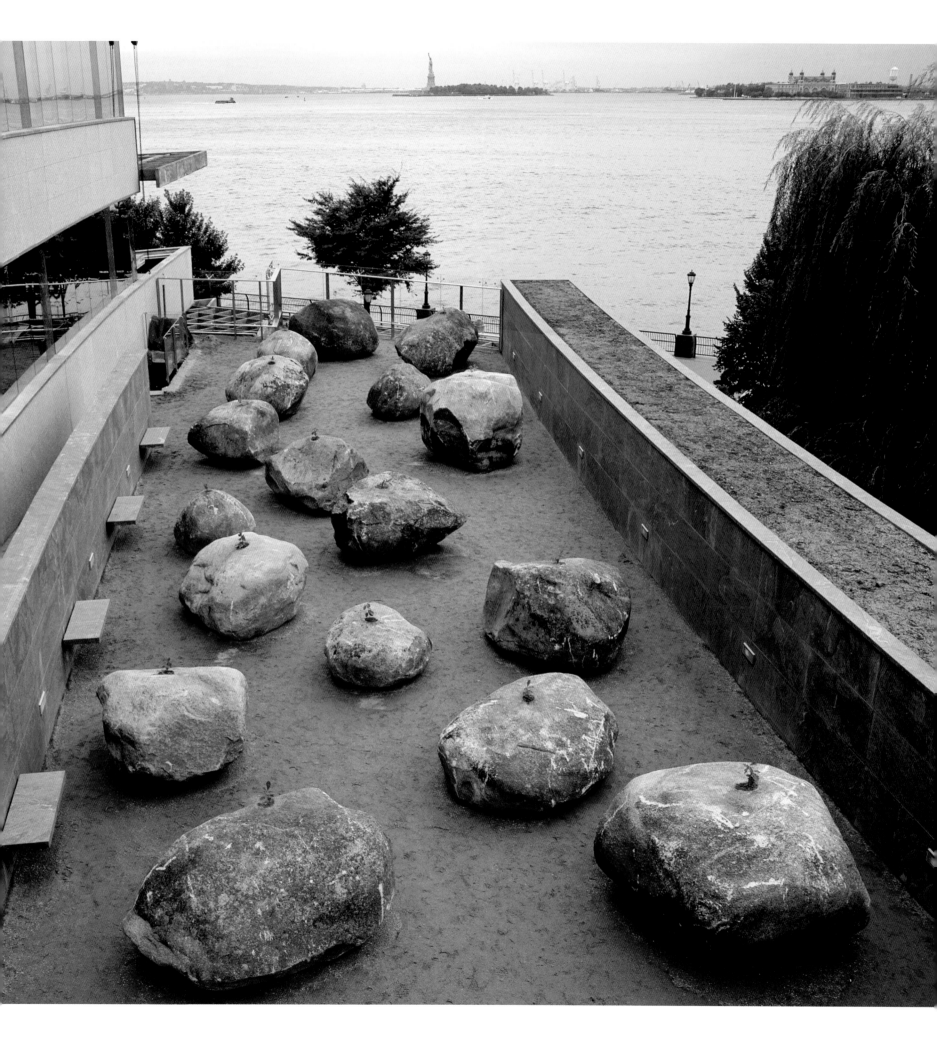

LIGHT

GOVERNMENT ISLAND, STAFFORD, VIRGINIA

12 October 2003

I arrived late last night and went to the island this morning. It is much smaller than I expected, but what an interesting place! The importance of the buildings that came out of it, The Capitol, and The White House among them, are in such contrast to this modest, intimate, hidden place.

I am here because The National Gallery at Washington DC has asked me to make a proposal for a sculpture for their collection. I suggested that as a starting point I should work in the quarries from which stone for some of the buildings of Washington was taken. I hoped that by going to the city's physical source I might gain insight into its origin, connection and relationship to the land.

The extraction of stone has left the island more interesting than if it had not been touched. Not only has the place been historically enriched by being worked, it has also become a more diverse environment than it would otherwise have been.

The quarrying has left holes in the island. I am reminded of information that my son recently found on the internet about a place called Goldsworthy in Australia: 'Once a mining town with a population of about 500, Goldsworthy no longer exists. All that remains to mark the town is a row of trees by the road . . . Before mining Mount Goldsworthy was 132 meters high, now it is just a big hole in the ground.'

Leaving a hole is not like flattening a hill. I prefer a quarry that leaves as much, if not more, surface area than before work began.

I struggled to find something to make. The leaves have hardly begun to change colour, and I found only a few red leaves to work with. I stuck these with water to the tip of a tapered rock in one of the overgrown quarries that pocket the island, drawing the stone to a red point. The combination of red and a point had violence about it. A passer-by said it looked like blood.

Although the disused quarries are now quiet and settled, there was a time when the effort of extracting the stone would have given the place a violent energy.

The red leaves on the stone changed with the light, becoming more vivid as the sun shone diffusely through the hazy sky. An elusive red. It will be more evident in a week or so when the opening of the canopy will allow more light to reach the wood floor – at present the light is dry and dull. It needs to rain!

13 October 2003

Began another work – similar to yesterday's, with red leaves on a tapered stone. The red is so elusive. The stone was initially in the shade and the red seemed quite strong, but as I finished the dappled light reached the stone and initially the red was killed off. The leaves were cast into shadow made particularly dark by comparison with the patches of bright light falling upon the stone and its surroundings. Soon, however, all sorts of amazing changes began to occur as the sun started to touch the leaves. At one point a tree cast a black line across the vibrant red. There were moments when the tip of the stone was illuminated against dark shadow.

It was wonderful but beyond my control. I was unprepared for what happened and was not able to see or understand properly what had occurred.

If it is sunny tomorrow, I may repeat the work. I would like to see the transition from shadow to light, and the changes in-between. It could be an important work. Colour for me is an expression of life. As the red increased and decreased in intensity I could not help but think of the activity and life that once took place in the quarry – a reminder of the human energy left in the stones after the quarry closed.

14 October 2003

Remade yesterday's work.

It was good to do so. Even though I knew what to expect, the changes were so varied, fast and fleeting that I was still taken by surprise and missed one or two interesting moments. I had thought that waiting several hours watching the sun pass over a work for the second time might be tedious (part of me wanted to be making a different work altogether), but it was even more interesting than on the first occasion. I learnt so much about the red as it reacted with the light. The tension as the tip became illuminated was palpable. There was only a short moment or two when the stone was more or less completely in sunlight; for the rest of the time it was part-in and part-out of shadow, which gave the red an extraordinary vividness.

I particularly liked the moment when just the tip was caught in the light, surrounded by dark shadows.

The colour drained away as the sun went down and no longer reached into the place where I was working. Strangely the red seemed stronger when the rock was in shadow at the start of the day than when it was in shadow at the end. Perhaps it was because at the day's end I was comparing it to how it had been in direct sunlight. There seemed to be a warmth in the

light that brought out the red early in the day which was absent later, when the light appeared much cooler.

Today has been a great lesson in time, colour and light.

It was not a large work, but it took a few hours to make. There was so little red that collecting took a long time. None of the leaves was completely red and most had blemishes that I had to tear out. This was a time-consuming process which resulted in small pieces of leaves which in turn meant that it took a long time to cover the area I needed.

I kept wetting the leaves so that they would keep their colour over the time it would take for the sun to pass over.

Although the red was difficult to draw out of the place, once gathered and concentrated it had an intensity that would have been less had the surrounding trees also been red. The red was a shock – somone who passed by the other day said that it looked like blood.

15 October 2003

Cool, sunny, very windy. So many leaves on the ground, but not a good day to work them. The light made them difficult to see and the wind blew them away.

I had decided to make a work inside a cut across the quarry face and collected clay in a nearby wood on my way to the island. The cut had, I presume, been carved out in preparation for splitting the bedrock.

I had experimented with clay during the week and had a clear idea of what I wanted to do. It was difficult to find workable clay that was not too soft after heavy overnight rain. I had to scrape away at mounds near trees to find drier clay which was full of fibrous roots, some of which were probably poison ivy. I have never had a problem with ivy but then I have never worked so close to it before – I guess I will now find out if I am allergic to it or not.

I rolled the clay into coils which I joined end to end in a continuous serpentine line along the opening. It reminded me of a carved snow work that I made in Cumbria in 1984.

I enjoyed making this work. It was an interesting piece but also a relief from the minutiae of the recent leaf works. I liked the way it articulated the fissure: it felt as if it belonged there.

The light was extraordinary, at times hypnotic, even nauseating, as the strong wind violently blew the surrounding trees creating a multi-layered sea of shadows across the rock face. I photographed as the shadow of a nearby large tree worked its way over the course of the day from one end of the work to the other – a slow and relatively static shape amongst the frantic gyrations of shadows cast from trees at a greater distance – like the hour hand on a clock.

I thought of Thomas Riedelsheimer, director of the *Rivers and Tides* film. My still images will not have the sense of movement present in the film, and I know Thomas would have enjoyed filming this work and would have understood its energy.

I stayed on the island until sundown. I wanted to see the work in a calm light without shadow, when its rounded line would be more fully formed and not fragmented by light and shade.

It will be interesting to see how it changes over the next few days as the clay dries, becomes paler, cracks and fall apart.

16 October 2003

Worked on the pointed rock upon which I laid red leaves the first day that I arrived. Over the past few days I have noticed how and when the sunlight passes across the rock. Today I made vertical clay ridges at its tip that would cut the light into lines defined by shadow.

The light changes that occurred to stone were sudden and short-lived – unlike the quarry face that I worked with yesterday, across which the sun gradually moved. There was a fifteen-minute period between 1.10 and 1.25 pm when a substantial part of the stone and the entire tip were illuminated without any flickering of leaf shadow. This was the work at its most complete. There were also moments leading up to that time that were equally, if not more interesting, as only fragments of the clay lines were caught by shafts of light filtering through the tree canopy.

These works have been the most successful I have ever made in dealing with what I find the most difficult of lights – sunlight through trees. The wood floor becomes a camouflage pattern of patches which breaks up form and burns out colours.

The works that I have made here have, I feel, understood the changing light that passes though this place. They have succeeded because they have worked with a specific time, place and material – a meeting of light and form which I have never achieved in similar conditions before. I have been allowed a new way of looking.

I probably could not have made these works last week or next when the sun might well have cast a different shadow. Timing runs through these works in every sense of the word.

The clay comes from the quarry – I had not seen it until now. The rain had reconstituted the dry hard earth, making it both workable and visible: it was a pale tan colour. Without sunlight the work appeared flat. The lines reminded me of the carved fluting on columns. A tree grew just behind the stone which added to the sense of a column but also made the clay lines appear as bark and the stone as wood.

18 October 2003

Clear and bright. Didn't know what to make. I was interested to see if a grass line might work as well on a sunny day as it did yesterday when it was overcast. I worked on a stone that I knew would go in and out of the sunlight. I pressed clay along two of its edges into which I then pushed grass stalks. Not long after I had finished, the sun began to pick out sections of the line. Considering I had not paid a lot of attention to this particular stone before, I felt pleased with the way that it changed. This drawing needed to be in a place of shadow and light.

I have learnt a lot this week and have made progress in understanding a quality of light that I have never previously been able to deal with properly.

This is important to me. I have worked for twenty-eight years. Not understanding a woodland floor on a sunny day has represented a serious gap in my perception of nature. I have made works on sunny days in woods before, but usually in spite of the conditions rather than because of them.

Red leaves
difficult to find
held with water
to the tip of a quarried stone

GOVERNMENT ISLAND, VIRGINIA

13 OCTOBER 2003

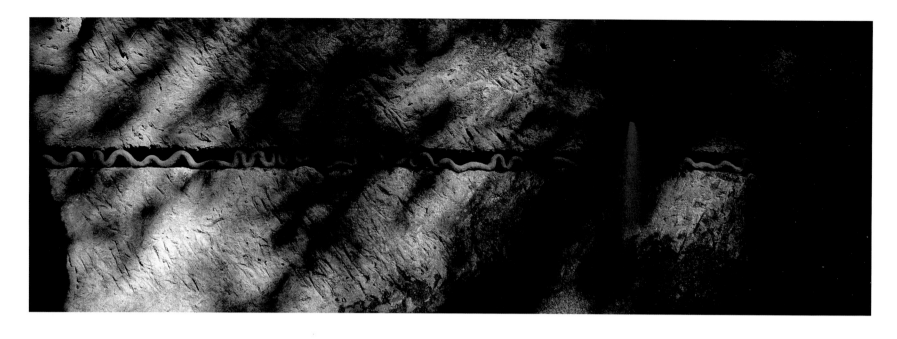

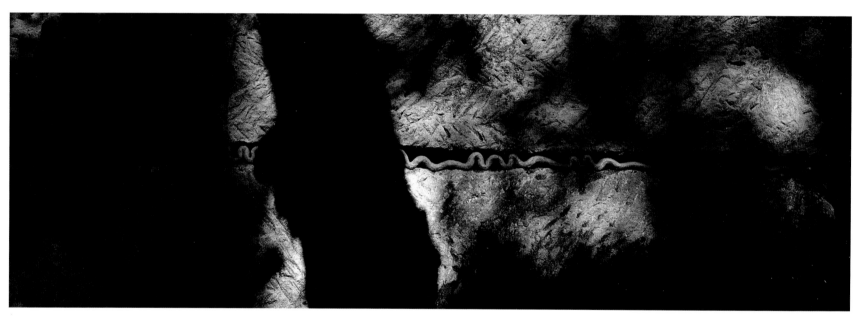

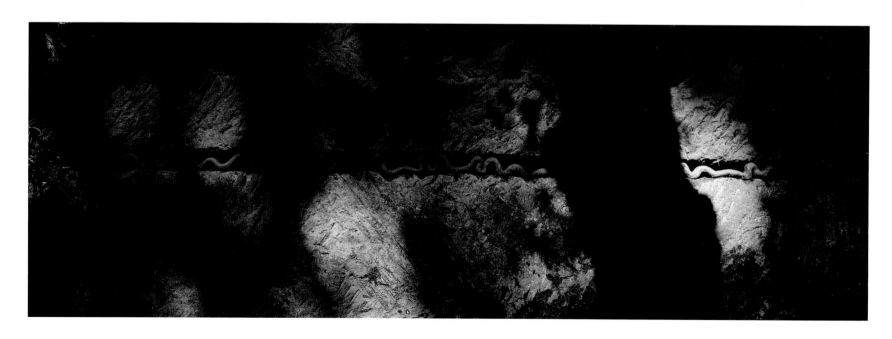

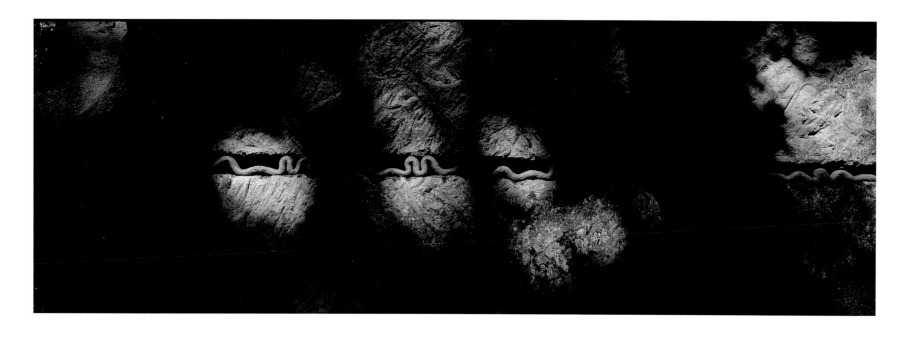

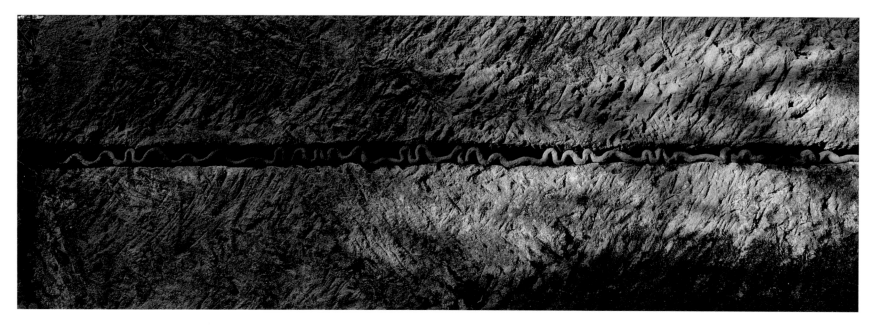

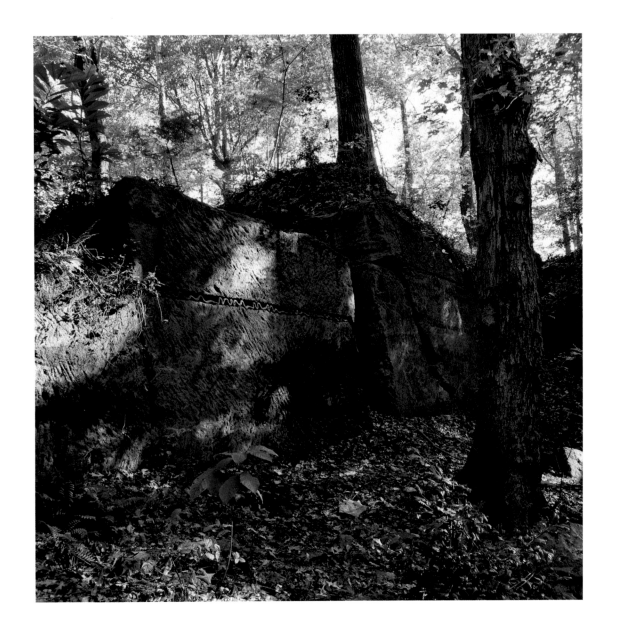

This page and pages 80 and 81

Clay worked and rolled
joined to make a line
in the cut of the quarry face
wind and sun

GOVERNMENT ISLAND, VIRGINIA

15 OCTOBER 2003

This page and overleaf

Clay worked into a stone edge
to catch the passing light

GOVERNMENT ISLAND, VIRGINIA

10 OCTOBER 2003

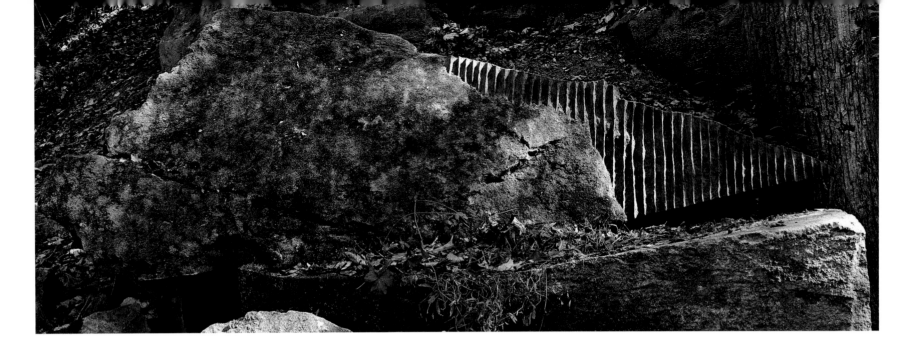

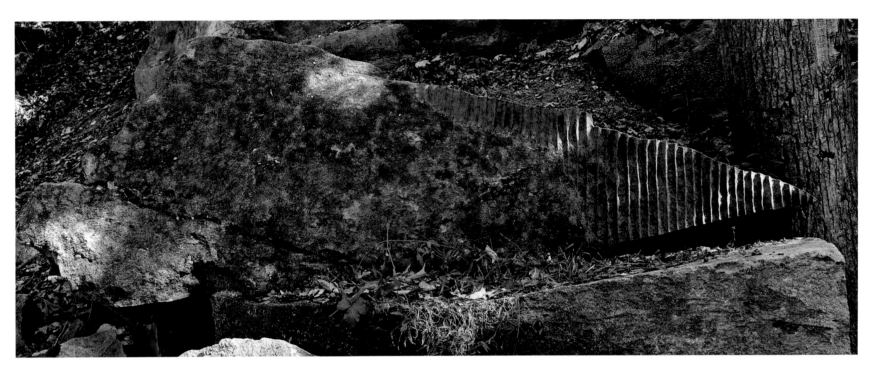

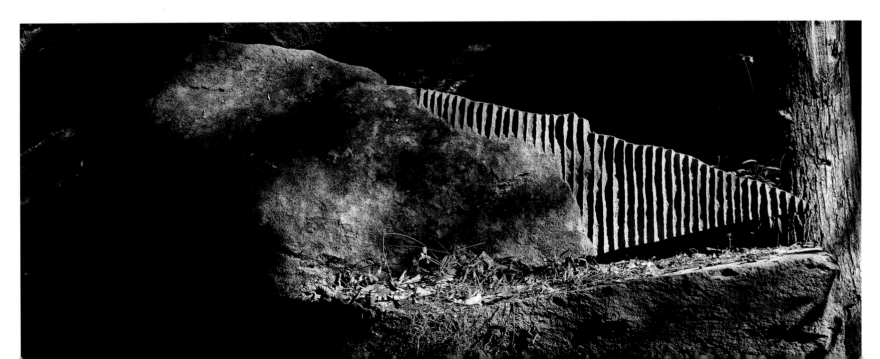

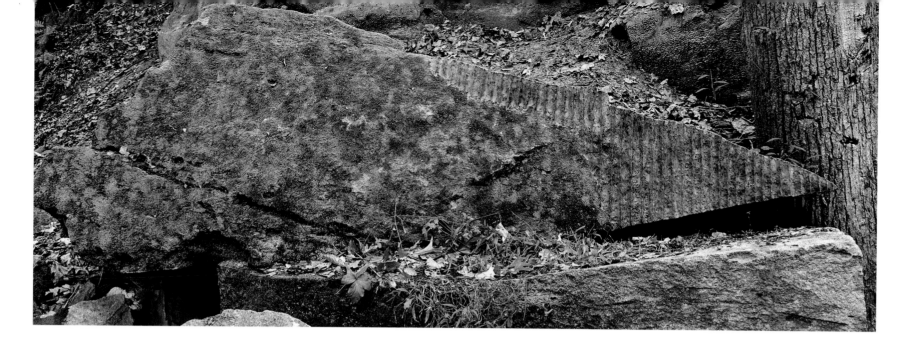

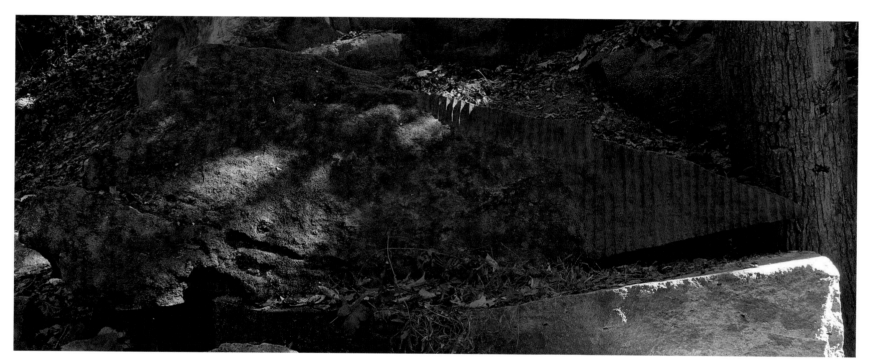

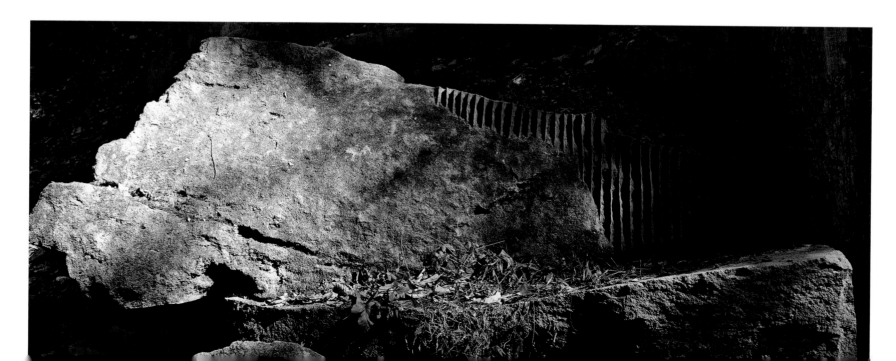

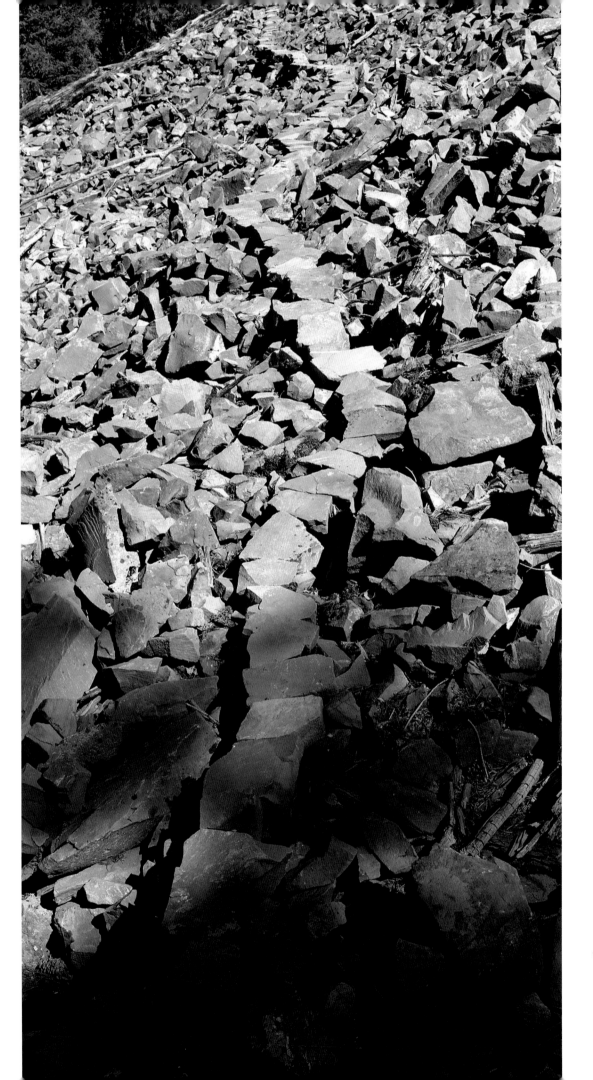

Flat-topped stones
laid in a line
to reflect the midday sun

SUN VALLEY, IDAHO

24 & 25 JULY 2001

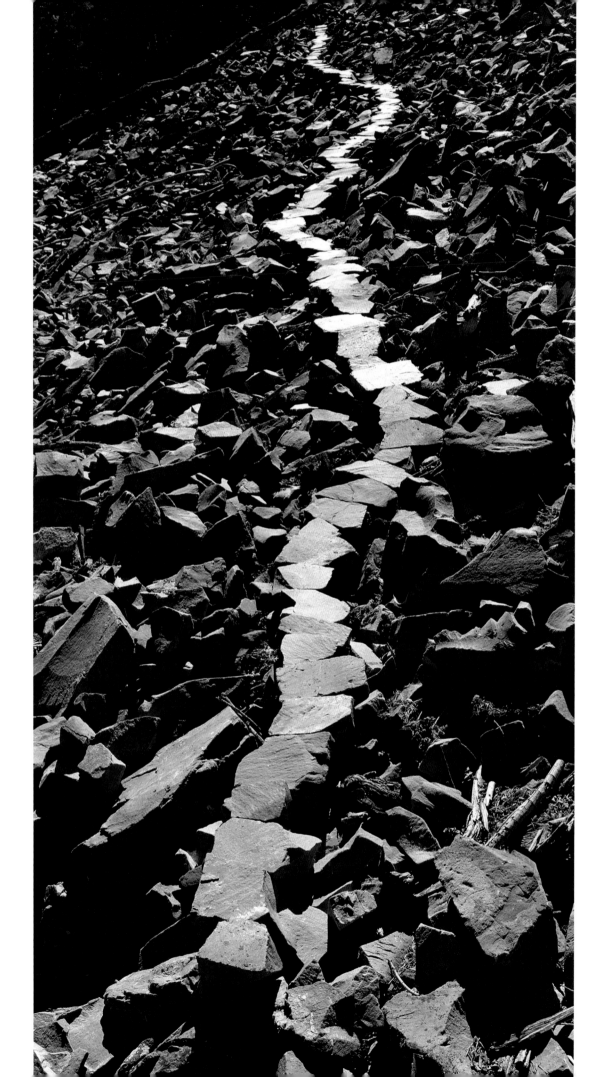

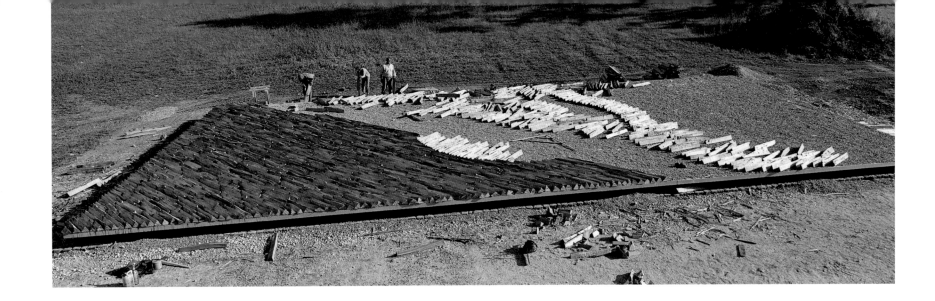

POOL OF LIGHT

BIOUSSAC, CHARENTE, FRANCE

In 2000 I was asked by the owners of an estate in the Charente region to create a sculpture using trees felled by Martin, the ferocious storm that hit south-west France on the night of the 27th December 1999.

I did not have time to visit immediately, but on hearing that many oaks had fallen I proposed to make a group of wooden cairns and it was agreed that a start would be made on gathering the curved branches that I would need. My first visit would be to see if the material was suitable for making a cairn and to find a site.

I visited a few months later and was shocked by the devastation. Knowing the owners as I do now, I understand the pain they must have felt at seeing the landscape they know so intimately ripped apart. The estate has been in the family since the thirteenth century and employs many people from the village whose families have worked there for generations.

The *château* is a large rambling house full of character and in need of some restoration. The roof had been replaced recently, and plans were in hand to tackle the house. It was a brave response to divert money and energy away from the renovation and to try to make something positive come out of the storm by commissioning artists to make work from the fallen trees.

I returned in April 2001 when a substantial amount of material had been collected – enough to begin the sculpture – I decided to make one large cairn instead of the group I had originally proposed.

Working there allowed me to get to know the place better. Plans were being drawn up to landscape the grounds around the *château*, and this led me to propose a terrace sculpture to the rear of the house. I liked the way the rear of the house opened out to the fields, in contrast to the enclosed courtyard at the front. The simple horizontal plane of a terrace would be a visual stepping stone between the house and surrounding fields and would, I felt, work sympathetically with a vertical Anthony Gormley sculpture of a tree with a figure in the distance.

The rear of the house faces due south, providing the perfect opportunity to make a work that responds to the light as the sun moves across the sky. I have made work previously in slate and sticks that employed the same idea but never on such a scale as this nor with the benefit of a fixed reference and view point such as a house from which the changes occurring to the sculpture could be observed.

I proposed to lay cleft chestnut logs on the terrace, placed in such a way that the edge of each log would at morning and evening split the light into sun and shadow.

The terrace was realised in August 2002 along with a second oak cairn, this time made in a barn that had been used to store wood.

On sunny days the sculpture is brought to life – a dark circle in the morning and the reverse in the evening. At midday, and on those days without sun, there is no circle at all. There are times when the sculpture is alive and times when it is dormant. The passage of wind that ripped the woods apart is now, I hope, made less painful by the passage of light across the sculpture. The making of any major sculpture contains a story of hard work and struggle – my own memory is of experiencing a personally difficult time and being sustained by an extraordinary hospitality. A circle of light coming to life at the beginning and end of the day can take on many meanings. For me it has become an expression of the ability to survive storms and upheavals. The sculpture may have come out of a destructive storm but it also has a great sense of optimism in the cyclical renewal and revival that occurs on each sunny day.

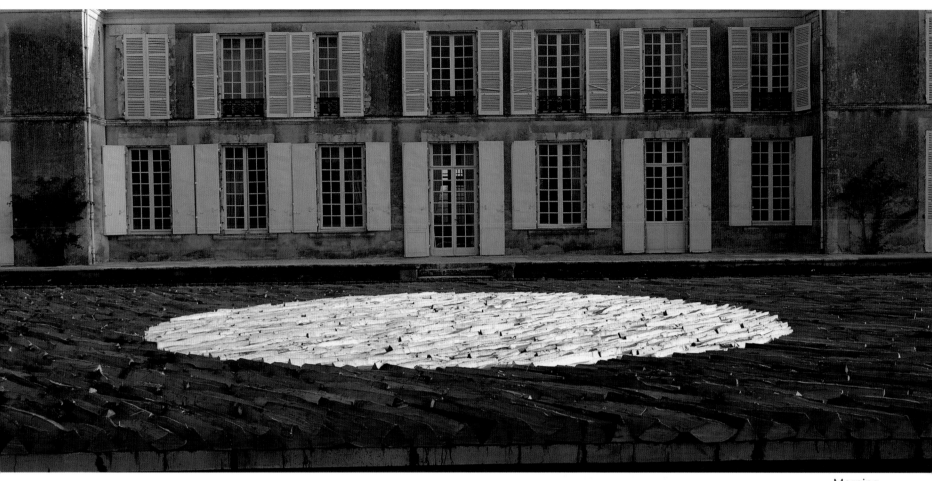

Morning

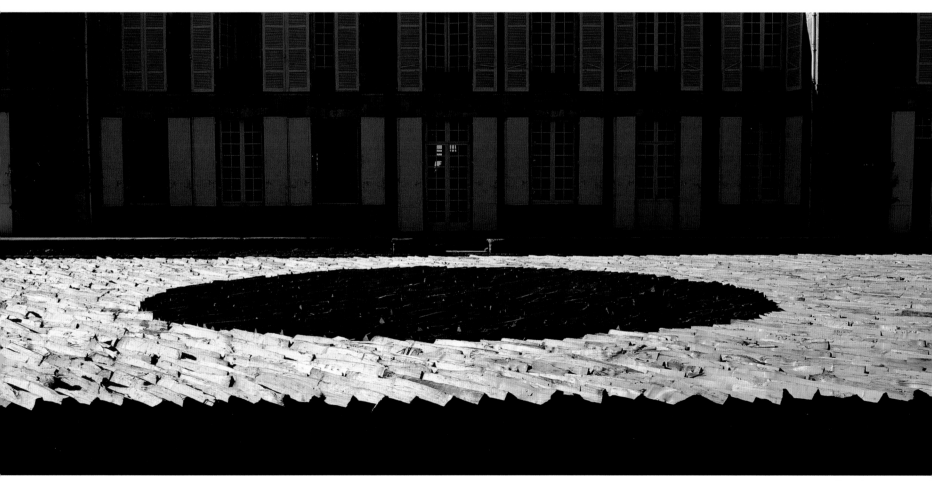

Evening

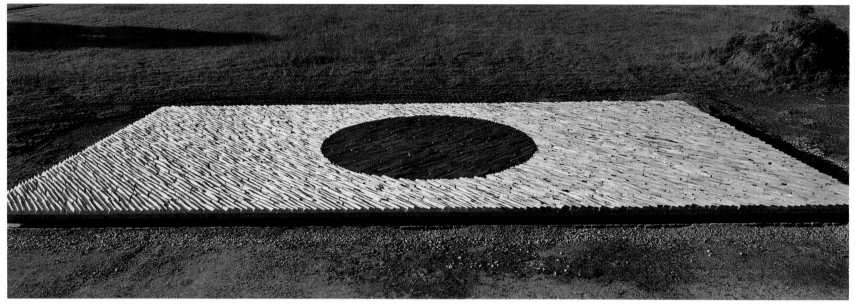

Early morning

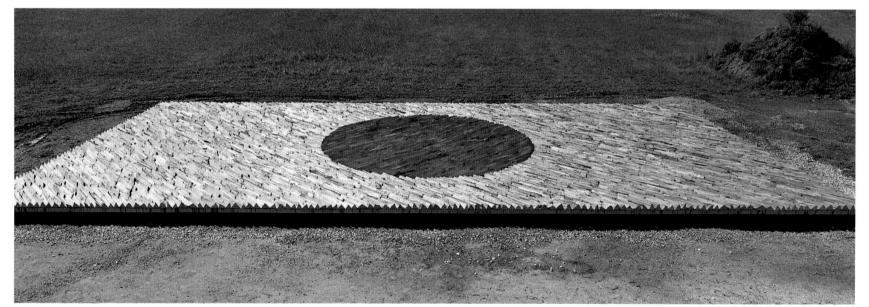

Mid morning

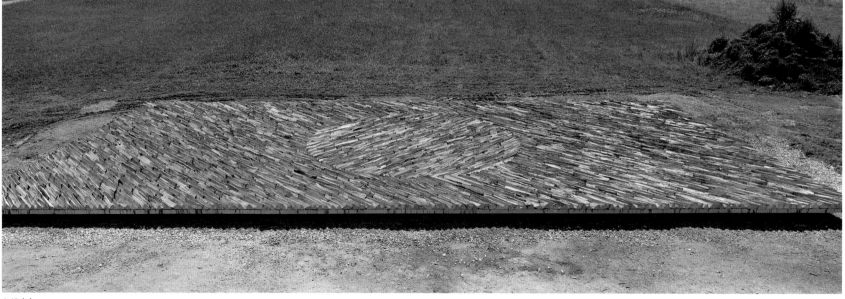

Midday

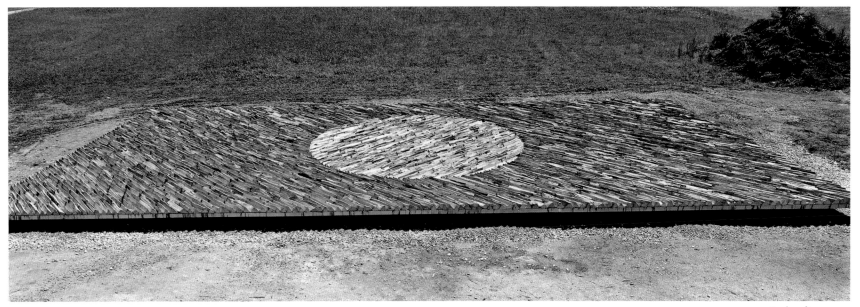

Early afternoon

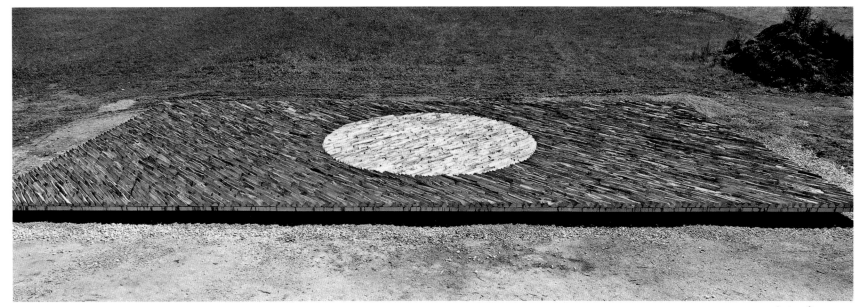

Late afternoon

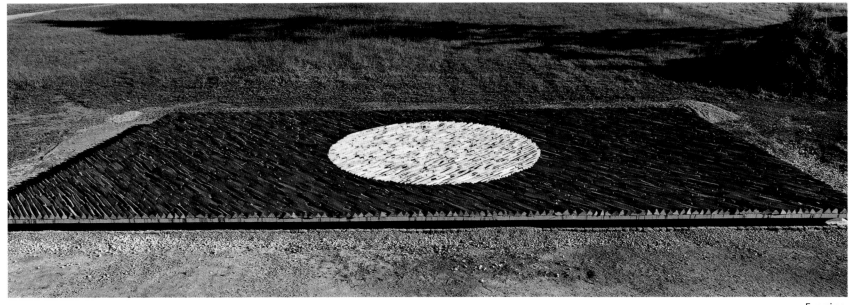

Evening

91

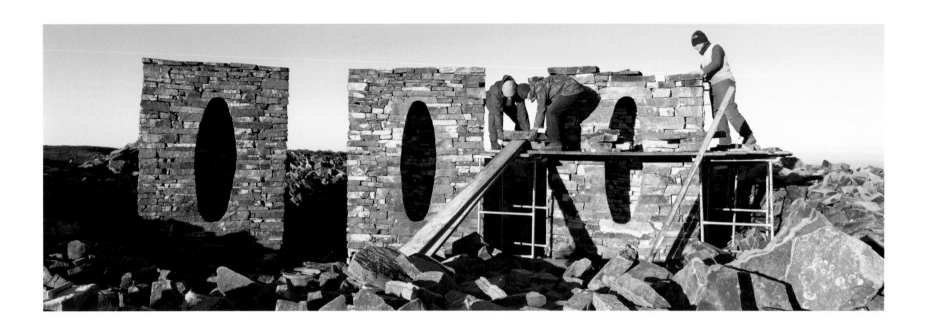

Stacked millstone grit
Work nearing completion on Clougha Pike in Lancashire
one chamber built each year

1999 - 2001

Opposite
Three Cairns proposal drawing
pencil on paper
1999

THREE CAIRNS

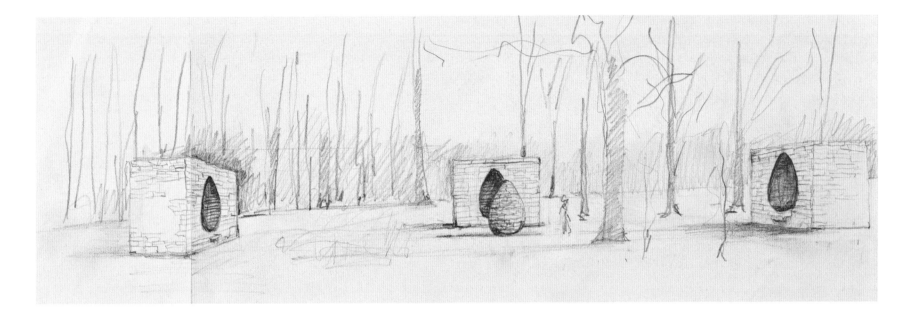

Andy Goldsworthy's vision of a sculptural work spanning the North American continent was conceived on a walk through the park that surrounds the Des Moines Center. Looking back toward the museum, he was inspired by the local Lannon limestone that Eliel Saarinen used, more than 50 years ago, to create a low, modernist structure – the first building of our three-building complex. Goldsworthy immediately identified with Saarinen's use of local stone and the way the stone was echoed in other structures in the area. He also was intrigued by the Midwest and its relationship to the two coasts – by the nineteenth-century mythology of a vast prairie crossed by settlers moving westward, and by the present reality of the heartland as America's bread-basket. Building on these impressions, Goldsworthy conceived an imaginary line through the continent, radiating from the center to the East and West Coasts. At each point would be an Iowa limestone cairn marking a place of importance, as cairns traditionally have done. The three works would be linked conceptually and comprise Goldsworthy's largest project in the Western hemisphere.

I originally had invited Goldsworthy to create a gallery installation, but it quickly grew to a continental project involving three museums and permanent as well as temporary works. Goldsworthy, always interested in the notion of temporality, immediately suggested hinging his concept on the creation and photographic documentation of temporary cairns that would precede construction of his permanent works. These temporary works would serve as a memory, showing the eventual impermanence of the more massive cairns that would come next. We were joined by the Museum of Contemporary

Art San Diego on the West Coast and the Neuberger Museum of Art on the East Coast. Temporary cairns were built in tidal areas in California and New York, and on the Iowa prairie (the latter in collaboration with Faulconer Gallery and the Center for Prairie Studies at Grinnell College). The ocean swept the coast cairns away in a couple of weeks. And each summer the prairie is enveloped in tall grasses; over the decades, it too will disintegrate.

Cairns have always dominated Goldsworthy's oeuvre, but in Des Moines he built massive walls to anchor the permanent cairn, echoing a smaller work he began in 1999 on Clougha Pike in Lancashire, England. Inspired by the forms of nearby ancient grave sites in Heysham, he built three walls, each containing a chipped-out cavity or chamber that one could enter for shelter or solace in a womblike space. In Des Moines, the walls provide a similar function but are more massive and the chambers are cairn-shaped; a stone step allows entry. The chambers of the east and west walls are carved out so that openings fit exactly the corresponding cairns in New York and California. The cairn in Des Moines is the template for the chamber in the central wall.

That a continent-spanning project can be experienced on such intimate terms is key to understanding Goldsworthy's art. The tension between temporality and permanence, between intimacy and monumentality, and between the East, the West, and a midpoint resonates throughout *Three Cairns*.

Susan Lubowsky Talbott
Director, Des Moines Art Center, Iowa

PRAIRIE CAIRN

GRINNELL, IOWA

Unusually for me, all the preparation for this work was done from a distance: the choice of stone as well as the general location. Consequently my actual arrival on site was tense with the expectation that things might not be as I need them to be to achieve the sculpture. I had already caught a glimpse of the stone on the back of a truck on the way to the site and immediately could see that its thickness would make it difficult to work.

The uncertainty gave the process a sense of the unpredictable, which in a sense made it similar to my usual approach of finding the place and material by chance. This is how I will make the eastern and western sea cairns. All three will be made in the same spirit, which I hope will reinforce the connections between them.

The intensely cold biting wind brought with it a tension and energy to the making. Working against time and elements – the cold of the prairie and the incoming sea at the coasts – will also connect the cairns. The eastern and western sea cairns will be driven along by the desperate need to complete each work in the time and space between two tides. At Grinnell the pace of construction has been dictated by the wind, which has given little time to think or consider – I have had to keep working in order to keep warm. If I slowed down, my left hand, which I use less than my right, would become cold, numb and painful. Construction took less than two days, which is very quick for a cairn, but it should be strong enough to last at least one year.

Although the weather made work difficult I would not have wished it different. I was given a small insight into a winter that has made the prairie tough, strong and beautiful. People who visit the prairie only in summer, when the grass is grown and the many flowers are in bloom will not understand or see the intense struggle that lies beneath. It is a lesson in the perception of beauty itself. That the first component of the Des Moines project has also endured such a test will, I feel, also add to the work and root it in the Iowa landscape. I now feel that my own personal introduction has been made. As I have often said: I do not feel that I have arrived in a place until I have made a work.

1 November 2001

I had hoped that this visit – to mark out the locations of the three walls and cairn at the Des Moines Art Center – might coincide with the burning of the Prairie Cairn so that I could witness and photograph it. I arrived late on Monday evening and the burn was planned for the following day.

I was woken up in the early hours of the morning by thunder, lightning and rain. Having just arrived from Scotland and still being on Scottish time I was unable to get back to sleep and spent the next few hours watching the weather channel on television.

We were not able to do the burn that day because of overnight rain, and strong winds the following day prevented it taking place on this trip. I was prepared to delay my journey on to New York where I am making the East Coast cairn, but the three-day forecast was not promising either.

I have to accept the risks of working with the weather but was still very disappointed.

This cairn has taken on additional significance because of my father's death and funeral last week. I want to connect his death to the burning of the Prairie Cairn. The cairn has been on a journey that has taken it from late winter, through spring, summer and autumn. Over that time my father made his own journey through illness and death. The cairn is a marker to the flow of change, life, growth, decay, death and renewal of the prairie landscape. The burning is a test that growth has to pass through in order to survive; the prairie regenerates and is preserved – a significant event for the cairn to witness.

I went to visit the cairn yesterday afternoon even though the burn could not take place – it was too windy, and the overnight thunderstorms which were forecast made today unlikely.

I returned to the cairn at dusk, hoping that the overcast skies might clear and I could see it by moonlight. Eventually a full moon appeared, at first behind clouds, then becoming clearly visible for an hour or so before disappearing again for the rest of the night. It was beautiful to see the cairn illuminated by the moon, a shadow cast down one side – perfect. The cairn stood calm and still, surrounded by long pale grass stalks that waved and hissed in the strong wind. But it was not cold, in stark contrast to when I made the cairn.

After three days of travel and meetings it was good to stand still on the prairie watching the cairn and thinking. In many ways being with the cairn at night was a more appropriate gesture to my father than the burning.

Photographing by moonlight is always problematic, especially with a panoramic camera. The small aperture you need to use in order to be assured of some depth of focus requires extremely long exposures (in this instance up to 35 minutes). The moon kept changing in intensity as it went in and out of the clouds, making it impossible to calculate the exposures, so they had to be determined by instinct and guesswork. I have yet to achieve good moonlight results with the panoramic camera. Even if all I find I have is a completely black piece of film it will still have been exposed to the image of the cairn and I will make a black print from it that will be presented as part of the series. The absence of an image would express something of this time of my life.

Today I set off for New York. In spite of the weather forecast, it did not rain last night so the burn could have taken place today, but it was too late to reorganise it. Perhaps it is better that I do this in the spring so that the burn is more closely associated with the continuation of life; this would ultimately be a far better memorial to my father.

6 May 2002

Woke up to heavy rain and thunderstorms. I was supposed to go to burn the prairie around the small cairn that I made last year but assumed that because of the rain today it would not happen.

Went to the Center to work on the sculpture in the morning. The sky

cleared and by mid morning it was dry enough for the burn to take place; by early afternoon I was out on the prairie.

The prairie is maintained by Grinnell College and the burning is a highly organised and controlled affair in which only a portion at a time is burnt.

There was a crowd of spectators and media that I had not anticipated and initially found off-putting.

A small area was burnt first to prevent me getting caught by the flames, along the edge of which I set up my camera on a tripod.

The grass was somewhat flattened and judging from the safety area that had been burnt, the fire was likely to creep slowly along at ground level. I was completely unprepared for the ferocity and speed of the fire that ensued. The prairie was lit so that the wind would drive it along. The speed with which the fire took hold was extraordinary. My camera became too hot to touch and started to melt. My face needed to be doused with water. The camera stopped working and I nearly retreated. The only other time my camera almost failed because of the conditions was also in this place when I was making the cairn, but on that occasion it was because of the cold! At that time, the shutter sounded slower than it should have, possibly because the lubricants had become stiff. Fortunately, there seemed to be no problem in the developed film, probably because I had taken a wide range of exposures to accommodate any anomaly in shutter speed.

I don't think I took any images of the flames around the cairn, but as the fire moved on the camera cooled down and was able to photograph the clouds of smoke coming off the burnt prairie. I found the smouldering prairie as interesting, if not more so, as when it was alight.

The process turned out to be far more significant than I had expected. The scale of the fire and the size of the flames and clouds of smoke engaged with, and then engulfed the cairn. I had feared that the cairn would stand somewhat aloof from the fire as it passed around it at ground level. I felt as if the cairn had passed through a real test and, upon emerging from the smoke and flames, it looked fresh and alive. The scene was not one of destruction but of regeneration.

Even the problems that I had because of the heat contributed to the experience. It made me aware of the violence and power of fire and the fear it can generate. Even if it meant me not getting images that I might have liked, I would not have wanted to have forfeited that moment when I was nearly forced to retreat.

8 May 2002

All of the photographs showing the cairn in the aftermath of the fire have light flares across them. I did not think the light was a problem but might have misread the conditions – it could have been the effects of the heat on the camera. I have images of the flames surrounding the cairn which surprised me. That was when the heat was at its most intense and when the camera was least likely to work.

For each of the three ephemeral cairns, what could potentially have been the strongest image is missing: the collapse of the western sea cairn, the cairn in Iowa surrounded by smouldering prairie, and the eastern sea cairn at night silhouetted against the receding sea.

In a strange way, for me, this absence adds to the series. It is difficult to explain why. The series remains one of my strongest achievements and yet contains great failures. Success for me has always been defined by failure just as beauty is by loss.

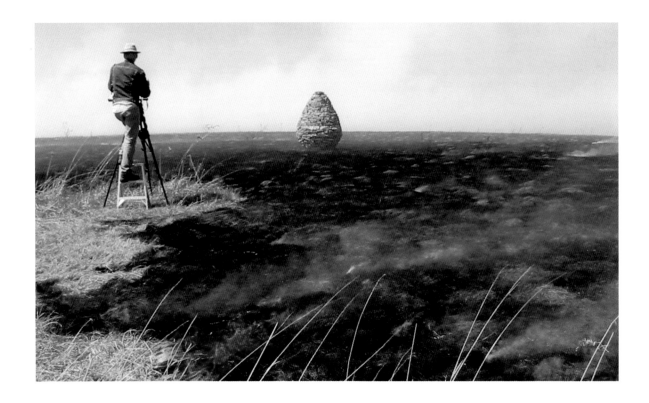

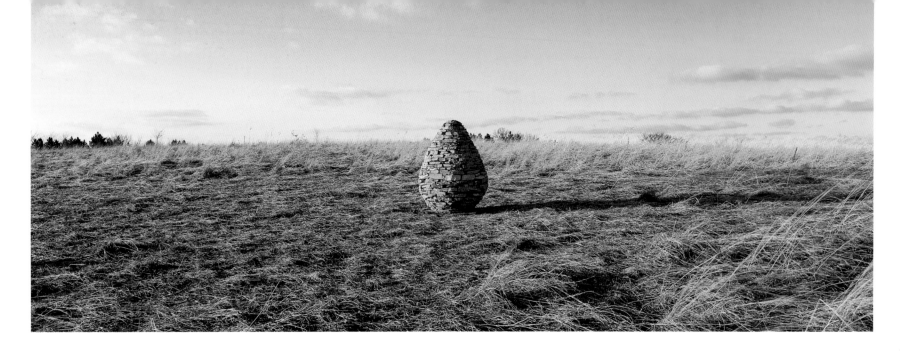

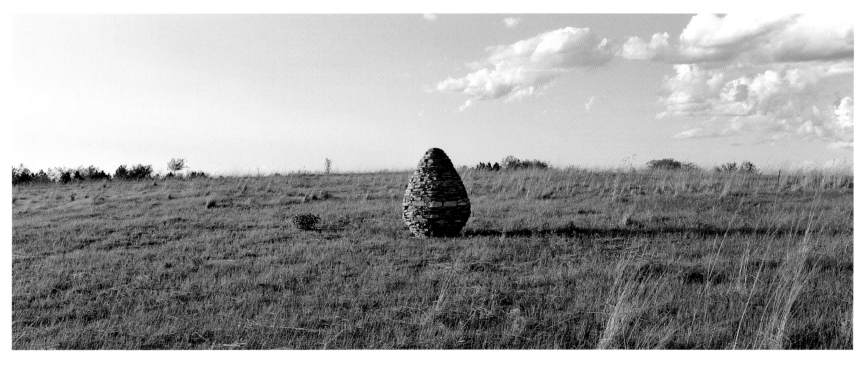

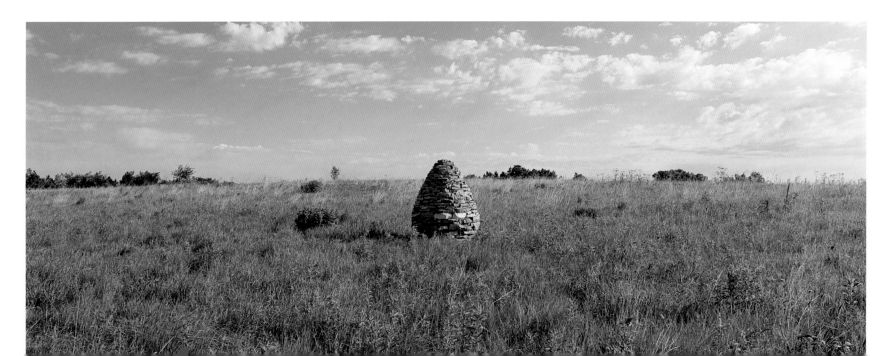

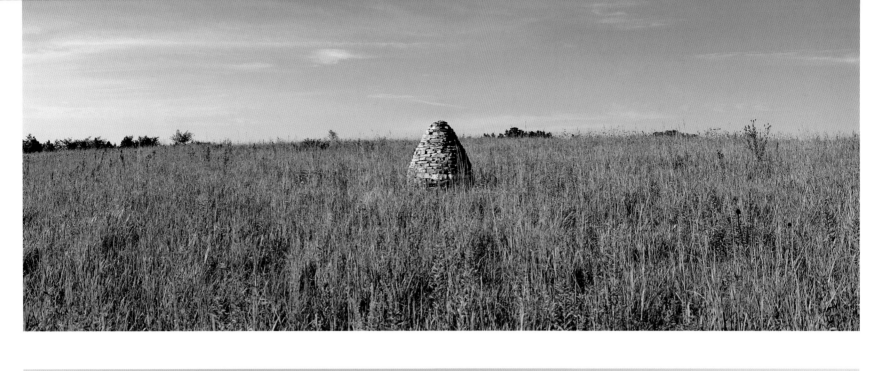

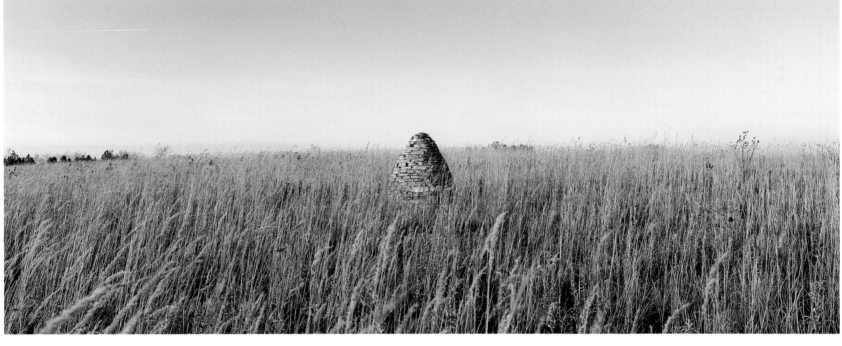

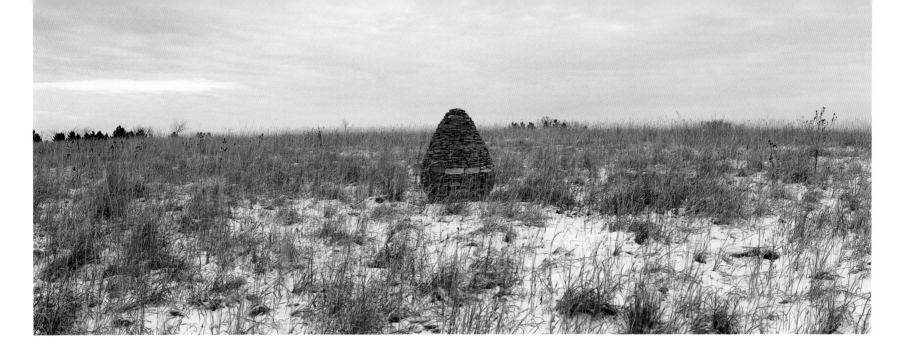

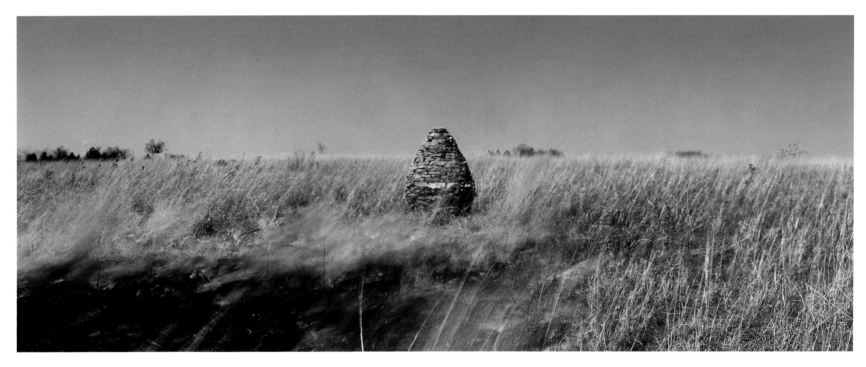

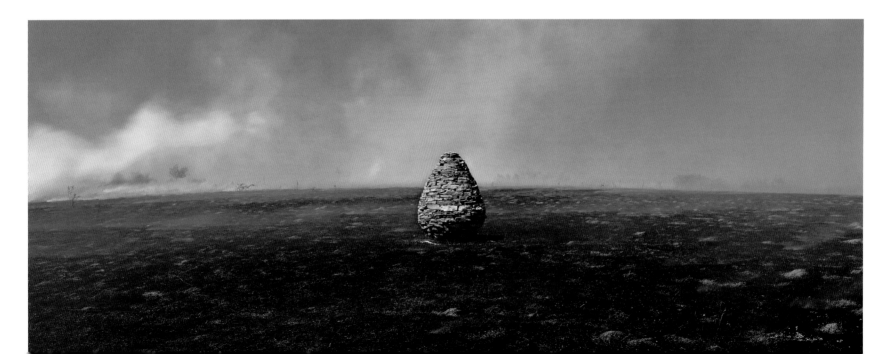

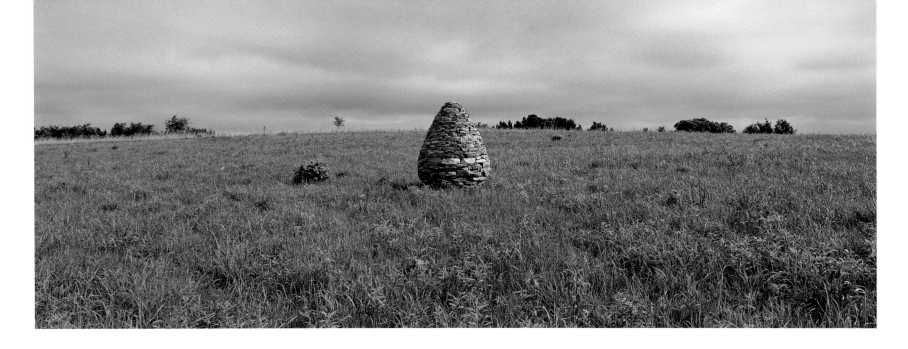

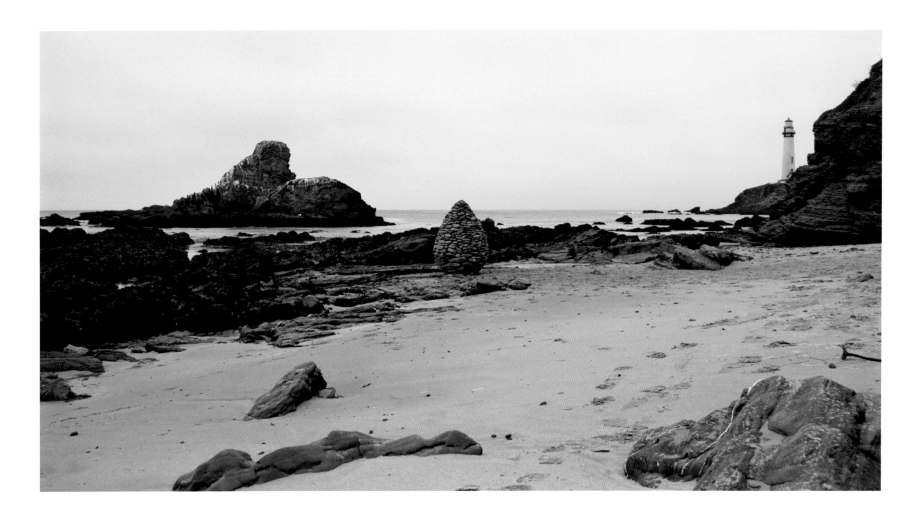

WEST COAST SEA CAIRN

PIGEON POINT, HALF MOON BAY, CALIFORNIA

23 August 2001

Up at 4.45 am. No fog! Perfect. Although I have refused to be too concerned about light and weather, in my heart I hoped for sun. The cairn will be partner to a cairn on the East Coast, and the images of them will be shown side by side in the *Three Cairns* exhibition. The sun will describe differences between the coasts far more than if it were overcast. The rising sun on the east coast reflects upon the water creating a glare of light around the cairn. In the west it is the opposite. There is a huge difference between having the sun at your back or in your eyes when looking at the sea.

It was dark as we arrived, but it soon became light enough to begin work. The tide was due in at 2.55 in the afternoon so I needed to be finished by around 11.00 am.

The stone was weak, and after four collapses I had to give up. Strangely this was exactly what happened to its precursor, the Nova Scotia cairn (made in 1999) as was the fact that with each new attempt the cairn became taller. I really felt that the fourth attempt would succeed and that I had built beyond the critical wide point, but it didn't work.

The collapse happened as I was walking away to collect more stone. I was stunned. This fragile stone has forced me to attempt every technique I can

to give it strength. I thought I had figured out how to construct with it but any cairn, no matter how well made, will always have a tendency to collapse if the stone is weak. The higher the structure becomes, the more pressure is put on the lower stones and any soft ones will break.

We cleared the stone away and placed it above the high tide line. I will return tomorrow and make another attempt. It's a pity. The day and light were perfect. Clear days at this time of year are rare. Tomorrow will probably be foggy as usual.

As we left I saw a whale surfacing out at sea.

24 August 2001

Arrived at the beach at 5.30 am. Foggy and darker than yesterday, but by about 6.00 am I was able to start work. This time I made the cairn on rock to give it more strength. Ideally I wanted it to collapse in the tide which was why I had built it on sand. Although very vulnerable during construction, the cairns become much stronger once completed.

In spite of being extremely fragile in the making, the Nova Scotia cairn went on to survive for four days of the highest tides in the world. By comparison the tide here is much lower, but there is surf.

I compensated for the lack of long stones by using larger-than-usual interior stones that overlapped the exterior stones. I did this yesterday, but this time made sure that the middle was always built higher and in advance of the

exterior – acting as a counterbalance to stabilise the stone on the outside.

I did everything I could to make the cairn stand and managed to build beyond the height that I achieved yesterday before there were any signs of movement. I could hear the stone settling and there was one big shift in particular. I attempted to arrest the movement by putting more weight on top, hoping to pin down the middle. As a result, a small column emerged out of the top of the work – its spine. This was a desperate measure: the possibility of a division developing between the internal and external structure is potentially disastrous, but I had no choice and when a second shift occurred later on I repeated the procedure.

The cairn was now so advanced that yet another attempt would have been difficult; time invested in the first attempt meant little chance for another. I was also becoming emotionally bound to this cairn: the shape was emerging beautifully: the belly was good and round which was surprising considering the stone. It was better than any of yesterday's attempts.

It is difficult to explain the relationship that builds up between me and the work. As it grows, the cairn's presence becomes stronger and more vital. Being made of stone it appears solid, and inevitably I begin to take its being there for granted – an assumption I should never make. I have to remind myself of its vulnerability. Even so, the shock and sense of loss when a collapse happens are acute.

Eventually the cairn grew to completion. A great moment.

We cleared away the debris, and there it stood. Once completed, the cairn became self-contained as if I had not made it but just found it standing there.

It was still foggy, but as the tide started to turn the fog began to disappear towards the south. As the day progressed the sun began to show and for the rest of the day I was below the line where the fog racing off the hills was being burnt off by the sun.

This created a light that I had dreaded and which I knew would cause enormous problems in photographing the cairn as the sea came in.

I used a medium-format panoramic camera. I like the way that the horizontal perspective works with the vertical movement of the rising sea. In the case of its partner cairn at Des Moines, this vertical movement was provided by the growing prairie.

This cairn will partner two other cairns which will be documented in the same way – from a fixed point of view over a period of time (several months on the prairie and a day for each of the coastal cairns) with a panoramic camera. This will, I hope, strengthen the connections between the three when they are presented together as photographs.

The problem with the panoramic camera is that it takes only four images per roll of film. If I do normal precautionary bracketing, that means only one correctly exposed image per roll. Changing films takes time and there is a strong chance of not being ready if the cairn collapses.

I forfeited the luxury of bracketing and guessed at the exposure for each image. The camera does not have a light meter and I take the reading externally. In the time between taking a measurement, setting the f stop,

priming the shutter and waiting for the right moment to take the photograph, the light had inevitably changed and I had to start all over again. Even during the six or so turns it takes to wind on the film I could miss the collapse!

I have never before experienced such difficulties in photographing a work. I was in danger of spending more time figuring out exposures than watching the sculpture. Photography is also a way of looking and understanding, but only up to a point, which in this case I felt had been reached; after that point it actually stops me from seeing.

Even under constant light the sea and reflected sunlight is difficult to expose correctly – in these conditions it became almost impossible. In the end I hazarded a guess as to what seemed to be the correct aperture and shutter speed for sun, shade and changes taking place between and adjusted the exposure according to what the sky was doing without taking a specific reading. Even so the light changed several times the moment I released the shutter. I am bound to have misjudged others – just as I did not always remember to shield the lens from the glare of the sun.

I was technically out of my depth and my limitations as a photographer were exposed. On my return home I noticed that the spray from the sea had coated the lens – yet another problem.

Of course I could have had a photographic assistant and two cameras so that one was always ready to be used. There are limits to how involved I wish to become photographically, and the idea of becoming too photographically organised does not interest me. Despite the difficulties that I seem to create for myself I like the intensity of having only one chance.

If these images fail technically, I will still present the work even though the images are flawed. This will at least express something of the day – the changing light and an artist struggling in a situation beyond his control and capabilities.

The event itself was beautiful, the tide slowly coming in. After the precariousness of its construction I felt that the merest touch of the sea would cause it to collapse, especially when the sea first rushed in around the base, but after a while it seemed to settle down and felt less vulnerable.

I loved seeing the waves hitting the cairn – each one a test but also a great sculptural combination – black wet stone and white water splash.

It began to appear as if the cairn would survive the tide – again a repetition of what happened in Nova Scotia. When suddenly a wave hit the cairn hard and it gave, I felt a sense of disappointment. For a moment it stood, slumped. I remember wondering whether or not I should take a photo. I took the image half thinking that I might photograph both the slump and the collapse but before I could finish winding on the camera the cairn fell into the sea.

I realise now that it could never have withstood the surf. As the tide receded I found stones scattered all over the beach. In fact there was very little left. Most of the stones had gone – buried in the sand. It was as if the sea had eaten and digested the work.

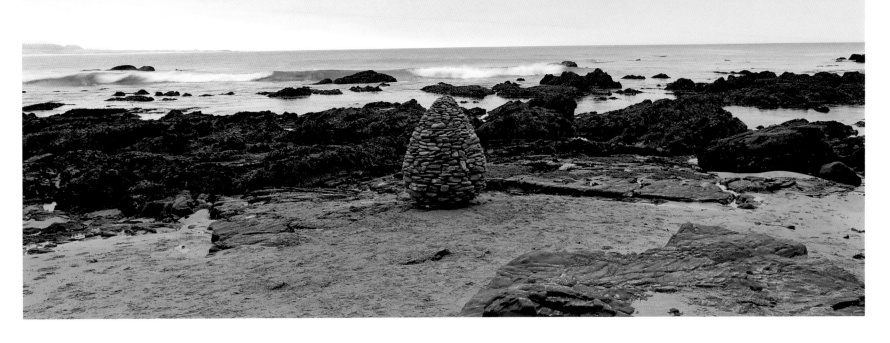

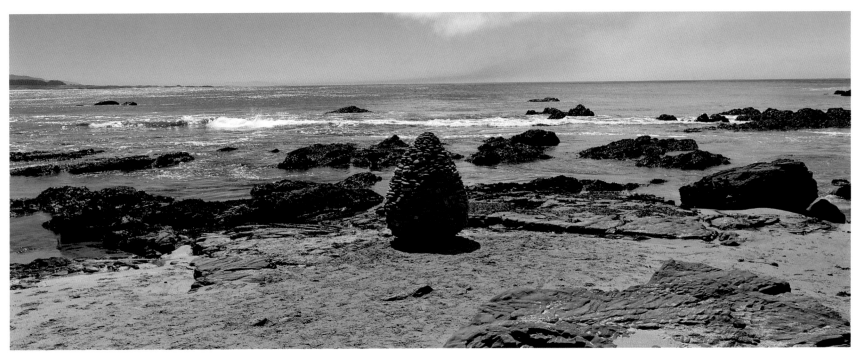

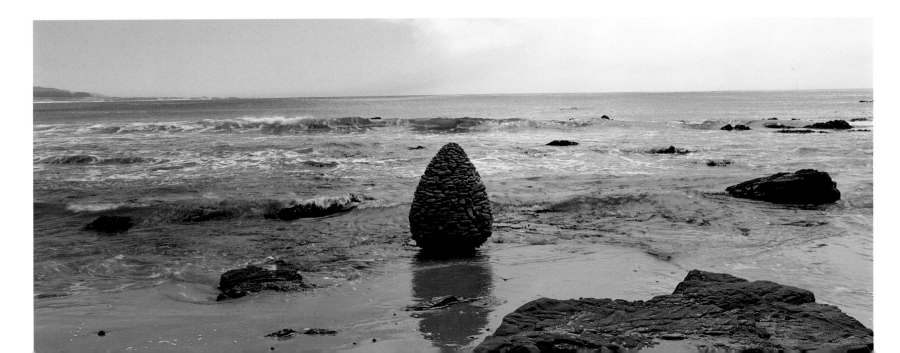

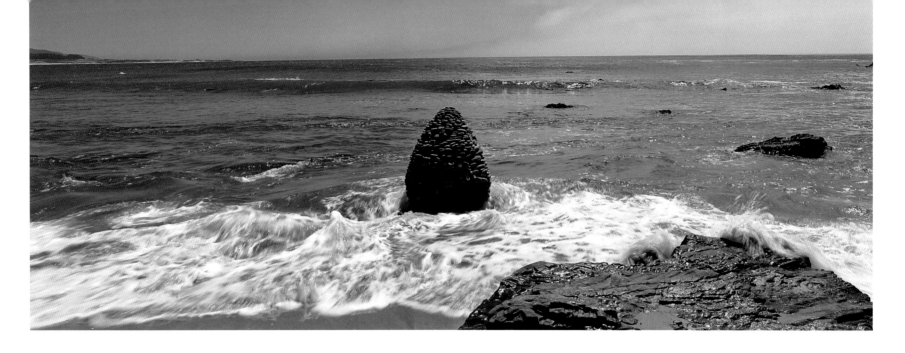

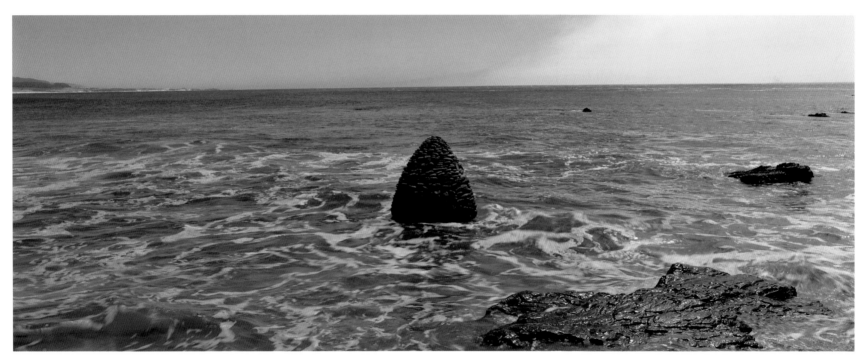

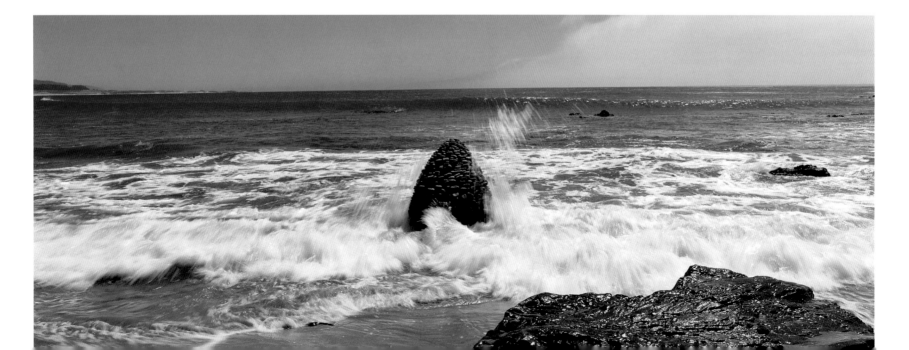

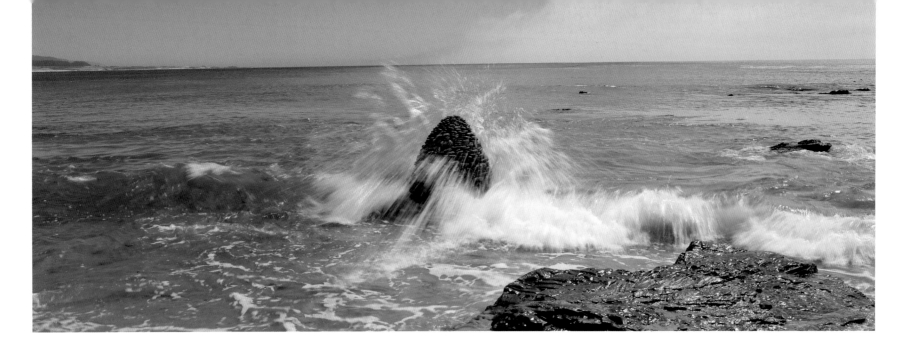

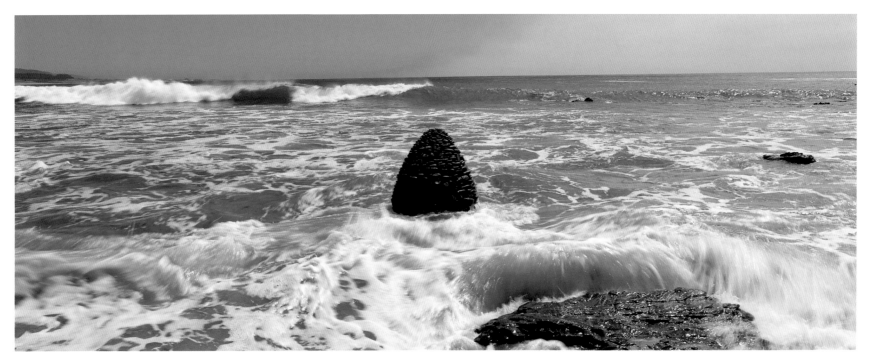

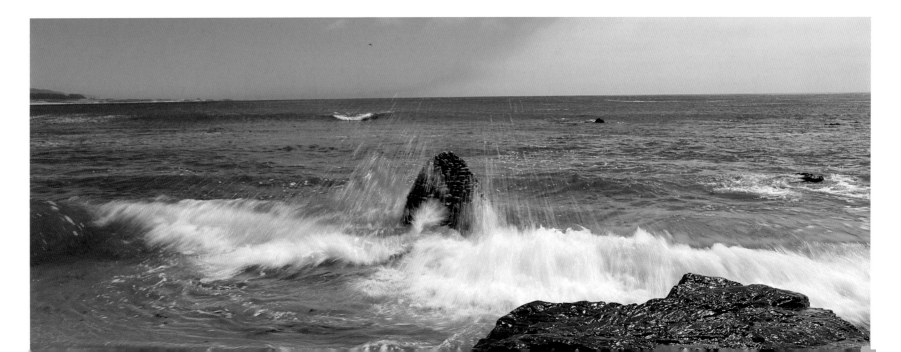

EAST COAST SEA CAIRN

NEW ROCHELLE, NEW YORK

5 November 2001

Arrived at the beach at 7.00 am. The tide was at its lowest point. My intention was to select the place for the cairn I will make tomorrow and to collect stone in preparation for its construction. It was also an opportunity to get a feel for the place and the tide.

This is such a different coastline to the one where I made the West Coast sea cairn. The sea appears gentler. I am sure there are times when it is very rough, but generally speaking the protection offered by Long Island makes it far more sheltered.

It was so calm that I decided to build the cairn partially in the hope that it may survive the afternoon and night tides so that tomorrow morning I have a head start. If this doesn't work then at least I will have got to know the stone which will help if the cairn has to be rebuilt.

The tide reached the cairn at 10.00 am, by which time I was about one third of the way up. As we left, the wind became much stronger and by the afternoon it had turned cold, overcast and stormy. This could mean rougher seas, which would make the survival of the partially built cairn unlikely. I will see tomorrow.

I am filled with a sense of anticipation, almost nervousness. I have cleaned my cameras – something I rarely do! – all part of the mental preparation for what in the past has been one of the most challenging situations in which to make a work.

6 November 2001

Arrived at the beach just before 6.00am. The clear sky was just becoming light and yesterday's work was surrounded by water but still standing. I had to wait only about ten minutes before the sea had receded enough for me to continue work on it.

The glare of the rising sun made it difficult at times both to see and to concentrate, but the work went smoothly and by the time the tide was at its lowest at around 8.00 am, we had finished.

The day took on a very deliberate and consistent feel. The incoming tide was calm and the sky remained clear – what a contrast to the conditions in which the western sea cairn was made! The sculpture never felt threatened by the sea, and the pace of both observation and documentation was calm and measured with an image taken about every half an hour.

The San Francisco photographs were taken as and when I had the opportunity – for the most part in anticipation of a collapse. Changing film was a nervous business, and I always held a finger on the shutter release, just in case.

Different days and different coasts have provoked different responses and ways of looking at the same form.

It was not merely a sense of orderliness that made me take the photographs at regular intervals. The aim was to record the cairn marking the passage of both the sea and the sun. The sun rose directly behind the work and as the day progressed shone from the side: the cairn began as a silhouette and was then gradually and beautifully illuminated as the sun picked out its form.

These parallel movements of time were for me the most significant elements in the success of today's sculpture – more important than the technical success of its construction.

High tide was at 1.57 pm, which gave me about three and a half hours of daylight to watch and photograph the sea's retreat. It had been around three hours from when the cairn first stood in water to high tide, and I hoped this might be reversed and repeated as the tide went out.

In fact it took far longer. Perhaps this is because the incoming tide is filling empty space whereas when it goes out there is the resistance of the water which perhaps slows it down, especially as the tide turns. Of course I may have been given inaccurate tide times, but these were specifically for New Rochelle so should be correct.

Eventually the cairn reappeared – its tip kissing the surface as if it was taking its first tentative breaths of air. This was so different to the way in which it disappeared under the incoming tide when its breaths became shallower and less frequent until there were none.

I knew my father was about to die when his mouth, which had gaped open for so long, closed momentarily several times before he stopped breathing completely.

By the time the cairn remerged, the sun had gone, taking with it the possibility of seeing the cairn completely out of the sea again. Perhaps this would have been too perfect. I am far from unhappy with what occurred today. My final image was of the partially submerged cairn and its reflection forming a diamond shape in the dark sea with street and house lights appearing across the sound on Long Island.

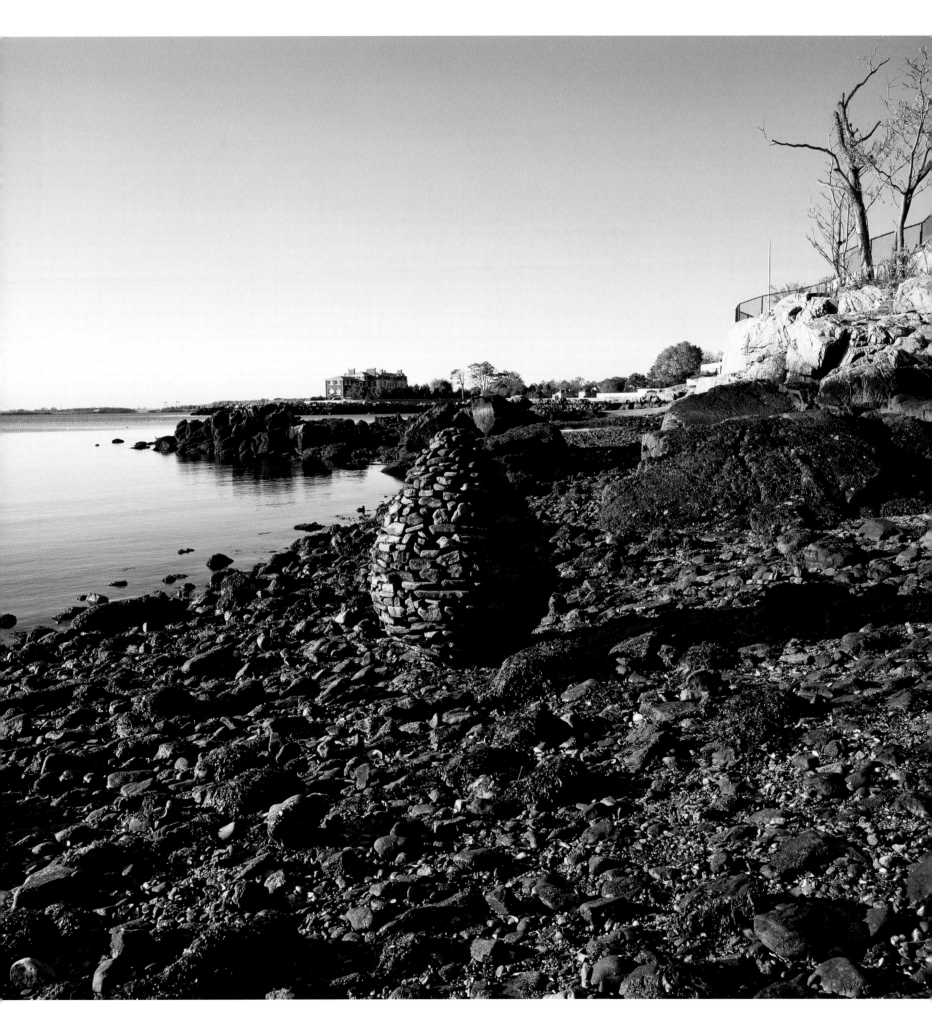

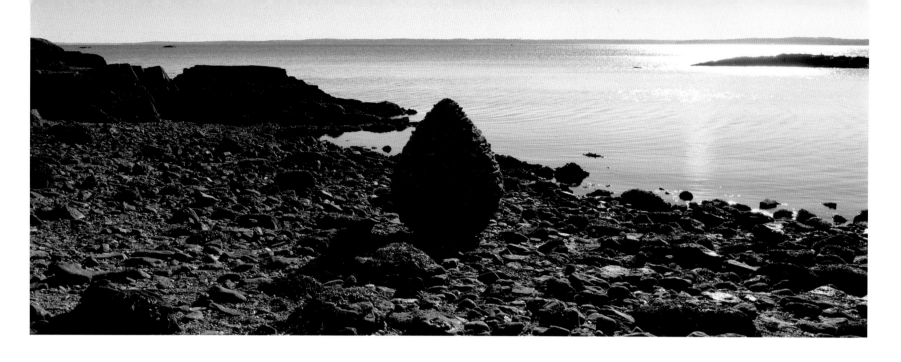

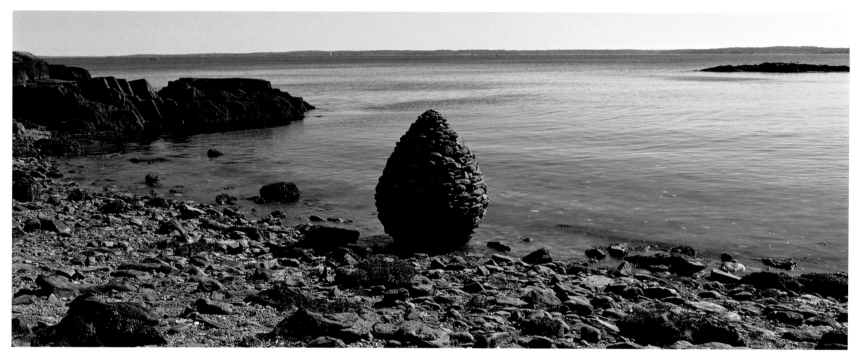

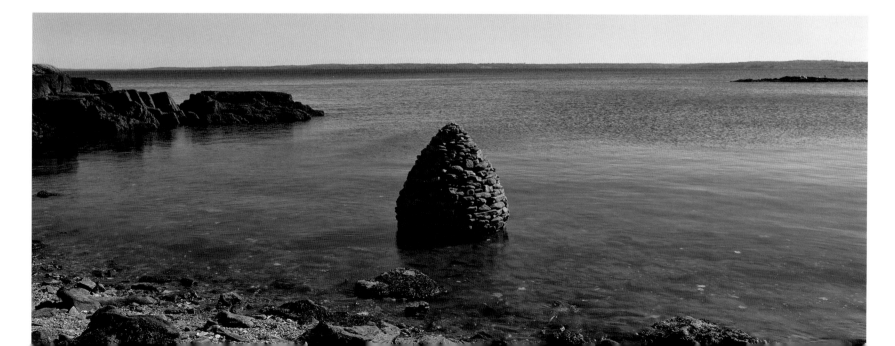

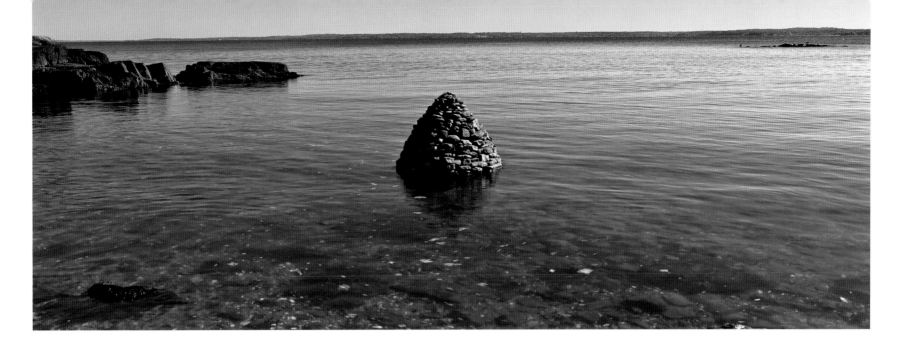

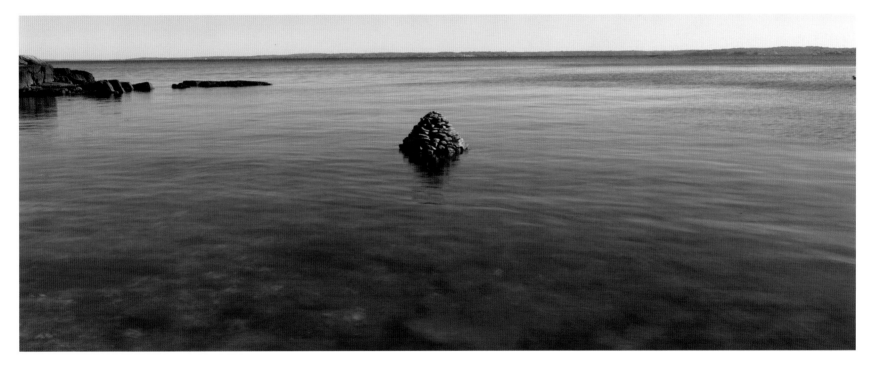

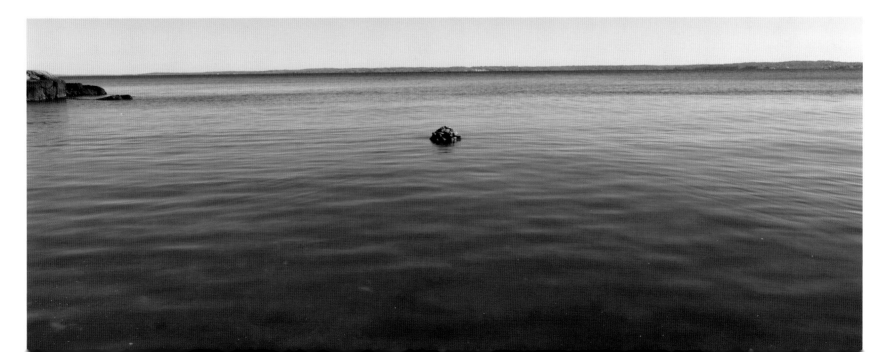

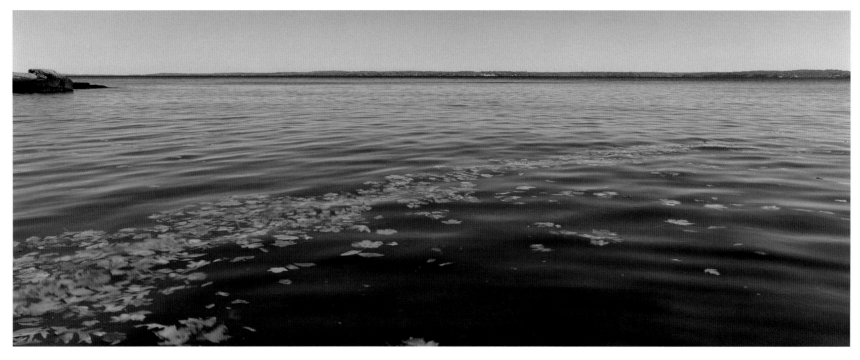

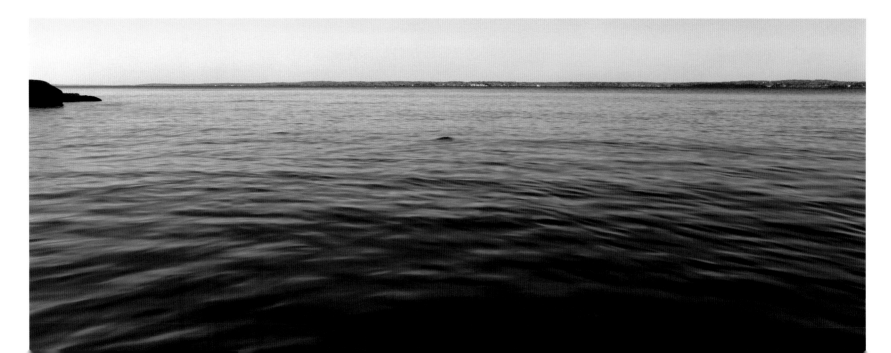

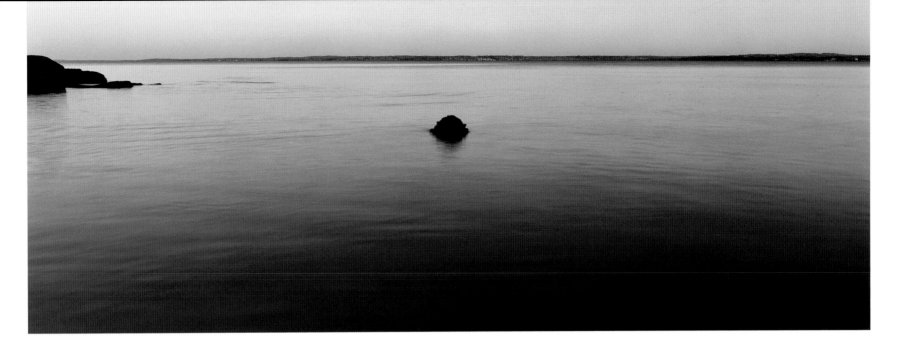

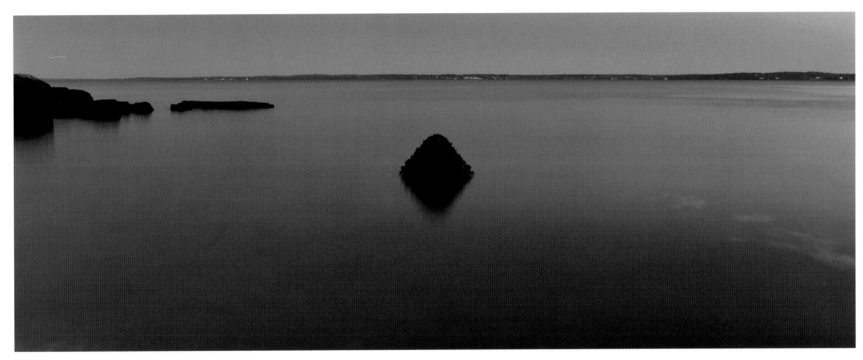

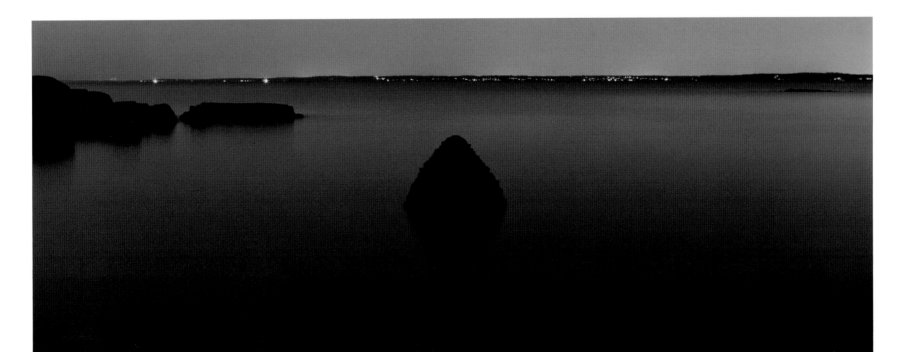

EAST COAST CAIRN

In May 2001, Andy Goldsworthy walked around the Neuberger Museum of Art and the 500-acre Purchase College campus and liked what he saw: a campus with intact stone walls from the farm it had originally been, an abundance of mature trees with overarching branches, and proximity to the 'sea', Long Island Sound. During the summer of 2001, he identified the perfect site for the Neuberger Museum of Art's permanent cairn. Iowa limestone was quarried and trucked to New York, and a foundation was engineered and poured. The region's rocky coastal beaches were explored for the temporal cairn and tides were checked.

For all the careful planning, nothing prepared us for the actual experience or the symbolic power of *Three Cairns*. Life, death, and regeneration, the underlying principles of Goldsworthy's art, took on profound and unexpected new meaning with the unimaginable events of September 11th 2001; for Andy, the meaning was personal as well, for his father had recently died.

When Andy and his assistant Eric Sawden, arrived on site to begin work in early November, our perceptions had been altered by recent events. Time seemed newly precious. The building of the permanent cairn seemed urgent. Concepts of permanence and vulnerability had become a strange paradox. Language became confusing, with 'the site' referencing both the cairn and the disaster. Environmental factors expanded to include emotional and psychological conditions.

The climate of change pressed conversations into personal subjects. Andy recalled his father and remarked that the cairn would take on meaning as a memorial. We spoke of the World Trade Center attacks, which resonated deeply for everyone, and observed that the building of the cairn would acquire additional weight as a marker of the event.

Andy's comments about the temporal cairn linger as a poignant metaphor for the cycle of life and death. As the tide gently rose over and engulfed the pile of stones, which did not fall down in a dramatic moment as he had hoped, he said, 'I like that it's still there even though I can't see it.' Fortunately, the temporal cairn is recorded in Goldsworthy's exquisite photographs.

Thousands of students and visitors pass by the East Coast cairn, under the arm of an oak tree, in a field that sprouts daffodils in early spring, then blooms in a riot of wildflowers that change from green and yellow and blue to a scruffy brown. The field is mowed down flat in winter and annually covered with snow.

There may be no visible evidence of the history surrounding the building of the cairn, yet it is forever enfolded in and imbued with the life-altering events concurrent with its making. And the conceptual connection to the national scope of *Three Cairns* seems more intense than anyone could have imagined, and the idea of its stability more vital.

Dede Young
Curator of Modern and Contemporary Art
Neuberger Museum of Art

NEUBERGER MUSEUM OF ART, NEW YORK
2 November 2001

Today I began work on the East Coast cairn. The site is one of three possible places that I selected on a visit to the State University of New York campus last September. All three sites are next to trees – a beech, a maple and an oak. I was happy for the cairn to be built at any of them. The oak tree was chosen, mainly for practical reasons.

I like the hidden feel to the place and the tall undergrowth of wild flowers which will change dramatically throughout the year. The tree has a branch that extends almost to the ground and under which the cairn will be made – as if the tree has embraced the cairn and placed a protective arm around it.

When I arrived there seemed far more stone than I will use but as I began to work I became less sure. This is the first time that I have had the quantity of stone for a cairn calculated in advance. I was astonished to be told that twenty-five tons were needed – we will see.

Work was slow today. First days are always slow – usually because the site is not properly organised or tools don't work or are not the right kind, and so on, but everything here was in order.

I cut the first stone from a single large slab. I did the same recently with a similar cairn at home in Scotland. It gives the cairn a strong start. I spent all day chiselling this stone and still have more to do tomorrow. I have never started a cairn so carefully and hope to make a base that feels rounded even though it is flat. To achieve this I have to undercut this first stone and this is what is taking time. I have also been slowed down by a painful wrist and elbow.

The stone for all three locations for the three cairns comes from a limestone quarry at Stone City near Des Moines, Iowa. This stone takes a little getting used to. It is easy to knock slices off across the grain but chiselling into the beds is a slow process. The stone seems to absorb the shock of the chisel which becomes tiring after a while.

Finished at dusk.

3 November 2001

Raining at the start of the day but it cleared later.

Finished cutting out the large circular stone that forms the base of the cairn. The junction between cairn and ground is critical for the sculpture to have the right feel.

I do not have all the sizes of stone that I ordered and there are very few of the large wide stones that I need to achieve a horizontal layered quality to the stonework. This is particularly important in order to reduce the impact of the base stone and other prominent flat stones.

This is a visual, not a structural, problem. The stone is actually the easiest I have ever had for making a cairn and has given me enormous control over the form. I have been able to calculate and plan it in a way I have never

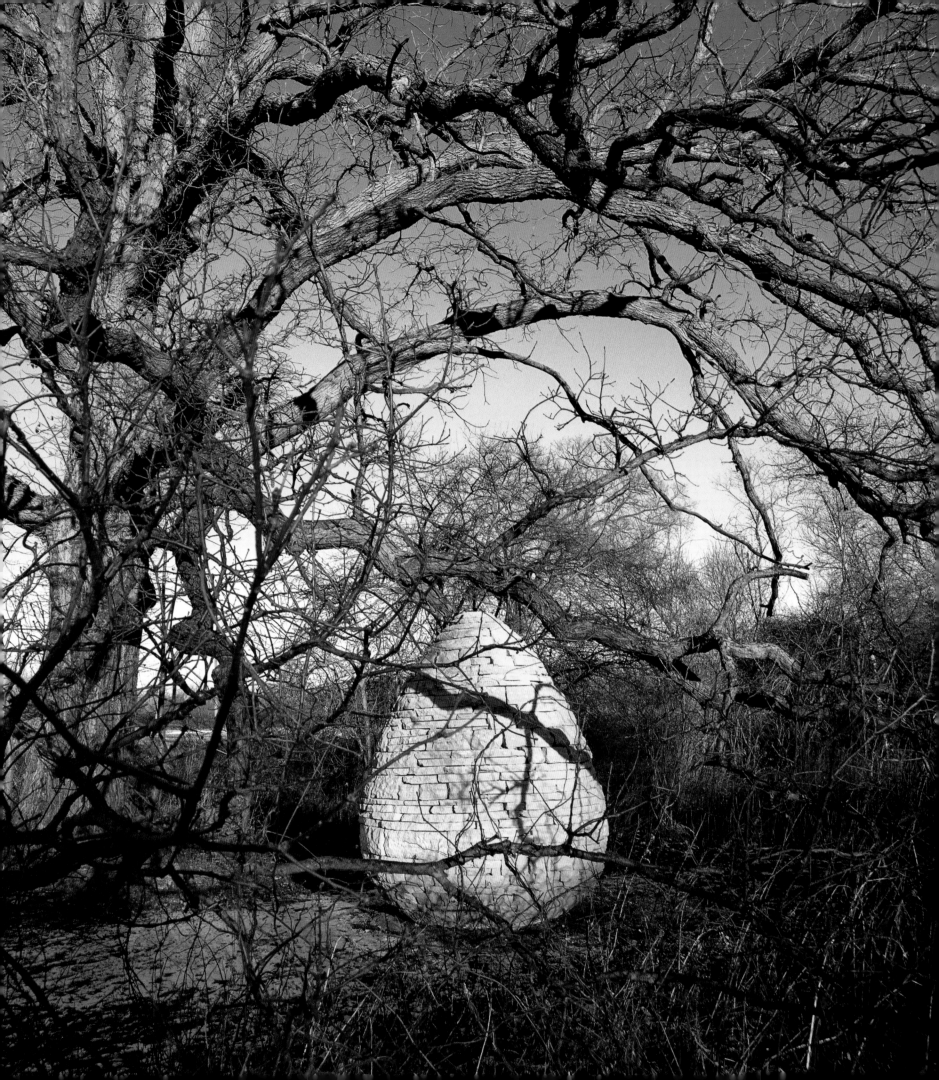

done previously. This will not necessarily produce a better sculpture. Cairns made by eye and feel have an energy because of their irregularities and 'flaws' but I want to use the opportunity offered to me by this stone to achieve a cairn that appears more or less symmetrical from all aspects. This will affect the openings of the empty chambers at Des Moines, which should echo the shapes of the cairns that they represent. I am taking measurements as I build the cairn which I will use at Des Moines to make the openings. This would not work so well if the shape of each cairn itself changed dramatically depending on the angle from which it was viewed. I am hoping that the whole cairn will feel related to its wall, rather than one particular view of it.

I have said before that if I ever make a perfect cairn, it may be my last – in a way I feel that this project represents the furthest I can take the idea of the cairn and that in wanting to achieve perfection I am trying to draw to a conclusion this form in my art.

Work progressed quickly. Potentially the base could be the roundest of any cairn I have made to date. On the other hand I may have reached the maximum width too low down, but it is worth the risk.

4 November 2001

A wonderful cool and sunny day – good for working.

I decided to do something I have never done before in the construction of a cairn which was to turn two out of three stones broadside so that the longest part of the stone lay on the outside. Normally all the stones are laid lengthways into the cairn to achieve maximum stability.

I am worried that the lack of large stones will have repercussions for the walls at Des Moines which cannot be made with small stones.

If I am to achieve a feeling that the cairns have come out of the walls, their stonework has to be similar to that of the cairns.

The stonework is strong and the construction in this instance has not been compromised – this has more to do with my own feeling about cairns and a belief that stonework should be as strong internally as it is externally.

I have reached the widest part of the cairn and have tentatively begun to draw it back in. I know how wide the base should be, the widest the cairn will be and its height, but the point at which I should begin reducing the girth and the line it should take are decisions always taken intuitively. There is no single or right way, but I know that whichever line I choose will have an enormous effect upon the feel, character and presence of the cairn.

This is the moment when the cairn comes into its own.

Tomorrow I go to the coast to collect stone for a sea cairn that I hope to make on Tuesday (see page 106).

7 November 2001

I have never before broken off while making a permanent cairn to make an ephemeral version. The two are linked but so different in execution.

The break has certainly benefited the Neuberger Cairn which I was able to see with fresh eyes today. The large stones I placed the other day certainly detract attention from the base – they are perhaps too prominent and I have tried to choose stones above it that redress the balance. Sometimes I feel that the source of a sculpture's energy comes from the effort of trying to regain a sense of balance lost at some point when I lacked control or concentration or perhaps made an error of judgment.

Such moments happen all the time in the making of a sculpture. Not to experience uncertainty or to make no mistakes would in a sense render the making of a sculpture pointless. Any new work should challenge my understanding of both how and why a sculpture should be made.

Work progressed well today. The cairn is about to reveal its character. I am still uncertain as to how well it will turn out and hope that tomorrow things will be clearer.

8 November 2001

A difficult day. I felt as if I had lost control over the form – not totally, but enough to make me uneasy, which may be a good thing.

I still have little idea of how the cairn will evolve or the feeling it will take on. Work seemed slow today. Problems with the scaffolding held me back.

I don't know what to expect tomorrow.

9 November 2001

The cairn remains unresolved and I still don't know what kind of presence it will finally have. Progress is slow and even though its diameter is much reduced I seem to be gaining only about the same height each day as I did when the cairn was at its widest.

There are several aspects that concern me, in particular the steepness of the angle at which I draw the cairn in as I approach the top. I would like to increase the angle as the cairn grows taller so that its profile is slightly rounded, but I may have begun to draw it in too soon. I cannot ever remember making a cairn without experiencing anxiety, but have been thrown off balance in this particular instance because the difficulty is so unexpected after the ease with which I began.

I am away for the next two days which is good. With luck, I will be able to work with renewed energy upon my return.

12 November 2001

A long day. I hoped to have almost completed the cairn but I remain some way off. There were moments, however, when I felt twinges of excitement at seeing it on the brink of being resolved. It is almost as though the cairn is about to be born.

The form is looking promising – difficult as yet to say more.

The weather has been sunny and cold – good to work in. Apart from one day it has been dry the whole time, which has been a great help, especially as this is a site that I could imagine becoming very boggy in wet conditions.

I placed two large stones near the top and they will hold the smaller stones in place. They required a lot of chiselling, and in an attempt to finish I worked until there was no longer enough light to see. I feel a certain amount of pressure as I hope to leave tomorrow. I will start early in the morning.

13 November 2001

Up early. Cold to start with but eventually warming up to become one of the most pleasant working days yet – cool, then warm and calm.

There was less to do than I thought and I had only to add three more stones to finish. It took most of the day to get those stones to work.

I had intended that the height should be 2.4 metres and was delighted when I measured the completed cairn and discovered it was near to that height. Normally I would let the cairn end within a tolerance of half a metre. Stopping short makes the cairn feel fuller whereas letting it grow tall makes it more elegant. I usually let the feel of the cairn itself determine the outcome. In this case, however, a tall cairn would mean a possibly awkwardly high wall in Des Moines. It is an interesting and creative constraint to work within the parameters of not just the form but also its chamber elsewhere. I now realise how critical the base was in keeping the cairn to the height that I wanted without making it look as if forced to be squat.

The completed form has a strong presence. The good beginning presses the belly into the ground and I cannot think of a stronger base.

Considering how easy the stone is to work with, I am surprised the cairn took so long to complete. Possibly it was just the effort of trying to get it right or maybe the small size of individual stones that added time to its making.

The scale of the cairn is good in relation to the tree next to it. A large mature tree such as the oak could easily overwhelm the cairn, making it feel insignificant. On the other hand, I do not want the cairn to overpower the tree. If anything, the right balance is one in which the tree is the dominant partner.

I feel tired. The cairn has been physically demanding. It has not been easy to make this work so soon after my father's death and September 11th. The cairn is not just a marker to place but also to the time it was made. It will always be linked to September 11th as my first large work after that event. It has a quiet, respectful introspective presence that I feel is appropriate to this time. The tree suggests growth – the parts of this scattered sculpture that are yet to be made.

Standing in front of the finished cairn I think with anticipation about the next cairn at La Jolla. It is good to be able to look beyond the sculpture to its partner in another place.

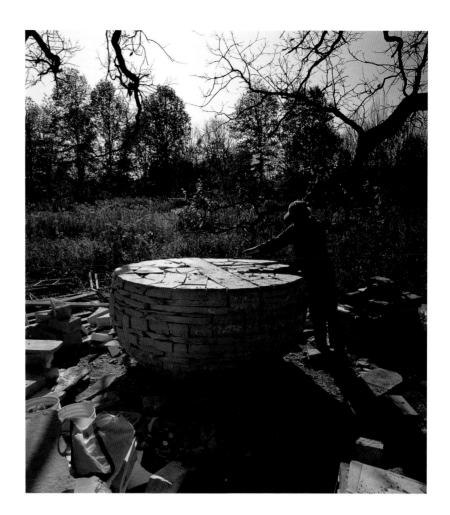

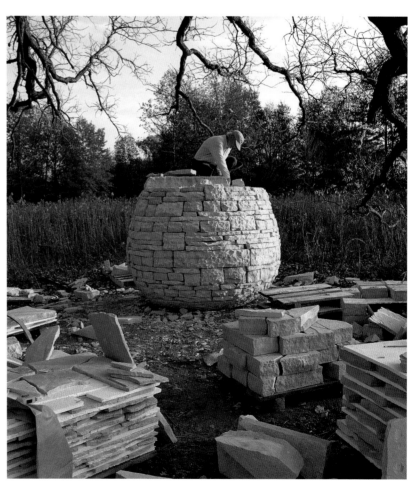

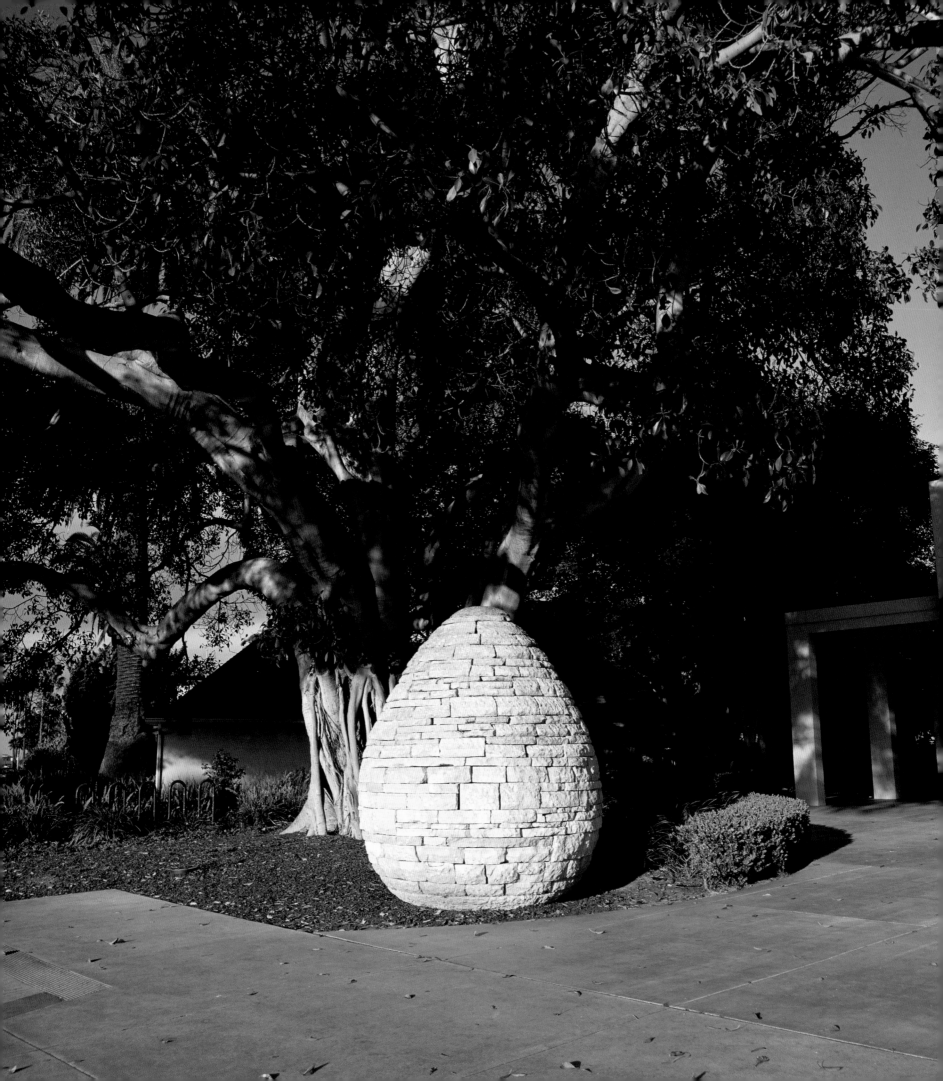

WEST COAST CAIRN

Nineteenth-century naturalist John Muir recognized the visual analogy between land and sculpture, praising the sculptural quality of California's topographic beauty created by glacial and tidal forces. The awe-inspiring power of time and natural processes to carve forms in nature provides inspiration for Andy Goldsworthy's work. Situated in front of the Museum of Contemporary Art San Diego, next to a busy intersection, Goldsworthy's California cairn at first glance defies the more typical associations of remoteness and ephemerality in Goldsworthy's art. Yet, as in all of his work, the site is crucial and deliberately chosen to facilitate his collaboration with nature.

Under the majestic canopy of branches of an imposing Morton Bay fig tree, the cairn's eight-foot tall form stands like a sentry. Together, tree and cairn illustrate the slow passing of time, with the tree actively growing, changing, and putting down new roots, while the stone appears passive – a witness to this evolution. Yet the Iowa limestone of the sculpture has chronicled an earlier passage of time. Inherent in quarry stone is a history of movement and change through its journey of excavation, transportation, and subsequent manipulation. This limestone's history dates back even further, bearing witness through the fossilized remains of ocean-dwelling creatures to the legacy of geological time. The horizontal layering of the cairn's structure reinforces this notion, becoming a visual corollary to geological strata. In a sense, the limestone has returned to its source, coming back to the ocean from which it originated.

Built a bit stockier than others in the *Three Cairns* project – a concession to the possibility of earthquakes – the cairn in La Jolla is an anomaly, demonstrating the incongruity of time in this particular location. In constructing an ancient form originally developed by a culture in a period completely removed from contemporary California, Goldsworthy creates a new awareness of the nature that surrounds us. Perpetually temperate, La Jolla is a unique site in relation to Des Moines and Purchase. The weather remains relatively consistent throughout the year, with no dramatic changes in climate nor evidence of seasonal shifts in the foliage. Southern California, by nature an arid desert landscape, has been transformed artificially via modern techniques into a flowering paradise. Goldsworthy's cairn is an archaic form taking root in an area in which the façade of nature is new, drawing our attention to the transient aspects of nature as well as the relativity of our sense of time in relation to evolution.

The immediate impact of time can be seen in the photographs of Goldsworthy's temporary cairn built at Half Moon Bay in northern California. Using stones found in tidal pools, Goldsworthy created a loosely constructed cairn ultimately intended to be destroyed by the incoming tide. The timing of Goldsworthy's actions was critical, always working in conjunction with the movement of the ocean. With its ultimate destruction at the hands of nature, the sculpture of the artist once more became part of the sculpture of the earth.

Stephanie Hanor
Curator
Museum of Contemporary Art San Diego

18 January 2002

Even though I have made many cairns I still felt uncertain and nervous on the flight from San Francisco to San Diego today. In some ways the fact that I have already made one to which the La Jolla cairn is related, in the same stone and of a similar size, creates its own difficulties. It is the first time that I have had two cairns so strongly in my mind simultaneously.

The three cairns at Digne in southern France, although related, were not visually connected as the East Coast, West Coast and Midwest cairns will be. The walls, even before their construction, are placing strict parameters and disciplines upon the East and West Coast cairns. The centre is already exerting its influence – even before that part of the project is made.

The site has been well prepared. The circular foundation has been laid without damaging the large Morton Bay fig tree nearby. I feel very good about this place. The relationship to the tree is strong and connects this cairn beautifully to the East Coast cairn, yet at the same time it will reveal differences between the two places. The oak at the Neuberger will change dramatically throughout the seasons whereas at La Jolla the tree will appear the same.

I have begun to cut the first stone – a somewhat tense moment as there is no replacement for it. There is a tendency for layers to drop off in too large a chunk. The stone feels harder than last time and I did not manage to finish this stone. I am tired after my lecture yesterday evening.

Looking forward to tomorrow. It's good to be here.

19 January 2002

Much harder day than I anticipated. Felt tired after the travelling and commitments in San Francisco.

It took several attempts to get the first stone to lie flat on the concrete base – longer than I had anticipated. It had to be lifted up several times and lumps carved off it before it worked.

People are beginning to stop and ask what I am doing; some know my work. This could become a problem if it interrupts the time I have to spend on the sculpture. Other people are just curious. One asked me to help bump start his car.

Slowly the base emerges. The beginning is always heavy with responsibility to both the sculpture and the place.

At the Neuberger the cairn looked good but not at home. The stone looks so much at home here. Perhaps it is the closeness of the sea – after all, limestone originated on the seabed. I like this connection, especially when the quarry from where it came is so far inland.

I am now locked into an intense dialogue with the stone. There is a feeling of physical engagement with the material that is consuming and at times exhausting, a struggle in which a moment's lapse of concentration can lead to a loss of control. Normally that can be interesting, but the parameters I have set for myself in the *Three Cairns* project are so tight that they do not allow for that kind of variation.

20 January 2002

A large blue tarpaulin has been suspended from the tree to prevent passers by being hit by stone chips. This prevents me from stepping back and seeing the work from a distance. Unfortunately the side from which it will mostly be viewed has now become a blind spot.

At the end of the day the tarpaulin was taken down and I could see one or two irregularities – not in the overall form, but in its detail – which would have been avoided had I been able to get an uninterrupted view of the work.

There is a tension between the visual and structural demands of the sculpture. From a constructional standpoint the thicker stones are stronger, but this gives a bulky quality to the stonework. I prefer the thinner stones that produce a horizontal dynamic. But in an area prone to earthquakes, I must do everything I can to make it as strong as possible. So far this is the sturdiest cairn I have ever made. I like the idea that an earthquake might affect its appearance.

21 January 2002

A good day is often followed by a bad one. With stone it is better to work without enthusiasm. Perhaps this is why wallers are so reticent when it comes to talking about how things are going. It is in the nature of stone for progress to be slow and steady which could possibly also be the attitude needed to work it.

Many of my responses to sculpture have been formed by my experiences of working on farms. All jobs, even the most tedious, seem interesting to begin with, but to get enthusiastic about picking stones, wild oats, potatoes, etc., would soon swing to depression. Far better to pitch for an emotionally neutral mood that can be sustained than an excitement that cannot.

In the end there was little to explain why today was bad – I did the same amount of work – just had a bad attitude. The questions of whether there will be enough stone and whether I will finish on time are obvious issues, but there is a deeper level of anxiety that accompanies the creation of a sculpture which I can only liken to the feeling I had when my children were being born.

The girth of the cairn has begun to fill out. It has reached its widest point. How long I hold it there is critical to the cairn's character. Strangely I am no longer so interested in the widening belly of the cairn, my uncertainties are focused now on when and how quickly I draw in the form – somewhat like being on a big dipper at the top of a rise as its movement slows. There is no going back once the turn has been made.

22 January 2002

I am still at the widest point. I fear that I may have kept it wide for too long but dare not draw in the circumference too quickly. I must keep my nerve and not panic.

The cairn is beginning to make its character felt, and I am finding the tension interesting. I am eager to continue work tomorrow in the hope that the form will be resolved.

I was not sure what relationship the West Coast cairn would strike up with its eastern counterpart before I began. I intended from the start that each cairn should be different and have with me the dimensions of the East Coast cairn. It would have been easy to make each cairn of a noticeably different size, but I now realise that I want a more significant difference than mere scale: character is more important. Making cairns of the same size that are nevertheless different is the challenge.

A dialogue is emerging between what I have already made in the East, what I am making now in the West and what will be made in the Midwest. The completed *Three Cairns* sculpture will never be seen all at the same time and will to an extent always exist only as an idea. The parts that cannot be seen exert an influence on those that can – the conceptual and physical frameworks of *Three Cairns* are being constructed at the same time.

The scaffolding arrived today. Its erection is always a physical and visual interruption to the work process, and I have learnt to be alert for problems caused by a sudden change in working position.

23 January 2002

The profile has turned inwards, and the circumference is reducing. I fear that I may have changed direction too soon – I will only know when the cairn gains more height, and then it will be too late to do anything about it. It is always like this.

Fear always accompanies the making of art, generated by the shock of seeing an idea taking form. A sculpture in the mind is safe and secure – the actual work rarely behaves as intended. Uncertainty and unpredictability are always present, even in a work as familiar as this one. It has to be right, whatever being right means.

The tree has been a focus and source of strength. It throws a protective arm over the work site. In return I hope the cairn will become a guardian to the tree. There is a good balance in scale between the two. The cairn appears larger here than the one in New York although in fact it is the same size. Not only is the tree smaller, but the site is less open, which also has an effect upon how the cairn is perceived.

Progress seems to be slowing down. I am having to use a thin, very brittle stone that is difficult to cut. These small stones take a long time to shape, but I need them to level the cairn off and give it textural variation, movement and depth.

24 January 2002

I almost lost the form today. I woke up with a headache which remained with me all day – difficult to concentrate. It began to appear as if the angle at which I had drawn the cairn inwards might be too acute, which could result in the cairn being too squat.

By the end of today I felt I had regained control and am hopeful that the cairn will work out well. There is often a low point during the making of a sculpture – hopefully today was it, but time is getting short.

It will be good to see the East Coast cairn again.

25 January 2002

Woke up after an early night feeling much fresher. I have been working on the sculpture non-stop for seven days. I feel an underlying sense of physical and mental tiredness that one night's rough sleep or a socially demanding evening can tip into exhaustion. As it is I begin at 7.30 am and finish around 5.30 pm.

This is the way I often work and I enjoy the total engagement with the sculpture that accompanies a tight and intense schedule. I have, however, misjudged the timing. I felt that as I already knew the stone, and would not lose any time travelling to and from work each day, as I did at New York, I would easily finish in eight days. I don't want to stay an extra day as I have only four days at home in Scotland before leaving again to install an exhibition in Belgium.

I will finish on time, but I would like to spend Sunday morning photographing the cairn, not finishing it off.

The rising sun, when it first appears, illuminates the cairn for about half an hour. After that the sun is higher and the tree casts the cairn into shadow. It is appropriate that a work with elements in the East and West, which has to do with time and travel, should meet the sun rising in the East, marking the beginning of a new day. I like this intense moment, when the sculpture is activated so dramatically for only a short time.

In the sun the cairn is white and in the shade it is brown. Generally the site here makes the stone look darker in comparison to how it appeared at New York. Things there will change when the tree comes into leaf and over time the stone will discolour, which will probably not happen at La Jolla.

26 January 2002

Out to work at 7.00 am in the hope of finishing today so that I can see and photograph the completed cairn tomorrow morning at sunrise.

I had almost finished when there was an enormous amount of activity clearing up around the site. I thought that it was everyone helping to clear up so that I could accomplish the sculpture today, but when at around 5.30 pm I said that I would finish off – if necessary in the dark – I was told that an event had been planned that required my clearing off. This was contrary to what I had been told at the beginning of the week and I was extremely annoyed after working so hard all day and having almost finished to then be prevented from doing so.

I could have achieved something quite extraordinary today and tomorrow morning. Now it will merely be a matter of finishing off, clearing up and going home.

27 January 2002

It was not sunny this morning so it would not have been possible, in any case, to see the completed sculpture in sunlight. This made me feel somewhat better about what happened last night.

I worked some more on the top stone – rounding it off. It is always a great moment when the sculpture is finished and the scaffolding taken away.

The cairn has a much stronger presence than I expected.

I feel very tired – the making has been much more difficult physically than I anticipated. It has taken me one day less than the Neuberger cairn but only because I've worked longer hours. I look forward to returning when I will be able to see the cairn more clearly. By then I will have seen the East Coast cairn once more and will have finished the Des Moines cairn. I already feel a connection between the two completed cairns.

The shape here is different to that of the Neuberger cairn – fuller might be one way to describe it. The last stone I put on stays in the mind: the Neuberger one is smaller and at La Jolla it is more rounded. No two trees or people are the same, and so it is with the cairns.

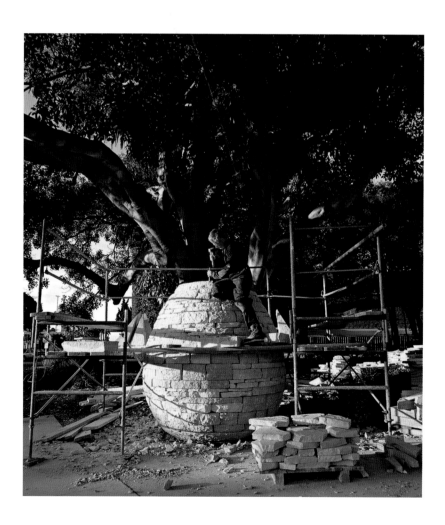

MIDWEST CAIRN

The limestone sculpture that Andy Goldsworthy built in Greenwood Park behind the Des Moines Art Center consists of three massive boxlike walls arrayed to the east, west, and south of a central cairn. Each wall has a teardrop-shaped cavity, specifically crafted to house one of the cairns in the project. Approaching the work, choosing a wall, and then stepping inside the cavity, one experiences a remarkable sense of the place coming together. The feeling is that of space encircling and housing the body, of being at home in an intimate den. If the *Three Cairns* project is about a dialogue between places in which key terms include 'home' and 'away', 'here and 'there', then the components of the Iowa project seem to be more here than there, and more home than away.

Associating the piece with the present and nearby, however, reinforces the cliché that Goldsworthy's work always maintains straightforward and unproblematic connections to nature and to locality. In fact, few events could be less natural and 'homey' than having an international team of artisans work with heavy machinery and precise surveying devices to create a 200-ton sculpture that could endure more than a thousand years. The pieces' *prima facie* naturalness and indigenous character – due in part to the use of a local material, Iowa limestone – is offset by the awareness that it results from an imposed and artificial gesture. Central to this gesture is the artist's use of spatial and temporal connections to indicate a place that, in contrast to other places, becomes a structural center or home by virtue of the immaterial relations of space and time set up in the work.

These relations are at the core of the *Three Cairns* project, as important to it as the physcial materials with which the artist directly engages. When Goldsworthy built the temporary cairn in the Iowa prairie and photographed it in different climatic conditions – in changing grass heights, in snow, and amid flames during a controlled burn – his images became a record of change, of the immaterial 'distances' that separate and connect one moment and another.

Similarly key are the many abstract spatial relations embodied in the permanent piece: the internal relations among the four components in the park, their alignments with the walkways in a nearby rose garden and with the buildings of the Art Center (which they divide down a central corridor, allowing one to sight the central cairn at the end of a long hallway), and their connections to related sculpture on the East and West Coasts. Through-out the *Three Cairns* project, the marking of space, which reflects the original use of historic cairns as trail markers, operates on a par with the making of objects as a fundamental artistic procedure.

<div align="right">

Chris Gilbert
Associate Curator
Des Moines Art Center

</div>

1 November 2001

I arrived at Des Moines three days ago to mark out the locations of the three walls and cairn at the Art Center so that foundations can be laid before I return next spring to begin work. This is my third visit to Des Moines. it was good to see the site again, and I feel strongly that this is the right place to make the work. Its relationship to the museum has become very important. I would like to strengthen this connection and will align the sculpture with the building so that it runs parallel to the museum.

Of course the sculpture should work from all directions, but the way people approach and come across it will affect the way it is read. At present, people need to exit the building and return to the car park before finding a way to the extensive grounds at the rear. This is a very different experience to going through the museum. The outdoor and inside art are disconnected, which is a shame for an arts centre with a growing outdoor collection that will hopefully match its extraordinary indoor works. There is an office with a window and door that open on to the grounds behind. If a corridor that is currently the print gallery could run through to this outside door, inside

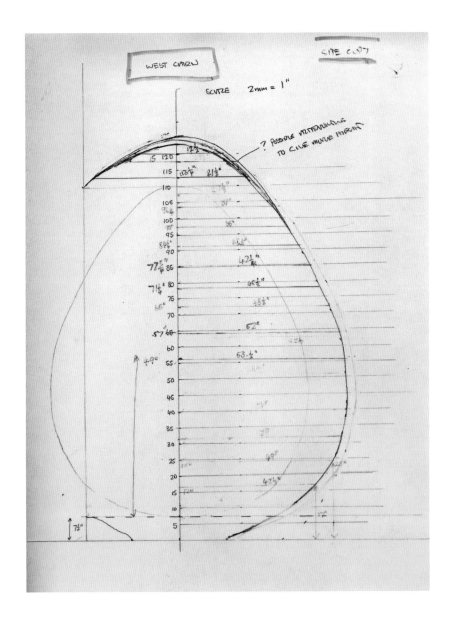

and outside could be linked. Should the corridor ever be extended, the cairn, placed in alignment with it, would connect the inside to the outside – a stepping stone between the two.

1 May 2002

I have never calculated a sculpture as exactly as I have this one. The only way to connect the physically separate components of the sculpture is through mathematics. It is the way I carry with me the East and West Coast cairns and can project them into the space at Des Moines. In the past I have usually asked my father, who was a maths professor, to help out, but he died last year. In a way the mathematical content of this sculpture is a connection to him. I am perhaps finding part of my father in myself.

At one point today I had to leave the site and find a quiet indoor space in which to work out dimensions away from the stone. This is a very different way of working for me: problems are usually best solved in the making. This sculpture however needs a different approach. I need to look at the space between the three cairns as well as the stone in front of me.

I find this approach challenging and creative, but only because I am not entirely sure of what I am doing and I know that, despite all my calculations, the final sculpture will still be a surprise. Some lack of control is essential to give tension and energy to a sculpture. If I were, through experience, to gain complete control of the sculpture through calculation then the process would become merely one of design – not of growth.

2 May 2002

Had I made the walls in a line as I had originally proposed, I would have forfeited the relationship not just to light but to time. For a sculpture that is about travel, space and distance, that would have been a serious omission. Placed in a row, the walls would have all been affected by the light in the same way. As they are arranged now, the West Coast wall is illuminated by the rising sun whilst the East Coast wall is in shadow – the reverse happens at sun down. This gives the walls a clock-like function which I welcome.

The west wall in shadow at the end of the day made me think of the West Coast cairn, sitting underneath the fig tree waiting for the rising sun to bring it to life. Connections like that are important.

Opposite

Drawing marked up with calculations made during construction of chambers at Des Moines to determine the interior dimensions of a chamber in relation to its corresponding cairn

MAY 2002

Right

Interior view into the apex of one of the chambers at Des Moines

13 May 2002

The light inside the chambers is so beautiful, especially with people working inside them. It is going to be a little disappointing when they are first enclosed, but I am sure that they will be just as interesting albeit in a different way. The disappointment will be felt only by those who have worked on the sculpture and become used to them illuminated as they are now. The interiors glow. The sunlight today picked out the forms of the cairn and walls. I must make a work that uses a light instead of a dark hole.

29 June 2002

The clearing of the site allowed the sculpture to breathe.

The space around any sculpture is important. In the case of the Des Moines site it is critical. The form of the cairn repeated in the walls projects the cairn across and beyond the site. The sense of expansion outwards from the centre is somewhat diluted by existing stone walls nearby.

The sculpture is about not just stone but space, distance and rhythm. I have never made a large sculpture that has such a strong sense of layering. Both the east and west walls give views of the cairn as well as glimpses of the opening on the opposite wall. Related shapes, forms and outlines connect visually across the site.

These cavities are not empty. They are about presence created by absence. This is not just a matter of making a negative space. It is more like the space left behind by a deeply loved person who has died or gone to live far away. Such spaces are both sad and beautiful.

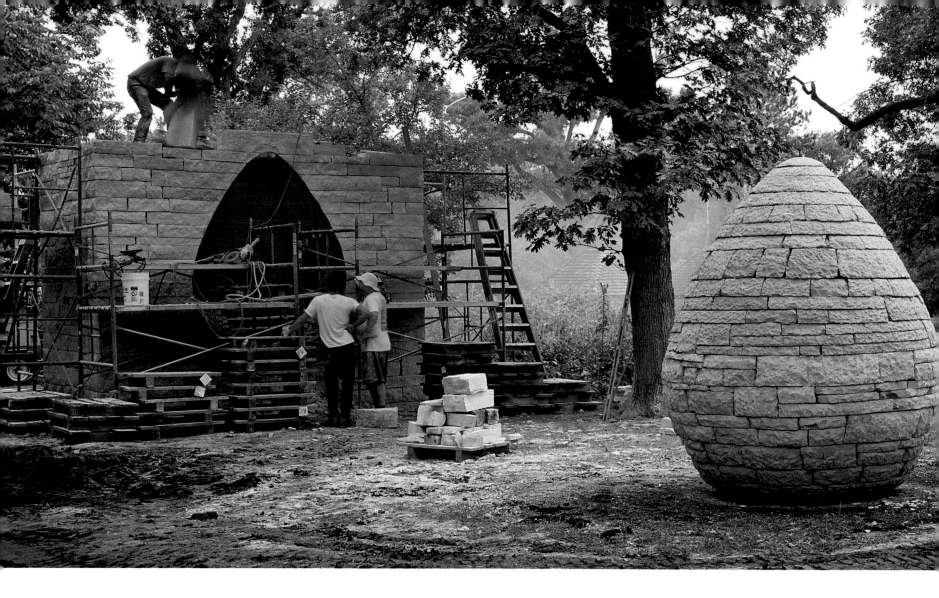

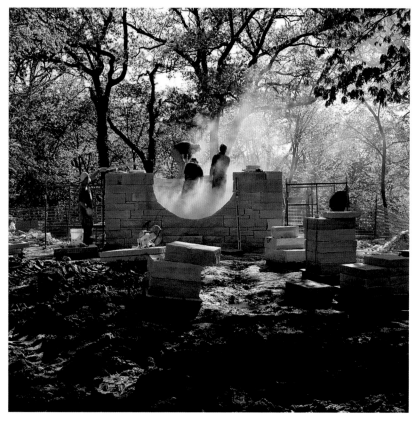

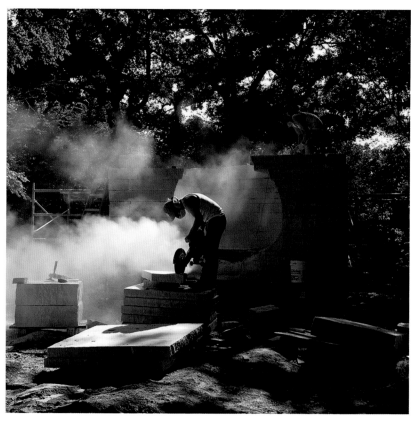

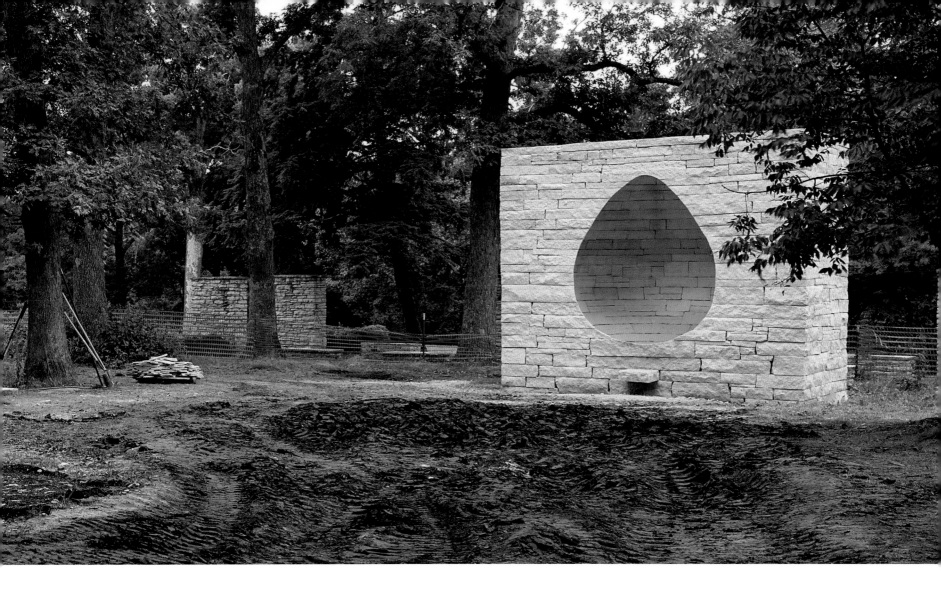

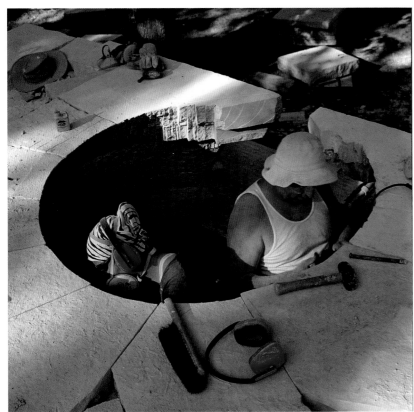

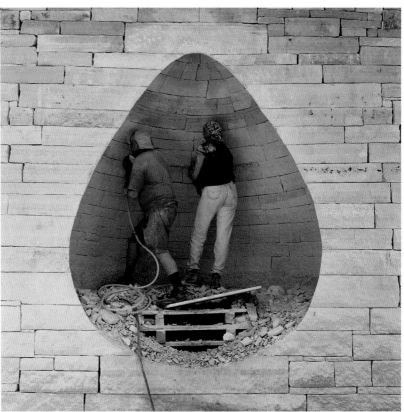

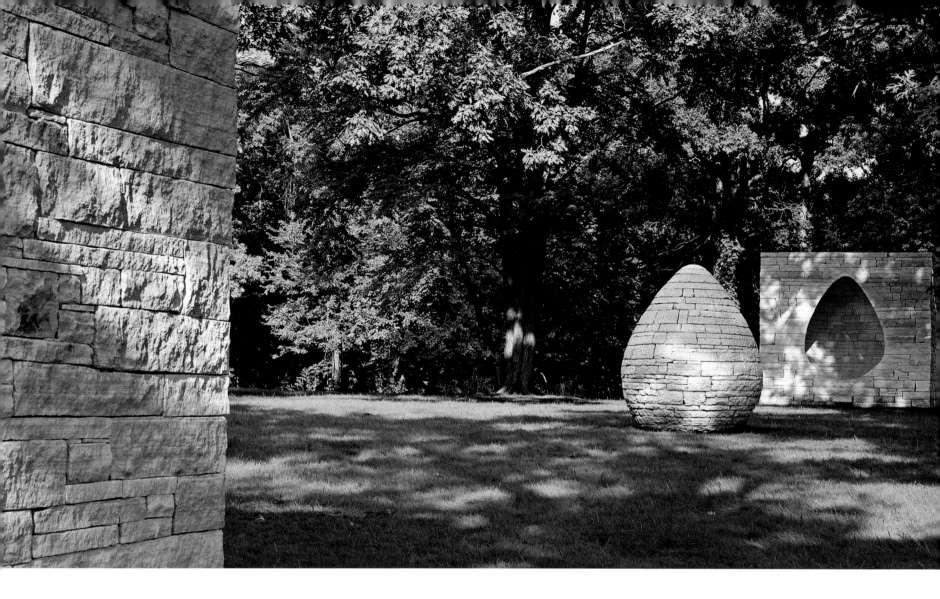

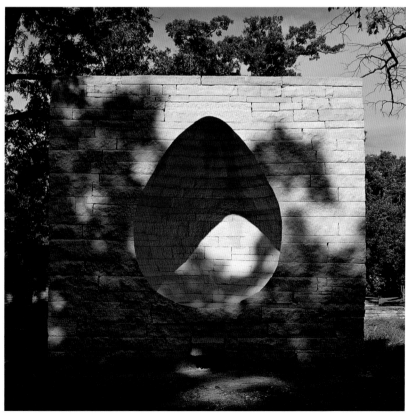

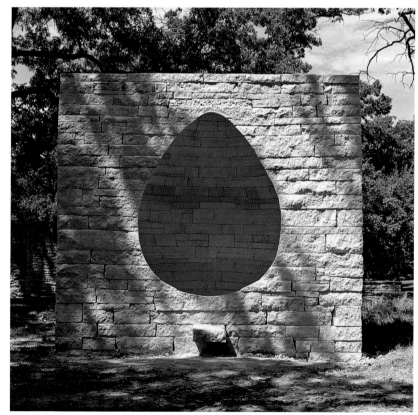

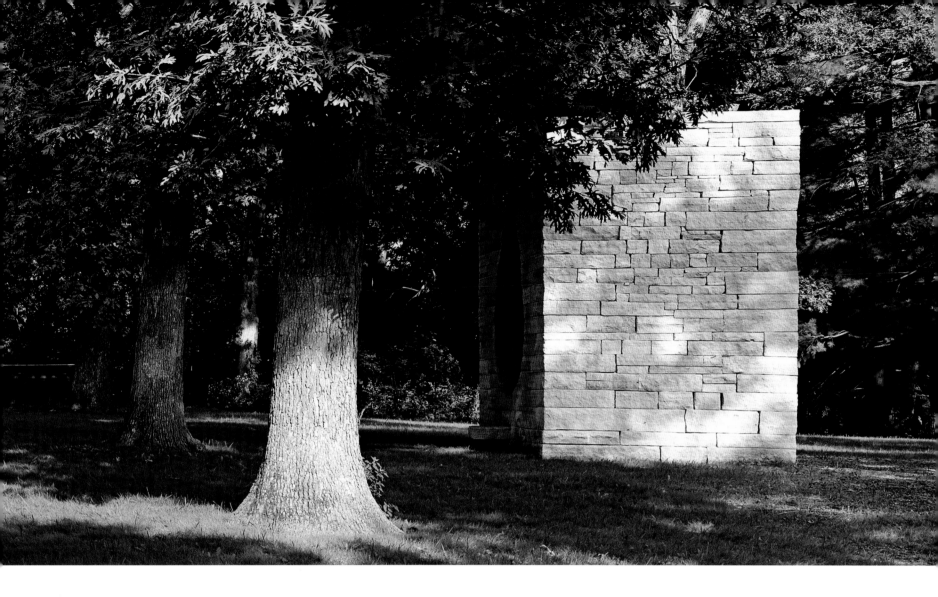

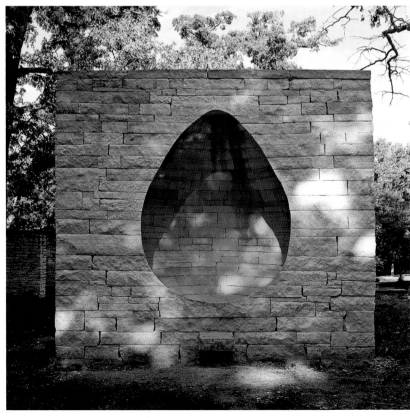

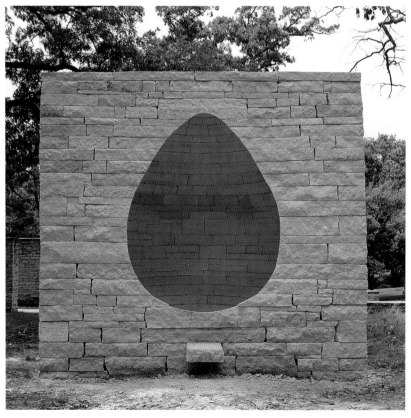

ELM

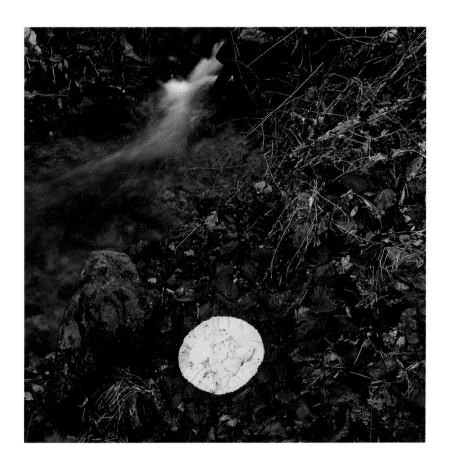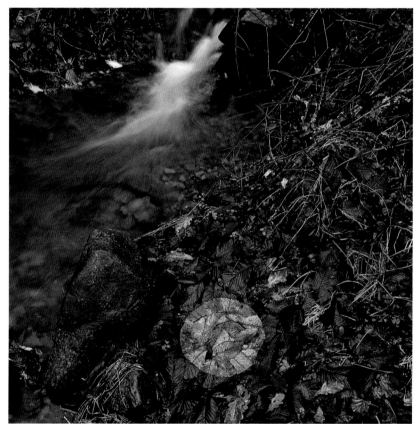

Elm patch

TOWNHEAD BURN, DUMFRIESSHIRE

NOVEMBER 2002

PENPONT, DUMFRIESSHIRE

Many of the following works were made as part of a project for the Haines Gallery in San Francisco in which each day's work was e-mailed to the gallery to form a growing exhibition over a period of a month. The time difference between Scotland and California meant that the works often appeared to be arriving before they had been made. The show opened on 22nd October 2003 with one work, made that day, on display.

8 November 2002

Today I went to see an elm tree that I work with every so often, especially at this time of year when leaves change colour. The tree fell several years ago but has continued to grow in the very boggy ground where it lies (*see* page 129). Last year I was able to work with its yellow leaves well into December. I was surprised to see that it is already completely yellow with only a few green leaves left.

The stream was in full flow. I tried placing an old roofing slate in a small waterfall – leaning it against the large clump of branches that had formed a dam. It is the purpose of slate to shed water from a roof, and I like the association between slate and water. Obviously, though, it does not come from the burn and I felt uncomfortable about its use.

I found instead a piece of bark that had fallen off a nearby dead elm tree. There are times when the introduction of a material from another place can be interesting, but I feel there is greater potential for learning in working a material where I find it.

To work on the bark of a dead elm with leaves from a living elm carries more meaning than placing leaves on slate. The elm is my richest source of yellow in autumn. For several years the elm trees here have been dying from Dutch elm disease. Over the last fifteen years I have seen the yellow gradually drain away from the palette of colours available for me to work with. Each year there is less.

Colour is an expression of life. Today I laid elm leaves gradating from green to yellow on elm bark, which I suspended alongside the waterfall by skewering it from behind with a pointed stick (*see* page 141). The last time I made a colour change leaf line was for my father the day before he died. Following the colours that occur in a leaf is an attempt to understand change that runs through all things.

Despite the possibility that one day there will be no more elm trees left, the challenge is to look to the life that may come out of their death. Not only did the materials that I used today come from a dead elm, but the waterfall where I worked has also been created by fallen branches from nearby dead elm trees that have accumulated in the burn. One tree has fallen across the burn. There are two such trees here which despite being uprooted are still alive. Perhaps the falling into water has given them renewed vigour.

9 November 2002

Calm and overcast – a good day to be working with leaves. Reworked yesterday's piece, but this time the bark was laid horizontally on stones in the burn so that it appeared suspended above the water. I added several more pieces of bark to elongate the line (*see* page 140).

I worked under fallen elm trees – some still living.

Being just above the water gave the work a strange feeling of being dislocated from the place, as if I am trying to hold something still whilst everything else is on the move. I can't decide if these works look as though they are stuck on top of the stream or appear as a torn hole revealing what lies below – it depends on how I look at them.

I enjoyed making the work. The only bad part was when a lens for my Hasselblad rolled down the banking into the river.

10 November 2002

Raining to begin with but soon clearing to give a bright, warm, calm day.

Stopped by yesterday's piece, which was still intact, but with a few fallen leaves on top. I took it apart so that I could reuse the bark. Went upstream to a small waterfall where I laid the bark, supported by stones, so that it followed the curve of the falls. There were many curves in the place – above me were more fallen elm trees, which formed arches across the stream.

The sun did not reach into the streambed, but still had a strong impact on the work. The yellow seemed to drain away from the leaves at times, depending upon whether the sun was in or out. The yellow was strongest when the sun reflected off clouds into the gully where I was working (*see* page 143).

Another enjoyable work to make. It felt like a brush stroke of colour. I have always liked this small stream and have worked in it many times. I feel that in what I have done recently, however, I have gained a far better feel for the place than I had before.

11 November 2002

Collected orange beech leaves thinking that I might replace the yellow leaves used yesterday. It is sometimes interesting to keep the same form but change the colour, just to see how different colours work. When I arrived, however, this seemed pointless and instead I placed four pieces of bark across the waterfall – using the two pieces that I had used previously.

Covered all four pieces with yellow elm leaves. This worked even better than yesterday, with more rhythm, movement and a stronger relationship to the water. I finished the piece and photographed it using my Hasselblad with the lens that fell in the river (which seems to be still working now that it has dried out). I was about to take another image using a different lens – just in case – when a gust of wind stripped many of the leaves off the bark. I tried to make repairs but the wind became stronger and blew more leaves away. It was actually quite beautiful to watch. Had I not finished when I did I would never have finished at all.

It has been calm for the past few days with work remaining intact. I wouldn't say that I was becoming complacent, but inevitably a sense of security creeps into the process and the way that I view the place. The shock of today has changed that – not only does it make me aware of the fragility of the leaves' hold on the bark, I am also conscious that the yellow

will soon be gone, a sense that was reinforced as I walked back home and saw leaves being blown off the trees in the strong wind.

This is a beautiful moment – colour is strong and in abundance. The work is going well. I know, however, that this state will not last. The intensity and beauty of the yellow are heightened by the knowledge of the decay that will inevitably follow. I will work with the yellow as it drains away in the hope that I will learn about change and the passage of colour.

12 November 2002

Dark and overcast. Began to rain as I started work and continued for the whole morning.

I made a yellow elm leaf line laid on thin lengths of bark that appear to be suspended above the stream. The line was drawn between the stream and fallen elm trees.

The rain became heavier and the stream began to rise. Parts of the line were beginning to be washed away as I left.

13 November 2002

Rained for most of the day. Worked at the small waterfall where I hung a piece of bark covered in leaves. I liked the way the bark floated in the space and decided this time to try and connect four pieces together in a rough rectangle that I would again cover in leaves.

Each piece of bark was held from behind with sharp-ended branches pushed into the mass of branches that had dammed the stream.

It turned out to be the most difficult work to make so far. Although it was relatively calm there was a wind apparently generated by the waterfall that would occasionally whip off the leaves. I had almost finished when the whole thing, bark and leaves, collapsed and I had to begin again.

It was a dark, overcast day. The yellow wasn't as vibrant as on other days, but there were times when a thinning of the clouds allowed enough light through to bring it to life.

14 November 2002

Strong wind. Worked with leaves on slates held above the stream by stones. The slate gave the leaves a better grip than they would have had on bark, which was important for a day that was as windy as today. I kept wetting the leaves but still they were occasionally blown off.

I left a gap between the slates over which I made a torn line. I would have liked to have made it longer but didn't dare risk working too long in the wind. Besides, the leaves left to work with are becoming much reduced.

15 November 2002

The wind has dropped. I worked again just in front of the small waterfall, this time on a fallen tree. This tree has previously been awkward to work around and made it difficult to view the things that I had made near the falls. It was good to turn what had been an obstacle into something positive and to see it as an advantage rather than as a problem.

Over the last two weeks I have been collecting red sandstone in a nearby quarry to make three cairns for an exhibition at Galerie Lelong, New York. The same kind of stone has, in the past, travelled all around the world as ballast in ships. The cairns will be built around the architecture of the gallery and will explore the idea of journey and how something from one place can integrate with and become part of another. After the exhibition I am hoping to remake the cairns outside, where they will be built around rocky outcrops – reminiscent of houses that I have seen in the south of France built around huge boulders.

I have been considering what I should exhibit alongside the cairns at Lelong and think that images of works made in and alongside and in the rivers and streams around where I live in Scotland might be appropriate and bring to the stone sculptures a sense of passage, movement and change. I don't think there will be an obvious connection through similar forms, more a parallel train of thought.

Today's work on the tree could be such a piece. I stuck yellow leaves to it by first dipping them in the stream. Running through the leaves was a torn line (*see* pages 130 and 131). I may call the exhibition *Passage*.

16 November 2002

I am in Yorkshire visiting my mother. I like to work in a disused and now overgrown quarry when I stay here.

I missed the presence of the river. Flowing water has been important to work that I have made recently, giving it energy. The quarry seemed quiet and still by comparison.

18 November 2002

I am back in Scotland.

It is good to be back at the stream, but I was shocked to see how little yellow is left. The energy of the yellow has given much needed energy to me recently. The prospect of it disappearing made me panic a little.

There are still a few leaves on the tree, which may yet turn yellow, but the past couple of cold dry days have taken most of the existing yellow away. It was also strange to see the place dry, and I missed the way in which the rain gives richness to the colours of leaves.

Elm leaves
laid on the wet trunk of an elm tree

PENPONT, DUMFRIESSHIRE

4 DECEMBER 2000

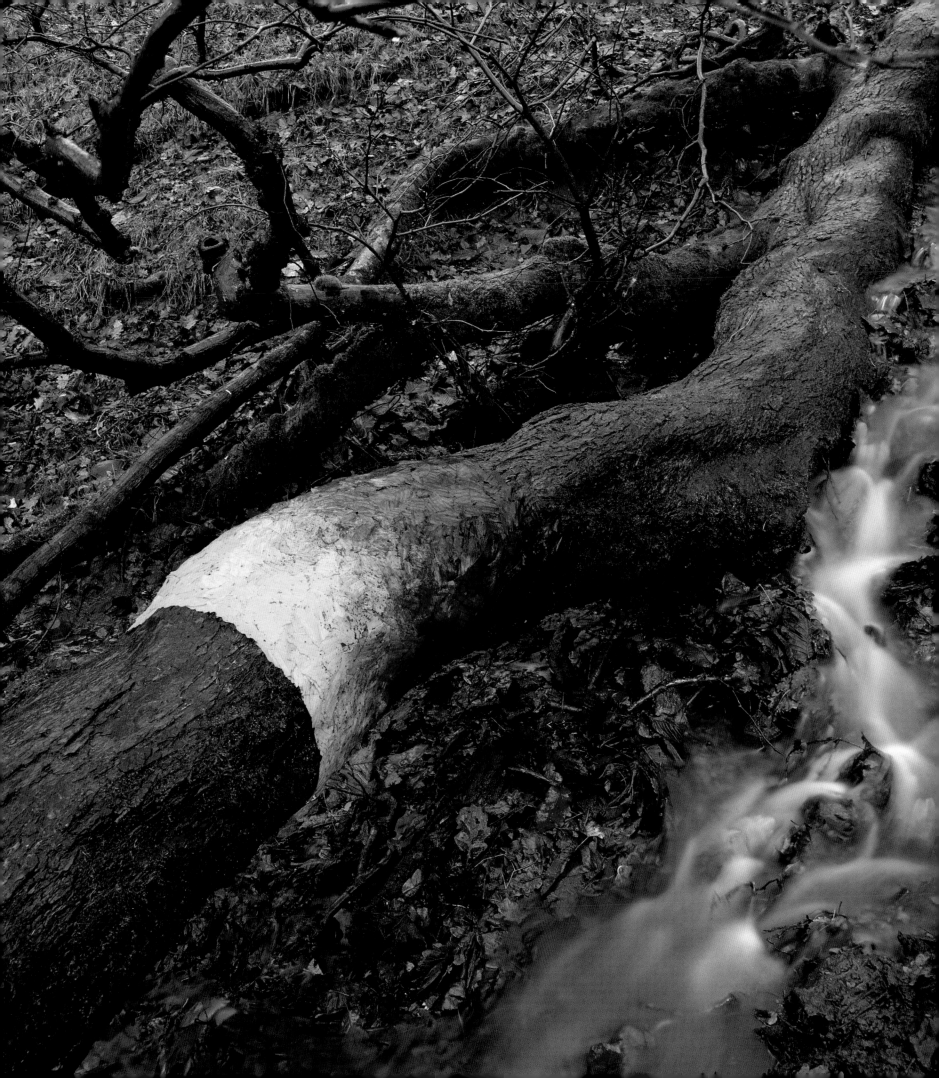

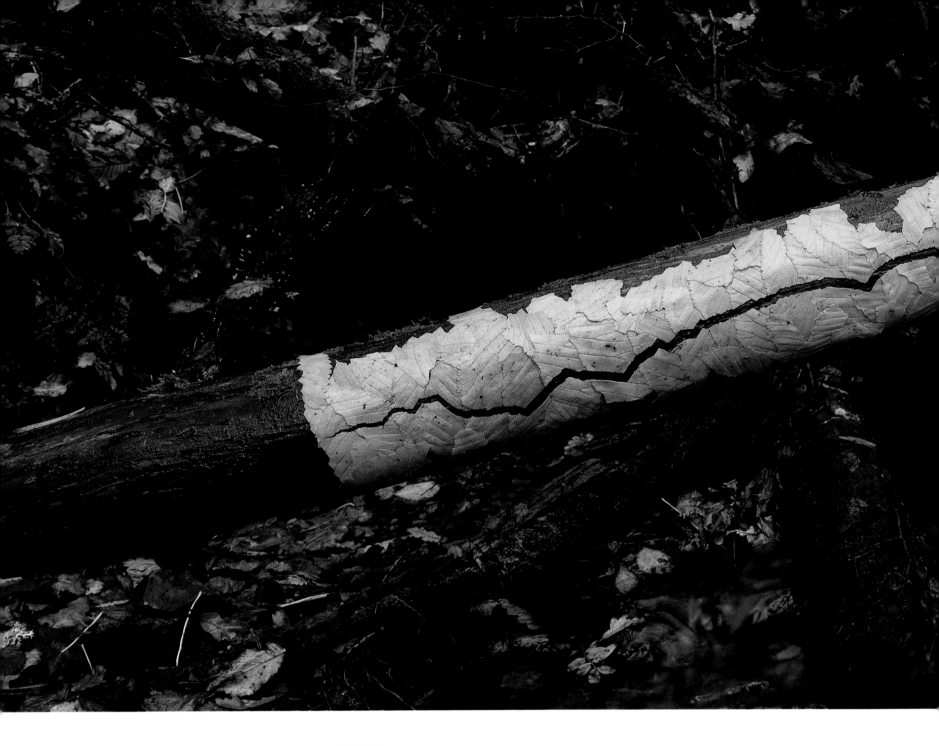

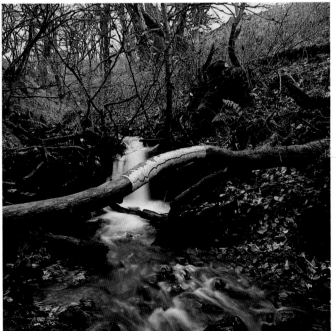

Torn leaf line
held to fallen elm
with water

TOWNHEAD BURN, DUMFRIESSHIRE

15 NOVEMBER 2002

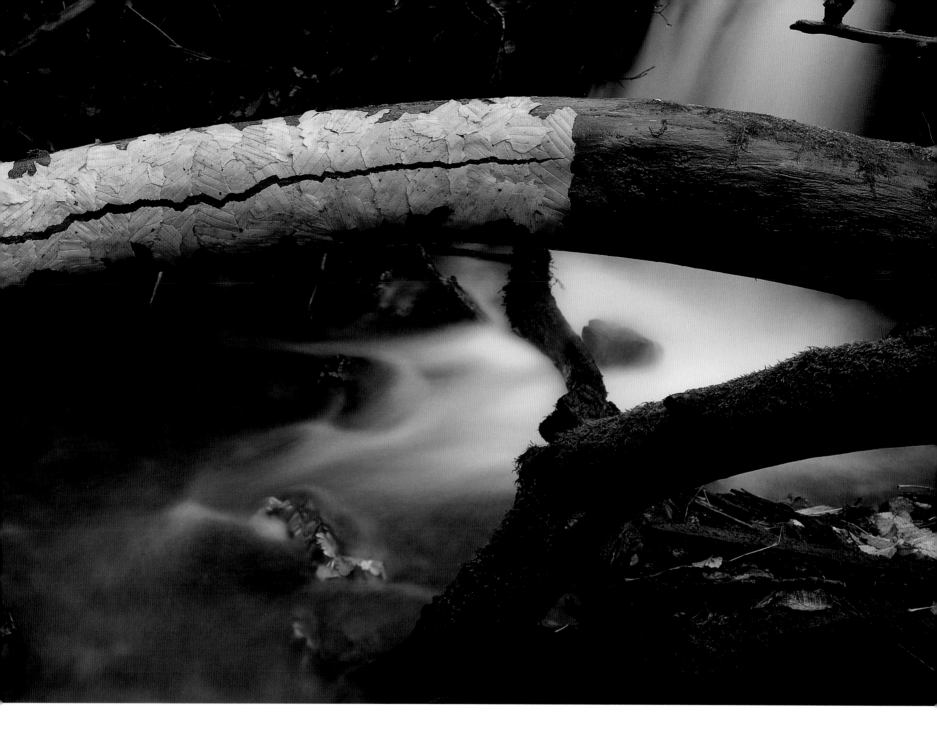

I have to come to terms with the disappearance of yellow. I gathered what yellow leaves there were and made a patch of colour next to the stream. It is a work that I have made many times before, but on this occasion I will return and photograph it as the colour fades. The slow flow of colour will be set alongside the fast-flowing stream.

19 November 2002

Worked again on one of the small waterfalls. Made a small ring out of curved branches, smoothing over the joins with mud so that it appeared to be continuous. I had intended to cover the ring in leaves but liked the sticks as they were.

Perhaps tomorrow I will rework it with leaves.

It was a beautiful cold morning with a touch of frost. Kneading the mud into a workable consistency was cold on the hands.

20 November 2002

Began to rain as I started work. A dark wet cold day. Returned to the ring that I made yesterday. The sticks were still in place and I laid elm leaves over the ring in a gradation of colours – green to yellow to dark brown to yellow and back to green.

I think that this is the first time I have done a colour change work that is cyclical. In some ways it is an obvious thing to do – after all, leaf colour is seasonal and returns annually. With elm, however, the cycle becomes weaker each year.

21 November 2002

Struggled to do something today. Darkly overcast – it never really became day. Messed with leaves around a stone.

22 November 2002

Developed the idea of yesterday's work, using sticks instead of a stone. I first laid down a pathway of bark, supported above the stream by stones, and then placed several sticks end-to-end on top of the bark. The joins between one stick and the next were filled with mud so that there appeared to be a single line.

There were still enough yellow elm leaves to work around the sticks in a gradation from dark to yellow. The glowing halo of colour gave the line a sense of hovering over the stream. I liked the exchange of energy between sticks and leaves, echoing what occurs within the living tree.

The leaves, bark and sticks were elm and whilst not intended as a portrait of an elm tree, it has something of that about it.

23 November 2002

It was wet and overcast at first, but the sky began to clear and the morning and early afternoon turned out to be sunny.

There is a moss-covered stone, which looks once to have been a top stone from a nearby wall. This wall is one of my favourites. It stands alongside the stream in boggy ground – not the best conditions for a wall to be made in, but it has been strongly built and has stood the test of time. Only recently did the end fall off and I suspect that this was due to the rubbings of cattle.

I placed bark around the stone upon which I laid leaves that changed from yellow to black. The yellow was dull under the blue sky but occasional passing clouds gave glimpses of what the colours could become in the right light conditions.

The weather turned as I finished and became overcast. The combination of the sun and clouds and the transition from a clear blue sky to a cloudy one cast a warm light that brought the yellow to life.

The glow lasted for about an hour before it became very dark and began to rain at which point the colour drained away. It was a beautiful hour – perfectly timed – a meeting of material, time, light and place (*see* page 139).

24 November 2002

Sunny. Returned to the stream.

Felt tired today and was not expecting much. Made a small but quite interesting work with two tapered rocks, each of which I worked to a point with mud and placed on either side of the stream with the points almost touching.

I covered the ends of each rock with leaves that changed from yellow to dark. This gave a tremendous energy to the gap between the points.

I have a feeling that I will be able to take the idea further – perhaps in another place. It was a good work, considering how I felt today. One stone was only partially covered with leaves, and I liked the way that the leaves grew out of the stone. This could be developed further in future works.

I finished and photographed the piece but then changed one of the stones. The one that I first used did not feel like a partner to the other. The change resulted in a much better balance between the two stones.

Each day that I walk upstream I come across old works. There is a dialogue between one work and another – a stream of ideas. I love the gathering of works, accumulated over time: an expression of a strong connection to place, which will remain even when all the sculptures have gone.

My work here has reached a peak for the moment; decline will now inevitably follow. I am tempted to say that this will parallel the decline in the yellow leaves. If anything, however, the less yellow I have to work with, the more intense the colour appears. The dark place where I worked today made the small amount of yellow I had so vivid and startling. Many of the works would have been less successful had they been made amongst a mass of fallen yellow leaves.

There will inevitably come a point, however, when the yellow will weaken, as will the work that I do with it.

25 November 2002

Made torn lines through yellow leaves held to a river stone with water. I have made torn lines before, but as with many of these recent works, the proximity of running water has brought a new energy and dimension to the sculptures (*see* page 142).

I now have four works along one small stretch of the stream – stepping-stones. The weather over the past few days seems to have preserved the yellow leaves used in the works so that it appears almost as if they were all made today.

26 November 2002

This is the last work I will make at home for a couple of weeks.

I go to Cumbria later on today to continue the sheepfold project.

I have needed these last few weeks at home, but it has also been a difficult time. Many of the works in the stream appear to be suspended above turbulent water – as if they have struggled to the surface to take a deep breath of air before returning to the water, and to some extent I have felt the same. My art helps makes sense of things.

Today's work was about separation, but the branch upon which it was made remains connected. It was almost dark as I began. There was very little colour to begin with and I worked in the hope that the yellow would strengthen as the day progressed. It was a heavily overcast day and I began to doubt if the yellow would ever come to life. Slowly, however, the yellow began to strengthen and by the time I had finished it was glowing.

It is difficult for me to know what impact the gallery walls in San Francisco have had on the work. I am pleased by how unconcerned I have been

about the exhibition. I do feel, however, that there has been a connection, which has been interesting.

The photograph has always been a way of describing the work and over the past few weeks I have been talking not just to myself but also to a place in America. This confirms what I have always felt – that art is one of the few ways of looking at the world in a very local, personal and individual way which at the same time can communicate internationally.

December 2002

I returned from Cumbria on 30th November and had one day to work before leaving for the States. I went to the river. During my absence there has been heavy rain and the stream has been in spate. The places where I had worked had changed so much that they were beyond recognition. There was no sign of anything that I had made. The two small waterfalls had taken different routes. Both had been diverted to one side of the stream – one by accumulated branches and the other because the high water had ripped away part of the bank.

It was difficult to see where I had worked and to reconcile the new streambed with my memory of the old. In some ways I was shocked and saddened. I had become attached to these places and part of me has also been taken away.

I should not, however, just see the change as something lost but also as something gained. There is a sense of violence in the changes brought by the flood but also a feeling of new possibilities – a potential in the new places where I can now work.

18 November 2003

I miss the continuity I enjoyed this time last year when I was at home for several weeks and was able to follow the change in the elm from green to yellow. This year a few leaves became yellow in late summer, after which the leaves turned brown without ever becoming yellow. It was strange because people talked about how colourful the autumn was after the warm summer – perhaps it was because I have been away for a lot of the time or maybe autumn for the last few years has been defined for me by how strong the yellow has become rather than the orange.

After two weeks away I went to a tree near to where I live that is usually the last to turn. Most of the other trees were past their best and had lost a lot of their leaves. This elm was a vivid yellow with as many leaves as I could wish for. The only problem was that I only had three days at home before leaving again.

I made three works – the best used flat-topped rocks that I placed in the stream before covering them with yellow leaves. The rocks were placed at the same height so that there was a strong sense of a horizontal plane floating above the water. This connected the yellow but at the same time allowed the water to flow between and through the work. The weather was perfect – calm, overcast but with a hazy light.

It was with some sadness that I left the tree last Friday to go to Digne in the south of France where I am working on a long-term project. I managed one

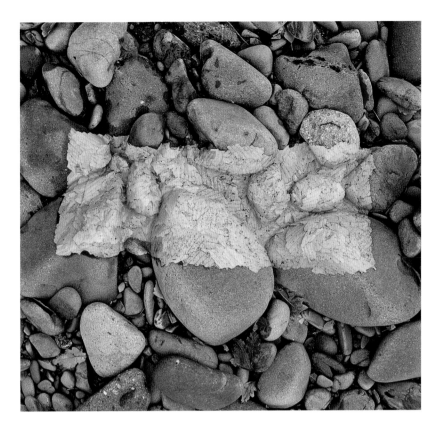

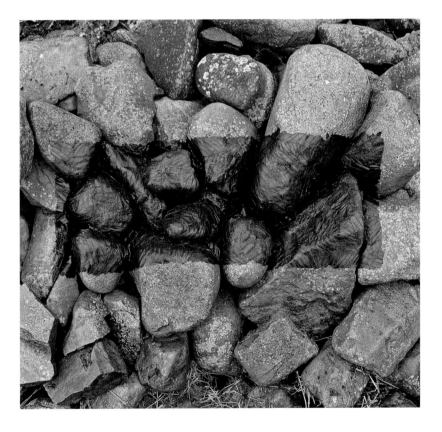

Elm leaves
laid over stones
held with water

PENPONT, DUMFRIESSHIRE
19 NOVEMBER (above) & 11 DECEMBER 2000 (below)

more work during the morning – a torn line through yellow elm on rocks.

I returned on Sunday evening and on Monday morning went to the tree. What a difference! Only a handful of leaves was left on the tree. Before, the yellow has seemed to be draining slowly out of the landscape. This disappearance was more like a sudden death. Within the space of a week the tree had gone from a wonderful full mass of yellow leaves to hardly any.

I collected some yellow leaves off the ground in an attempt to resuscitate the colour. Surprisingly, I found enough to cover a line of connected branches which crossed the stream from bank to bank and momentarily brought the yellow back to life (*see* page 144).

The following day I would not have been able to make this work. There were just a few yellow leaves left and I only managed to make a small and uninteresting work.

February 2004

Now that the yellow has long gone, I have turned my attention to the dead brown leaves lying on the ground.

Leaves remain on the ground for a surprisingly long time after they have been shed. Even now, in mid February, I may still find leaves to work with. I like the rich, dark brown leaves best on a wet day when they are supple to work and their metallic-like surface reflects the light. They are for me evocative of the transition from autumn into winter and the damp, grey short days that are so common at this time of year in Scotland. Their durability seems to be reflected in their ability to cling to surfaces of stone, wood and bark in a way that a fresh leaf would not.

Gradually the leaves become too rotten and fragile to work and my attention shifts to other things. A large elm tree that has stood for several years since it died has recently been brought down by strong winds. Its barkless twisted and curved branches will possibly provide a way of continuing to work with elm.

25 February 2004

Heavy rain at the beginning of this month has filled the burn and the small waterfalls are in full flow. Most waterfalls run over stone, but these are the result of fallen trees and branches, mostly elm. This made it possible to push branches into the mass of interwoven material over which the waterfall flowed.

I joined together curved branches in the form of an oval so that the part that connected the work to the debris behind the waterfall was concealed by the white, fast-flowing water, and the branches were given a feeling of being suspended in front of the waterfall (*see* page 145).

The heavy rain was followed by a long period of dry, cold weather, and the burn has shrunk to summer-like levels.

Yesterday I decided finally to work with the recently fallen elm tree. I have felt cautious about using it. The sinuous curved branches are so extraordinary that I was afraid that I might not make the most of them. I

often find an idea by working with a material. The problem is that by the time the idea is found the materials are sometimes so changed that the idea can no longer be realised. Some places and materials offer one chance only – as when I am working on freshly fallen snow.

There was something of this quality about the tree. I felt that there was so much potential within it to make a good work. I pass by the tree most days and I looked often at it hoping that something would come to mind. I could not wait much longer – the tree had fallen into a field and it would be only a matter of time before the farmer cleared it away.

I had decided to make a line of branches incorporated into a wall that I would build alongside the burn when I realised that the low water offered the possibility of making the wall across the burn like a dam. This was far more interesting. Not only did the line connect one bank to another, it meant that the dammed burn will at some point cause the wall to collapse with all sorts of potentially interesting happenings along the way.

This was a good work made on a bitterly cold day. The stones came from the burn itself as well as a heap dumped down the banking by farmers when the field was stone picked. These stones would have previously become walls (there is one nearby). It seems right to use them to make another wall. The incorporation of elm branches is also appropriate for a burn with many other dams also caused by branches.

26 February 2004

I returned early this morning to see the dam. Leaves are already gathering against the upstream side of the wall, causing the water to rise.

It looked well in the diffused light of an overcast sky – the sunlight of yesterday was too dramatic and confusing. The overnight cold had freeze-dried the mud that I had used to fill the join between one branch and another. Yesterday the mud was dark and stood out against the light dry wood. Today it was hardly visible. I am pleased that a work so connected to water should at this stage be so dry. The stone, burn and wood will be very much changed by the rain that inevitably will come. I don't know what will happen but look forward to whatever changes ocurr.

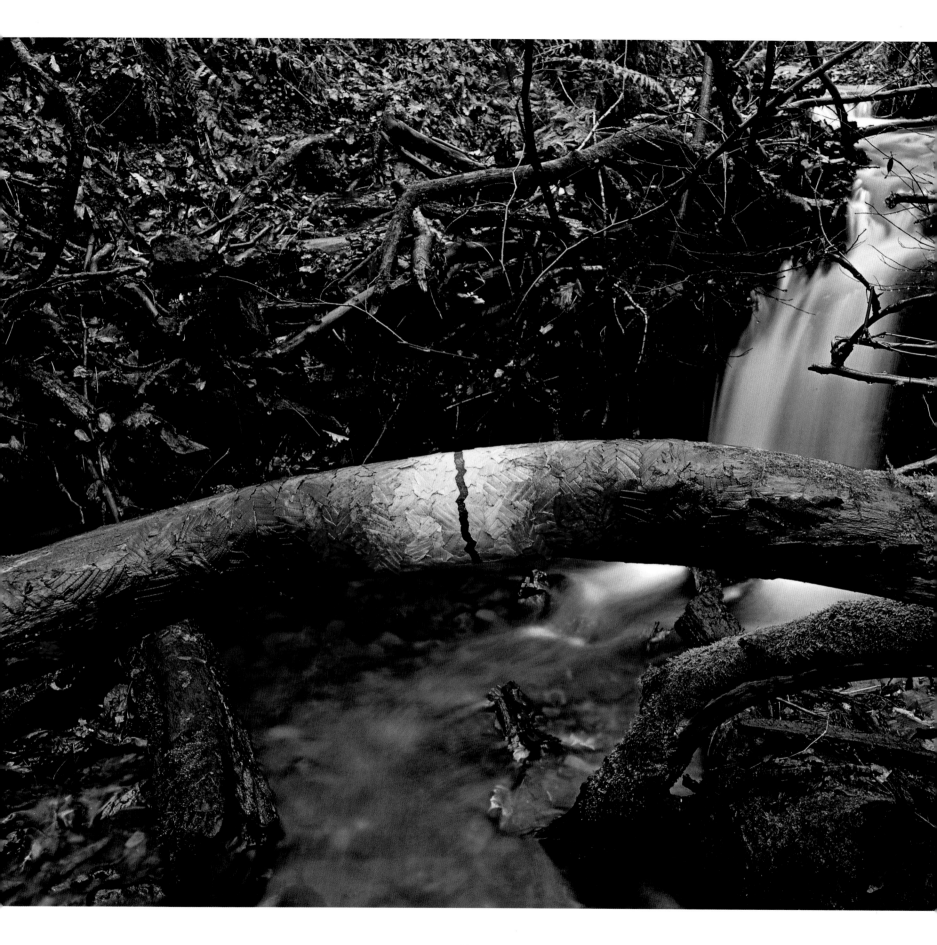

Leaf line

torn over dead elm tree

TOWNHEAD BURN, DUMFRIESSHIRE

26 NOVEMBER 2003

Last yellow leaves of autumn
wrapped around branches
held with water
laid in a line
windy
turning brown over the following two weeks

CAPENOCH, DUMFRIESSHIRE
17 NOVEMBER 2000

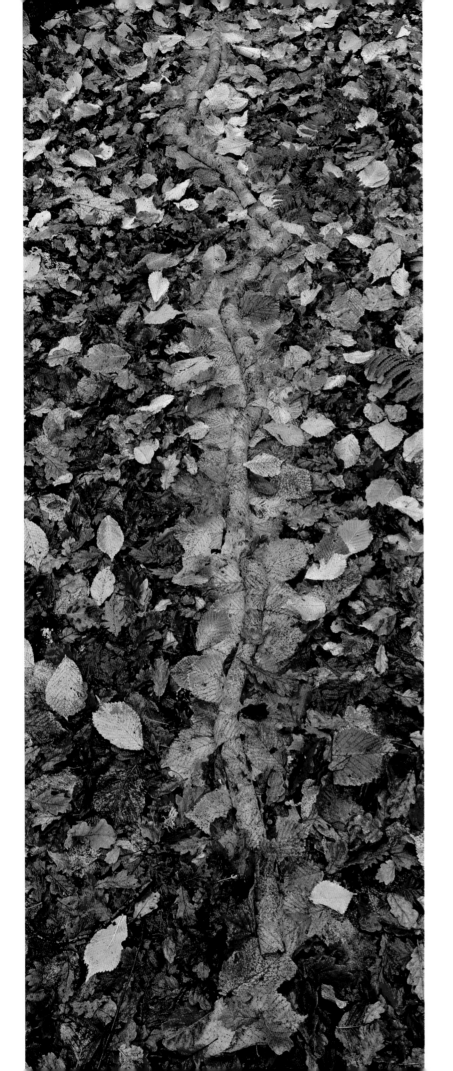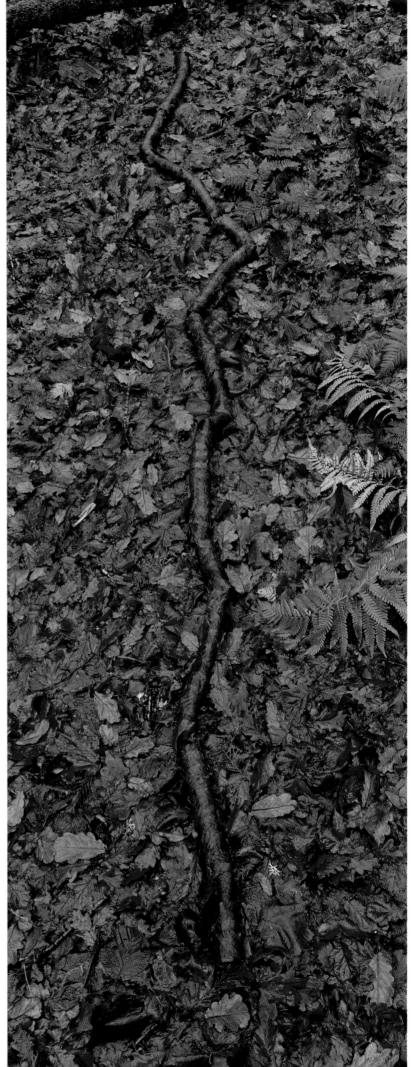

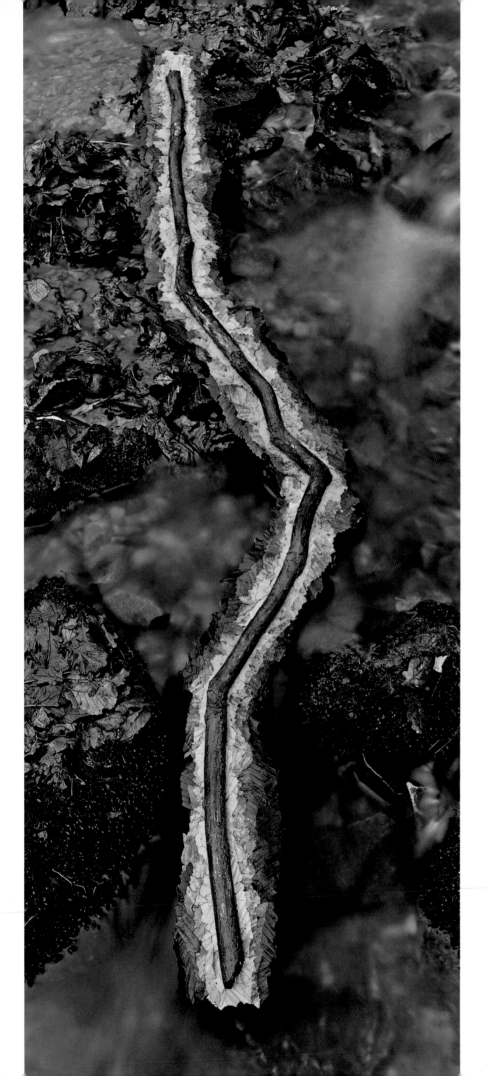

Elm sticks
laid on elm leaves
held above the stream
by elm bark

TOWNHEAD BURN, DUMFRIESSHIRE
22 NOVEMBER 2002

Opposite

Moss covered rock
laid round with elm bark
covered with elm leaves

TOWNHEAD BURN, DUMFRIESSHIRE
23 NOVEMBER 2002

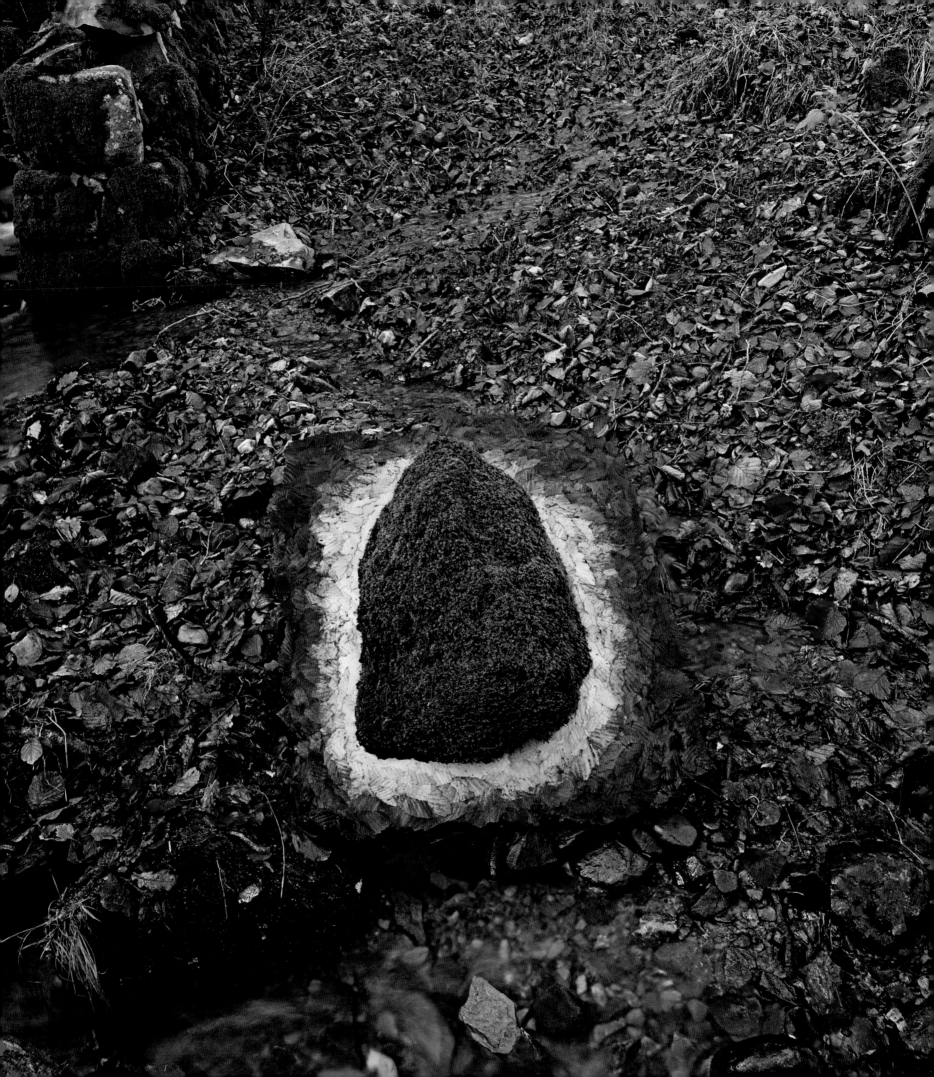

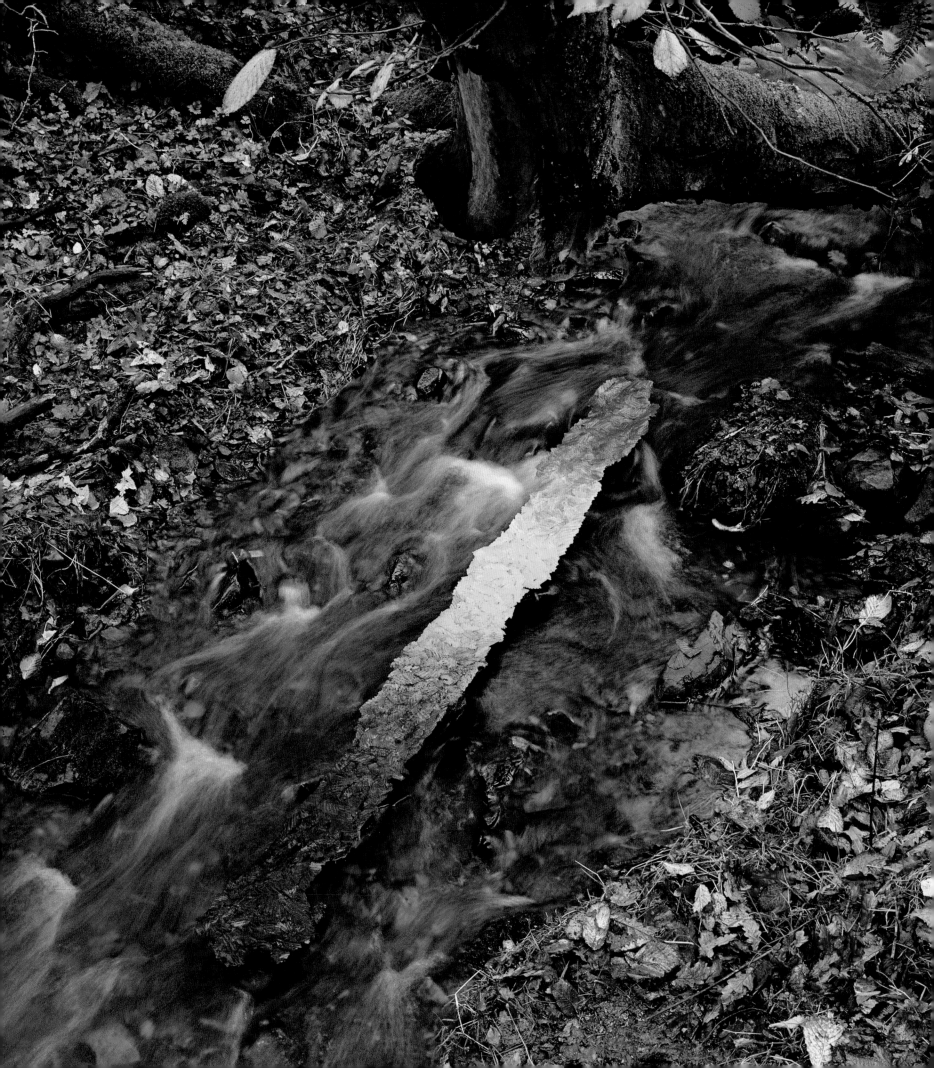

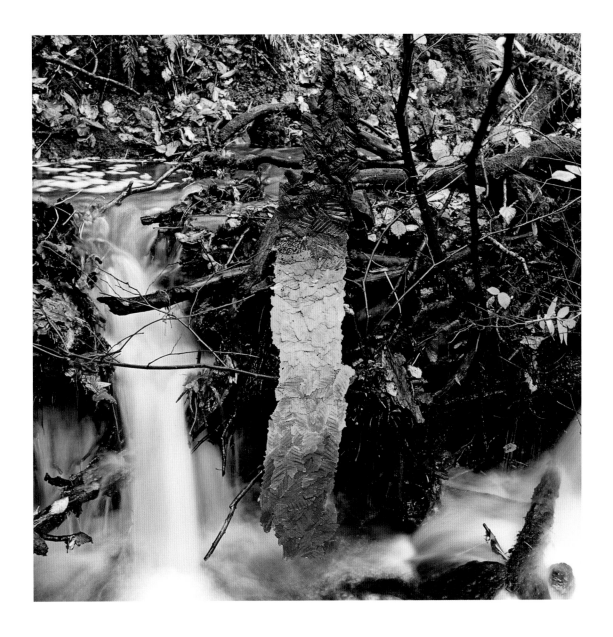

Elm leaves laid on bark

from dead elm tree

TOWNHEAD BURN, DUMFRIESSHIRE

8 NOVEMBER 2002

Opposite

Elm leaves

laid on elm bark

becoming covered

with fallen leaves

TOWNHEAD BURN, DUMFRIESSHIRE

9 NOVEMBER 2002

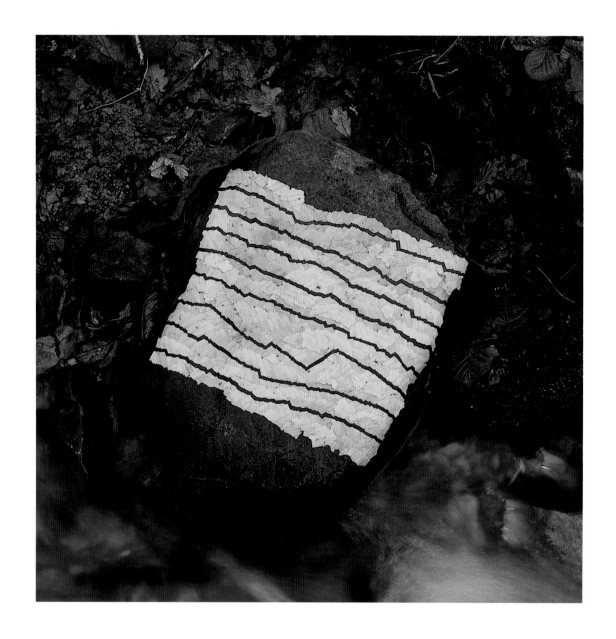

Torn lines
through elm leaves
held to stone with water

TOWNHEAD BURN, DUMFRIESSHIRE
25 NOVEMBER 2002

Opposite

Elm bark
covered with leaves
supported by stones
over a waterfall

TOWNHEAD BURN, DUMFRIESSHIRE
10 NOVEMBER 2002

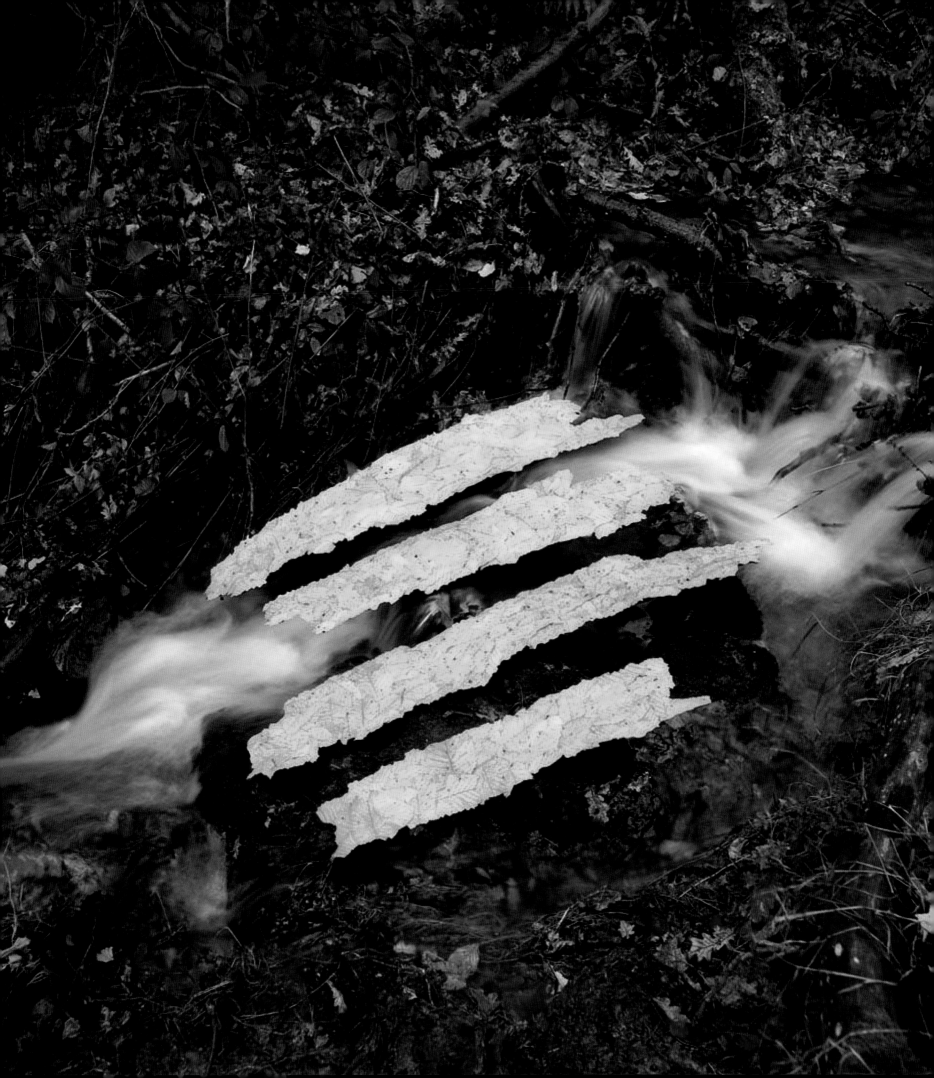

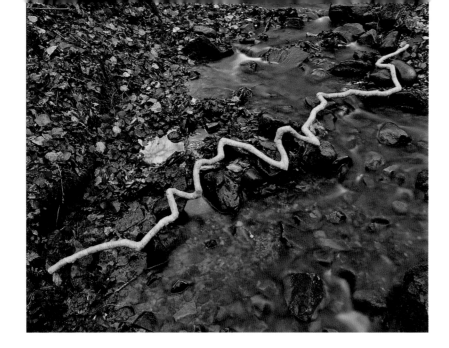

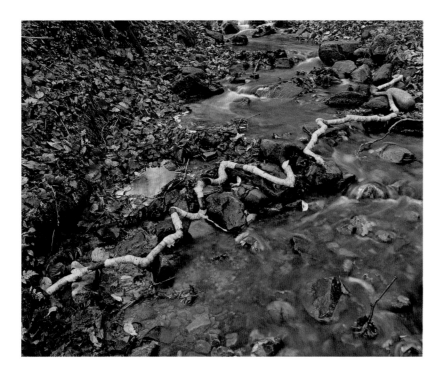

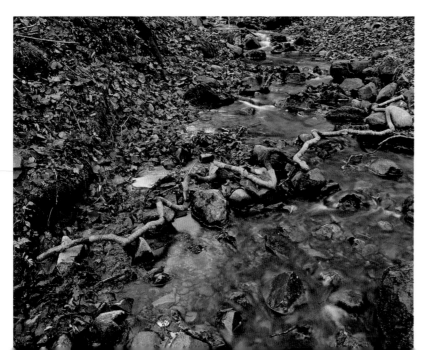

Elm sticks
wrapped in elm leaves
laid in a line
crossing the burn

TOWNHEAD BURN, DUMFRIESSHIRE

NOVEMBER 2003

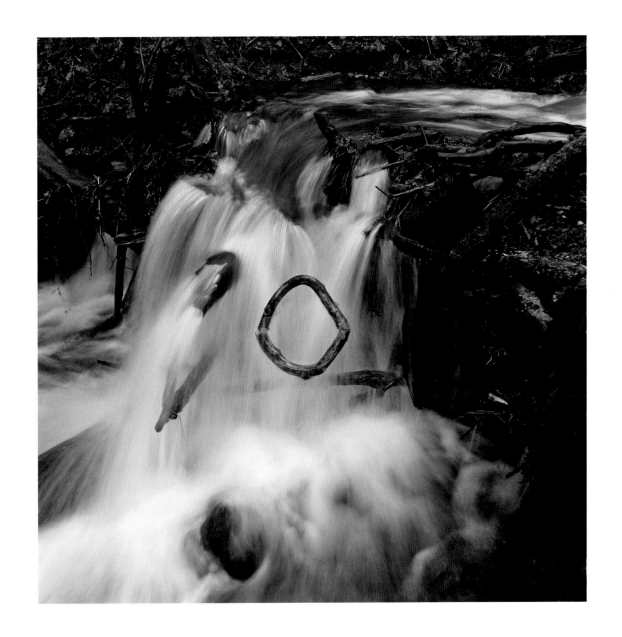

Two curved elm branches

supported by sticks

pushed into debris

damming the burn

behind the waterfall

TOWNHEAD BURN, DUMFRIESSHIRE

FEBRUARY 2004

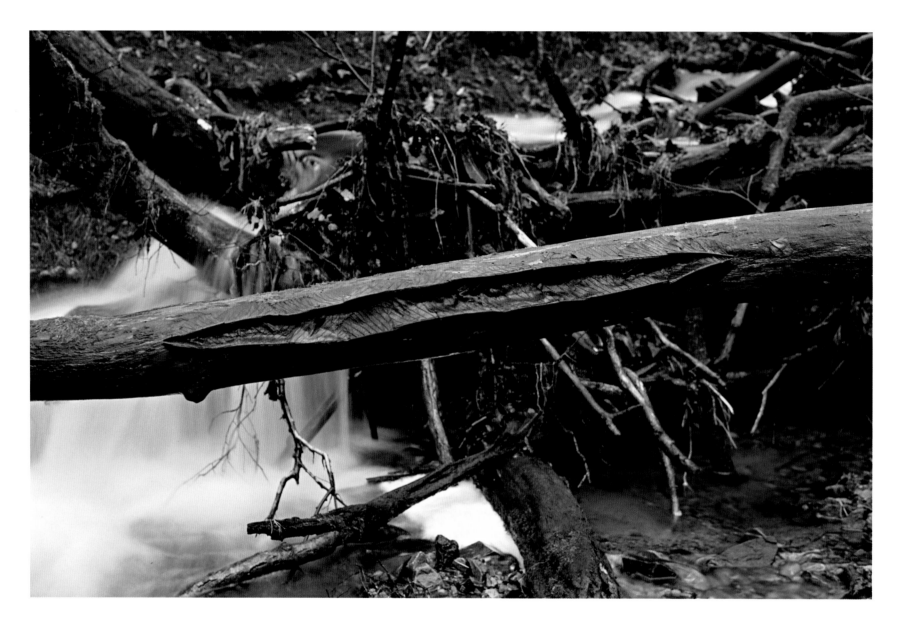

Elm leaves
creased along the central vein
held to a branch with water

TOWNHEAD BURN, DUMFRIESSHIRE

24 DECEMBER 2002

Opposite

Elm bark
supported from behind
with a pointed stick
holding the bark above the water

TOWNHEAD BURN, DUMFRIESSHIRE

JANUARY 2004

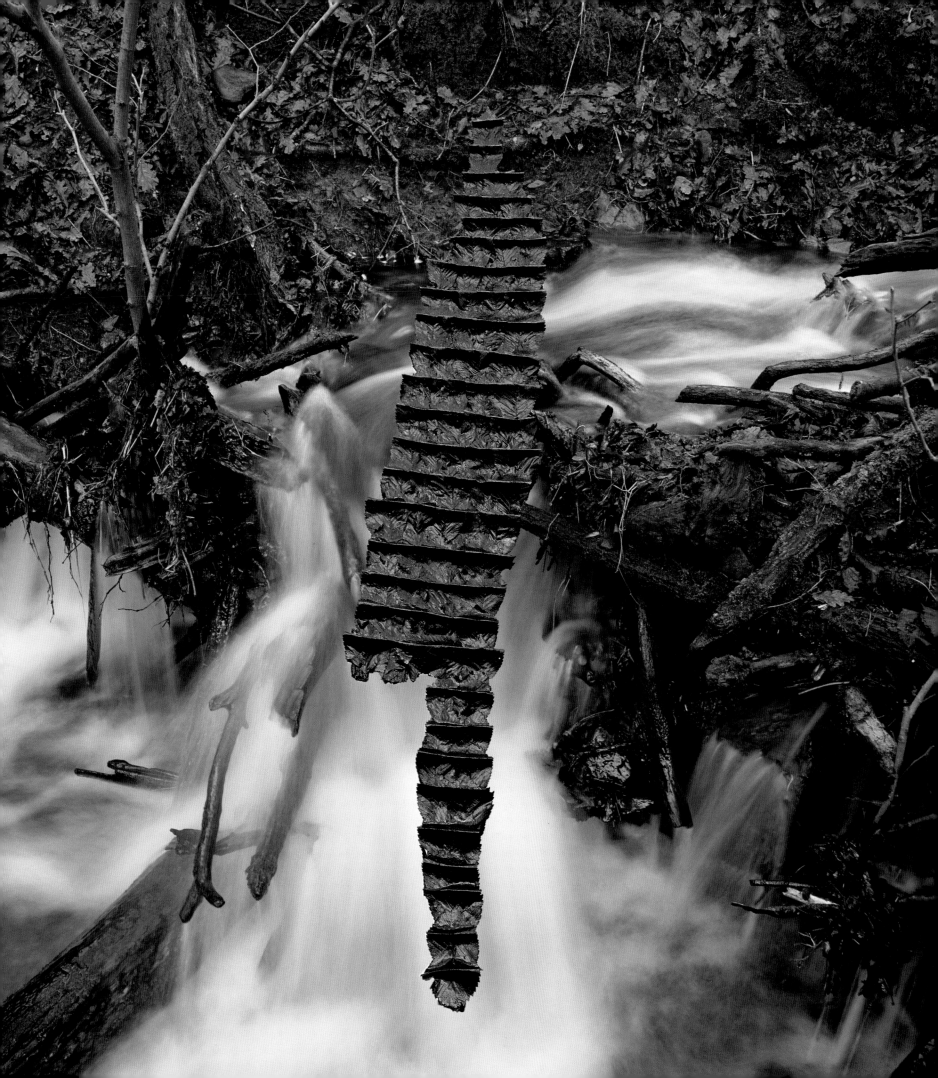

Above
Branches collected from a fallen dead elm near the burn.

Elm branches
worked into a ball
laid in a wall
made across the burn

TOWNHEAD BURN, DUMFRIESSHIRE
19 APRIL 2004

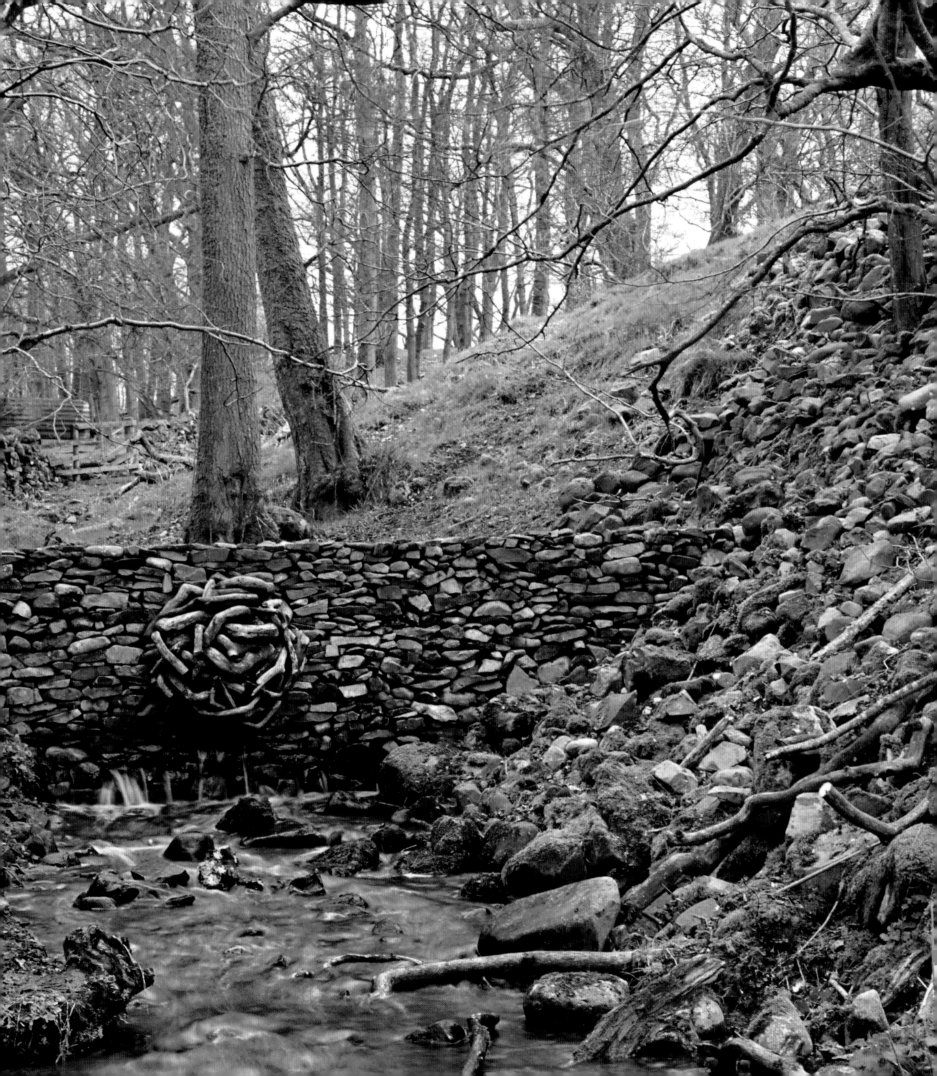

Elm branches
worked into a wall
spanning the burn
made over two days

TOWNHEAD BURN, DUMFRIESSHIRE

FEBRUARY 2004

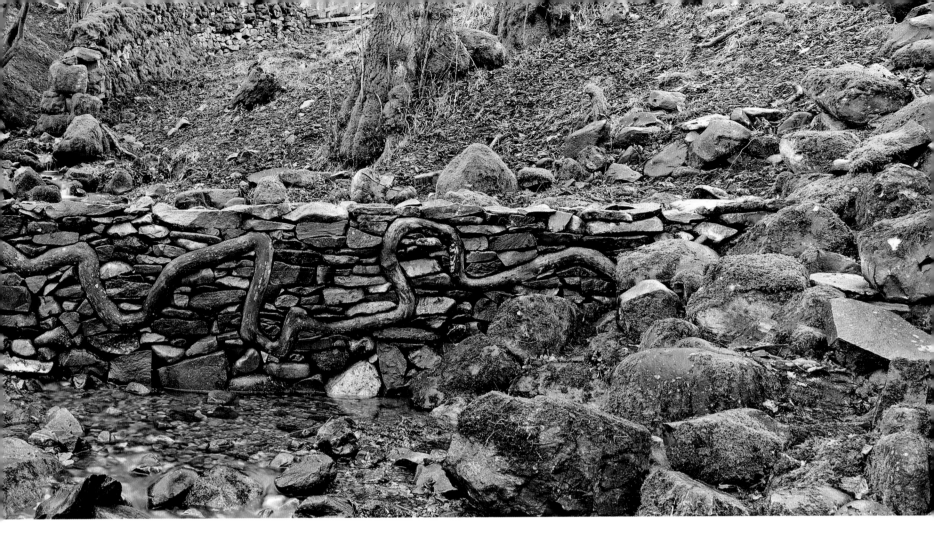

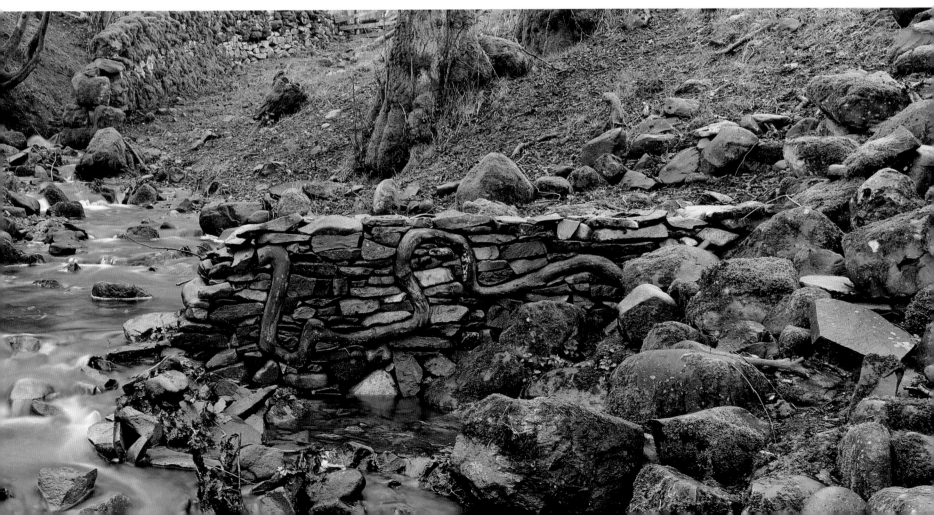

NIGHT PATH

To create *Moonlit Path*, Andy Goldsworthy first pulverised white chalk from the Sussex Downs and then used it to lay out a winding trail through an ancient wood in Petworth Park on the Leconfield Estate in West Sussex. Even on the darkest night, the dazzling white path is luminescent enough to guide the visitor on a gentle, hour-long ramble through the woods. But, since the path will be open to the public only on the three nights of the month around the full moon, Goldsworthy intends it to be seen when its pale radiance is augmented by unearthly light from above.

You reach the entrance to the path long after dark, of course, and admittances to the wood are timed so that the already apprehensive visitor sets off alone and in silence. This is an important part of the experience. As you walk through the woods guided by the shining path in front of you, the softest sounds become intensified. By this hour, even the hum of distant traffic has died down. The crack of a twig, fronds or branches brushing against your side, invisible footfalls in front or behind you: each is heard with a clarity that would be lost in the daytime.

On a clear night, milky light flooding a forest clearing becomes confused in your mind with the artificial 'moonlight' at your feet. At the same time, the world has become infinitely strange, a place drained of colour, reduced to tones of light and dark. Like animals, the longer we stay in the wood, the more acute our sense of sight becomes.

To see a landscape by moonlight is rare in an age of sodium street lamps and brightly lit houses. At its simplest level, Goldsworthy's project connects us with something elemental in ourselves, some instinctive fear of the night and awe of the moon, worshipped by the ancients in the form of Hecate or Diana.

But, if *Moonlit Path* is a landscape, it is also a metaphor. For Goldsworthy lays out his path in such a way that it constantly twists and turns, taking you up hillocks and down hollows, never for an instant allowing you to rest. At times, your path looks clear and straight and easy, with the real moon at your back, shedding light on the way ahead. At other moments, the trees close over your head, and the path you are following becomes almost invisible. Now you have to trust your instinct and find courage to continue on in the darkness until you find your way – and the comforting light – again. In short, the path is like life itself. Inseparable from its beauty is its ephemeral nature; since it won't last for ever, and most people will walk it only once, its value to us is connected with a sense of loss.

Moonlit Path is one of the most original and poetic works Goldsworthy has ever made, and yet it is very much connected to the art of the past. J.M. Whistler and Debussy would have recognised at once that it is, in essence, a nocturne. Even stronger are its links with Eastern art. Many times during the walk, I was reminded of the Japanese artist Yoshitoshi's series of woodblock prints, *One Hundred Aspects of the Moon*. And, in both Japanese and Chinese culture, to witness the ephemeral manifestation of the full moon is considered a refined aesthetic pleasure, celebrated with parties and fesitivities.

What's more, *Moonlit Path* is constantly changing. No two people will experience it in the same way. I saw it at the end of June, when the woods looked as lush and romantic as a set for *A Midsummer Night's Dream*. But I can imagine that in the autumn, as the leaves turn colour and cover the ground underfoot, the atmosphere will be one of contemplation and nostalgia. In the depths of winter, the ghostly path snaking through leafless trees will have a fairytale feel, like a scene from *Hansel and Gretel*. Sadly *Moonlit Path* will be open to the public only until May 2003, which means that relatively few people will ever see it. Those who do will never forget the experience.

Richard Dorment

from a review first published in *The Daily Telegraph*, 10 July 2002

PETWORTH PARK, SUSSEX

When I first worked at night, over seventeen years ago, it was in order to take advantage of the lower temperatures that allowed me to make ice works more easily. Since then, I have made many works, sometimes under moonlight, at other times in complete darkness or during dusk or dawn. Inevitably I became interested in night itself and began to make works for and about night – not just with ice but also with snow, leaves, sand, stone and chalk.

A place is so different at night – it is like being somewhere else. Perception, feeling and senses are changed by darkness. A different range of emotions and senses is released. We have a fear of the dark – it is unnerving. At first I felt strange being out and alone in the dark in a wood or on a mountain, but now I feel a sense of protection from the cover of darkness. I want to understand, explore and use the responses and feelings provoked by night.

By day we are spectators but at night we are enveloped by the dark – the division between ourselves and place becomes obscure. Form becomes less defined. The experience is more introspective.

19 February 2002

The laying of the path has started and it looks more or less as I had anticipated. I am beginning to get some feeling for the wood through which it will travel. I originally thought I would draw it out completely but have decided to see how one part looks before adding another.

The majority of the wood is oak and is well kept, with evenly spaced trees and little wood floor debris. The quiet calmness of this part of the path has affected its layout which is far simpler than I originally thought it might be.

It is a relief that the path is calm, whilst all the practical problems of its construction are resolved.

The weather has been relatively dry which is an enormous help.

I often start projects not knowing what I am doing. I sometimes envy artists who spend their lives working with one kind of material and know exactly how that material should be worked. It might save me from the first difficult few days of every project that I embark upon. If I knew what I was doing, however, it would not be so interesting.

I have to start with a strong idea but with an open mind about how best that idea can be realised.

22 February 2002

There is a difference between chalk in lumps and chalk as powder. I had intended to finish the path off with powder to give it a flat, trodden-earth feel. Now I am not so sure. The powder seems to be grey in comparison to the lumps. I don't understand why – it is, after all, the same material. Perhaps it is something to do with the way in which the powder reacts with water and light.

Sometimes the path appears white and at other times grey. Working with chalk is also working with the weather. The ever-changing, fleeting qualities of the white give it tension. If it were always white it would be like emulsion on a wall. This white is alive with variation which in turn gives life to the sculpture.

4 March 2002

Returned after a break. The path has continued under the direction of my assistant Eric Sawden. I was too tired to take it all in. Returning to works in progress is always tense. I was struck by how dull the white was compared with when I left. At that time the wood floor was wet and dark after rain, which made the chalk whiter by contrast. The chalk also appears white when wet but when it is only damp, it goes grey. When completely dry it turns white again.

Today the white was at its worst. The chalk is damp and dull. The surrounding wood-floor vegetation of leaves and bracken has dried pale, which lessens the contrast between wood and chalk.

7 March 2002

The chalk, although damp, is beginning to dry out, and today the path looked brighter. It was sunny and warm. A few bits of chalk had dried out completely and were brilliant white – a glimpse of what is to come?

There are many degrees of white in chalk. The path will, to an extent, always be perceived as white, but there will be rare moments when the white will be brilliant. Chalk responds to weather, light and the colour of the sky. The weather gives life to the path and as with anything alive there are times when the path is awake and times when it sleeps.

There will possibly be only a few times when the path is completely dry, and, should this occur on a clear night with a full moon the result could be intense. This is not to say that the work should not be seen in other lights and weathers – far from it – just that the viewer has to see the sculpture not as a fixed object but as the elusive and unpredictable product of season, light, atmosphere and weather.

Variation and change give the sculpture a tension and energy that would be absent were it made from a synthetic, weatherproof and always brilliant white material.

Although I have talked of this work as *Moonlit Path*, which alludes to the element of chance involved in its viewing, it is not intended to be seen exclusively by moonlight, and a better name is probably *Night Path*. It may be that the path will be at its best on a clear dark moonless night, or under a full moon filtered through a heavily overcast sky.

17 March 2002

Walked the path at night for the first time. It was good to do this now when a large part of it has been completed. I began at dusk and there was no moon. The wood became less defined as darkness fell – the path a faint glow of white with blurred edges. It was beautiful.

During the day there are people working on site. At best the path should be walked alone. There is a sense of floating through the wood. My entering the dark pine woods was accompanied by the hooting of an owl.

Night Path
laid chalk path
approximately three kilometres long

PETWORTH, SUSSEX
APRIL 2002

24 March 2002

Walked and photographed the path over the last two nights. It will be so different when I come next time and there are leaves on the trees. I have been given some indication of what may happen. In the darkest part it was difficult to see the path at all; it had been more visible when there was no moon. The dark shadows cast by the moon engulfed the path in a way that I did not expect. The upside of this is the path's intensity where the moon shines directly upon it.

What is certain is that the path will change far more dramatically throughout the year than I had realised, which is interesting. The work should be experienced several times in the course of a year to be fully appreciated.

25 May 2002

Returned to photograph the path. There is a full moon tonight. It was a shock to see how green the path has become – especially in the denser parts of the wood. The recent wet weather has caused this change. The path remains white in the more open areas so I assume that the trees have contributed to the discoloration by preventing the sun from drying it out. It could also be due to pollen deposits from trees and plants.

I always anticipated that the path would need maintaining. It would now seem that this will mean relaying a thin layer of chalk on the path from time to time. The path will be maintained in this way for one year after which it will rapidly fade away.

27 May 2002

After waiting for two cold nights of overcast skies, rain and strong winds, last night was beautiful, calm and not too cold.

I concentrated on photographing the part of the path that runs into Petworth Park. The deer were barking and, strangely, birds were singing. It was an extraordinary atmosphere. The path at this point overlooks the park. To the East the moon caused dark shadows to be cast from the trees.

Around 2.00 am mist slowly rose in the park until it reached the place where I was standing.

I walked the path inside the wood. Despite the discoloration it still holds up. So different to how I had imagined. I had always been concerned that the moonlight path could be a too romantic. Walking it last night was anything but. The sculpture has become a far darker piece, in all senses of the word. It is intensely unnerving. I felt twinges of fear even though I have worked in woods at night many times. The path makes the surroundings seem distant and disturbing.

Surprisingly very little moonlight penetrates to the wood floor which feels like a black sea flowing around the path. To step off is to step into the unknown. The faint white path feels suspended above the black.

The white changes dramatically, depending upon which part of the wood is being walked and the orientation of the moon. Generally the path is brighter with the moon at your back. If you walk towards the moon, the path almost disappears. When the path is at its most indistinct ahead of you, if you turn around you will see it at its brightest.

In the pine plantation, the path almost disappears completely so that you are forced to feel, not see, your way along. The result is a demanding and disturbing experience, not for the faint-hearted.

All sense of direction is lost. Even I felt a stranger in the wood. There is little indication of how far you have come and how much distance there remains to cover. The path takes on an endless quality. There will be some who wish they had not embarked upon the walk and as they find themselves going deeper and deeper into the wood. I wonder how many will turn back!

Shafts of moonlight spotlight leaves, branches and tree trunks, making them stand out with a brilliant intensity. Occasionally a pool of light falls upon the path. Each touch of light is different – some are so slight and delicate. One shaft created a hole of light through which the path passed in the black wood – beautiful.

12 June 2002

I have installed several chalk sculptures in the gallery at Pallant House in nearby Chichester, where I am having an exhibition.

The stones are from the same quarry at Duncton as the chalk for the path but instead of being fresh and white, they are old, dark and weathered. It is difficult to believe that it is the same stone. There is sometimes flint embedded in the chalk. It is interesting that something so hard should be contained in such soft material. I used shards of flint to etch into the stones, revealing the white below the surface.

The shapes that I have cut are quiet and formal – rectangles and circles. I see these drawings as landscapes and the rectangles relate to the ploughed fields edged white where the chalk has been brought to the surface. I like the way the underlying geology of both stone and landscape cause both field and drawing to appear to float above the surface.

Most of the stones have been placed in fireplaces. Pallant House is a difficult space, and I have chosen the hearths because they are empty and no longer used in the house. The smoke from coal fires has in the past contributed to the blackening of stone whether in a building or in the landscape.

22 June 2002

The moonlit path opened last night. For a short time it rained, but for the most part the weather stayed dry. It was overcast which, if anything, made the path stronger. The recoating with a layer of chalk has brought it back to life. A large group of students helped Leconfield workers to first clean then lay the path. It is more that an act of maintenance – the care and attention the path needs is also a form of nourishment that gives energy to the sculpture.

I understand the difference between a lifeless and a living sculpture because of my ephemeral work. The same red leaf can range from dull to brilliant, depending upon how it is worked, placed and seen. My role is often to draw out the red and in the process to understand the nature of red. It has been the same at Sussex with the white chalk.

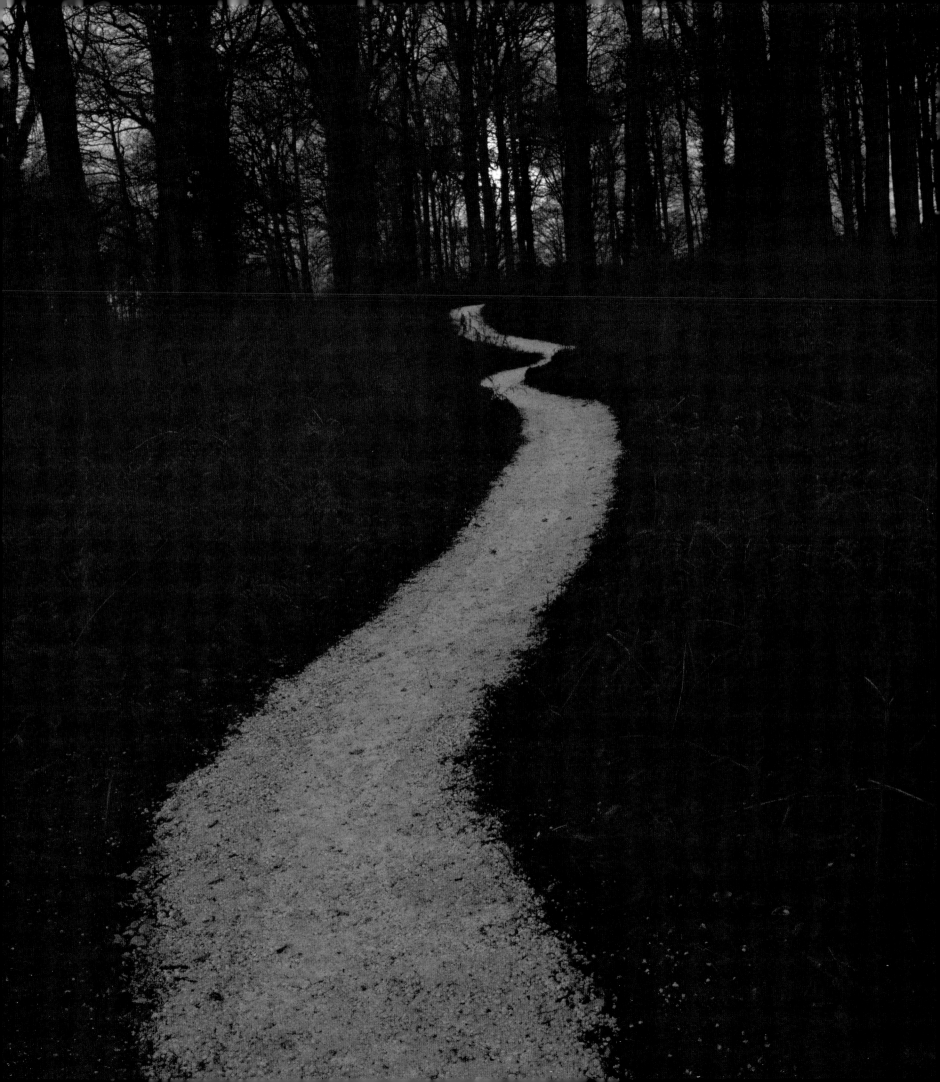

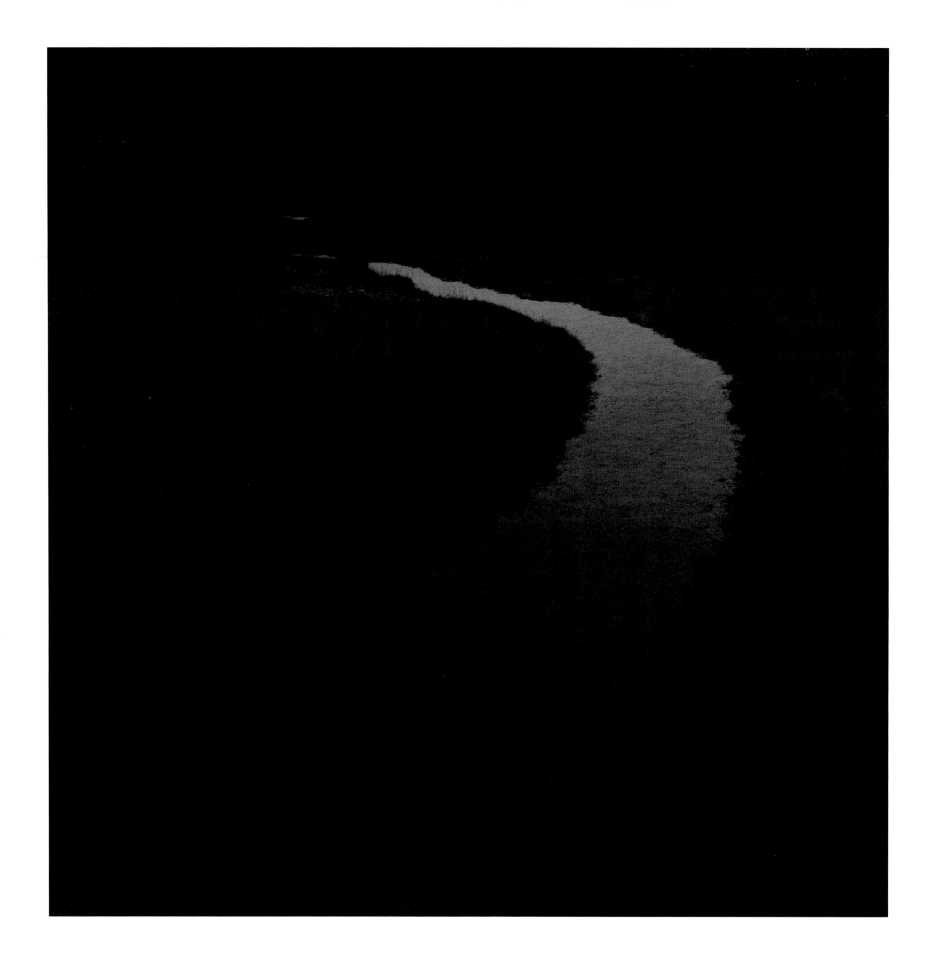

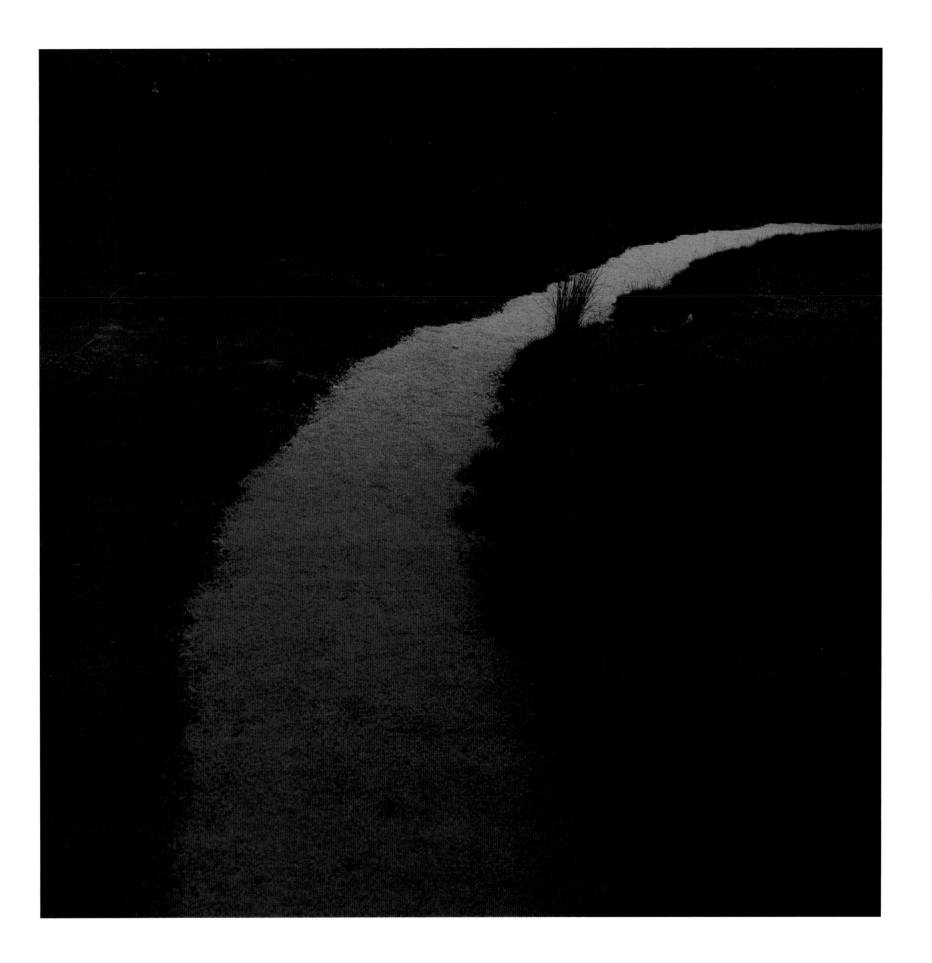

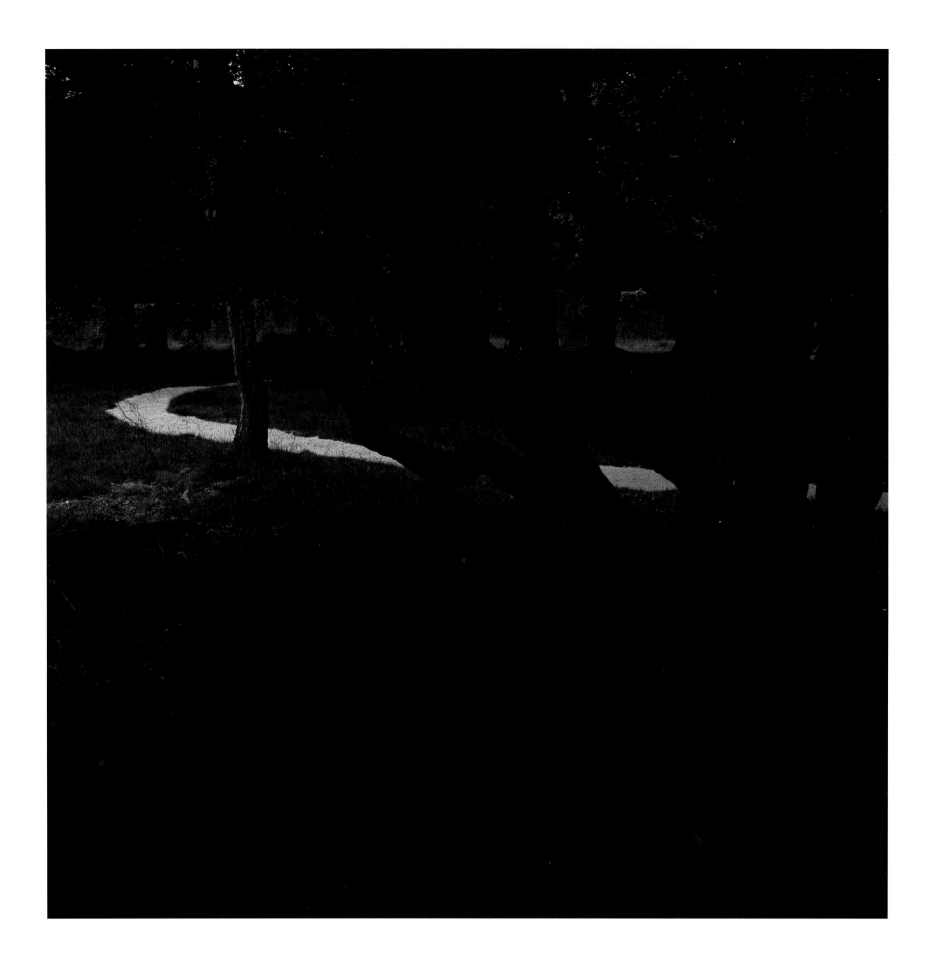

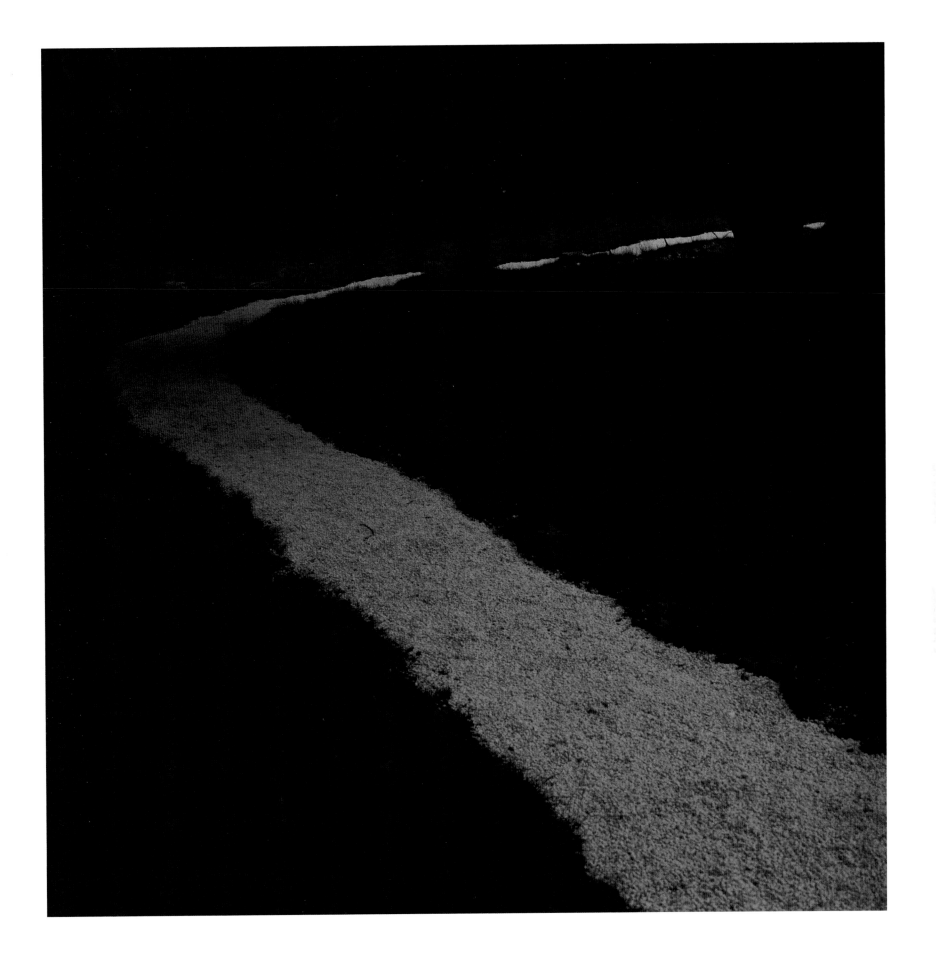

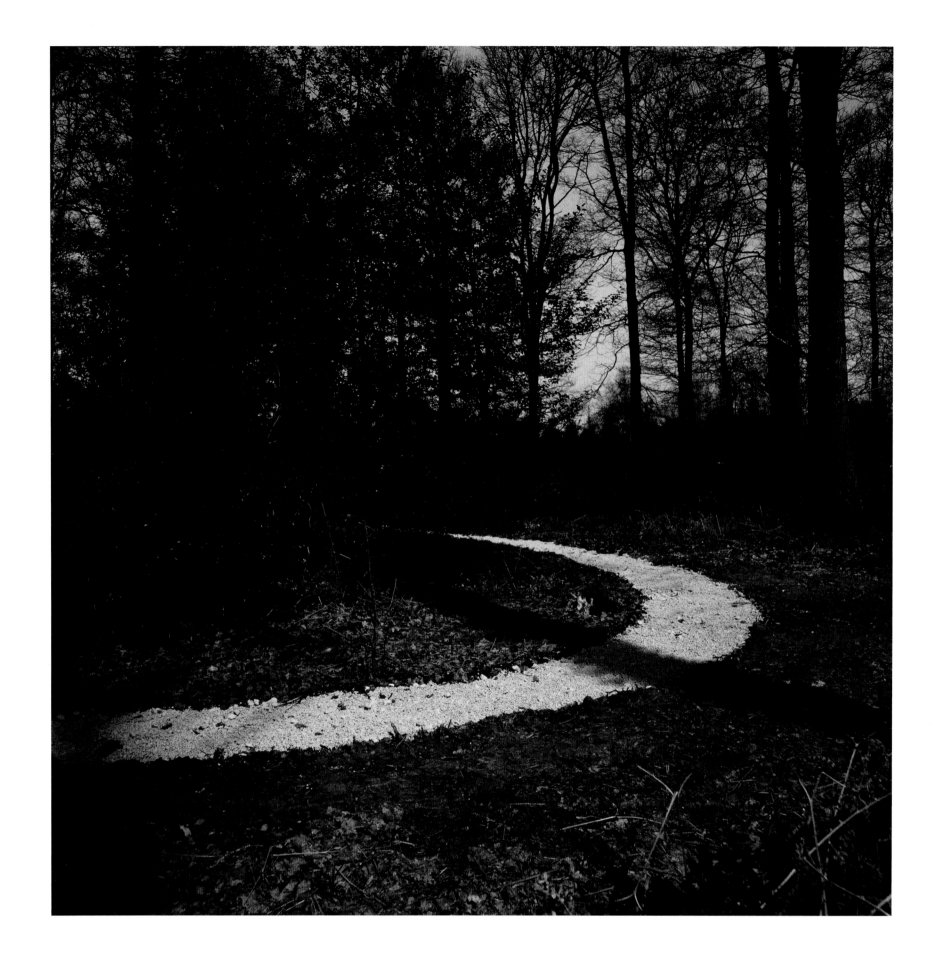

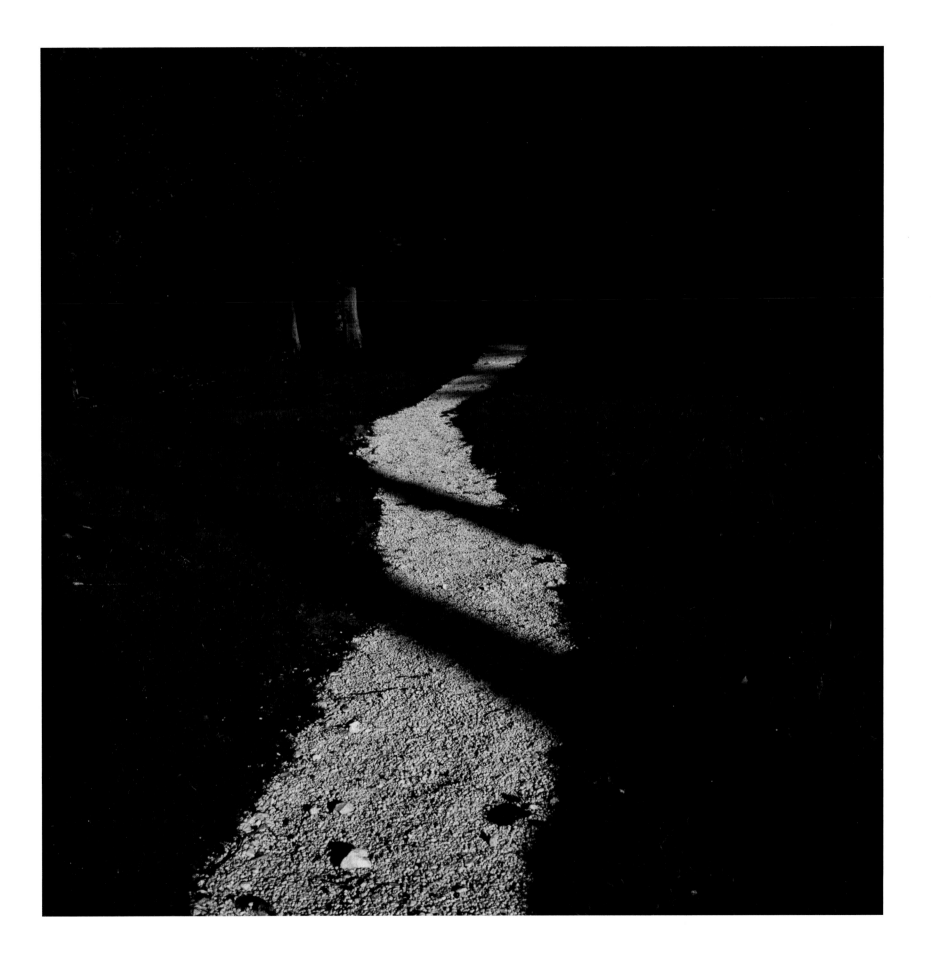

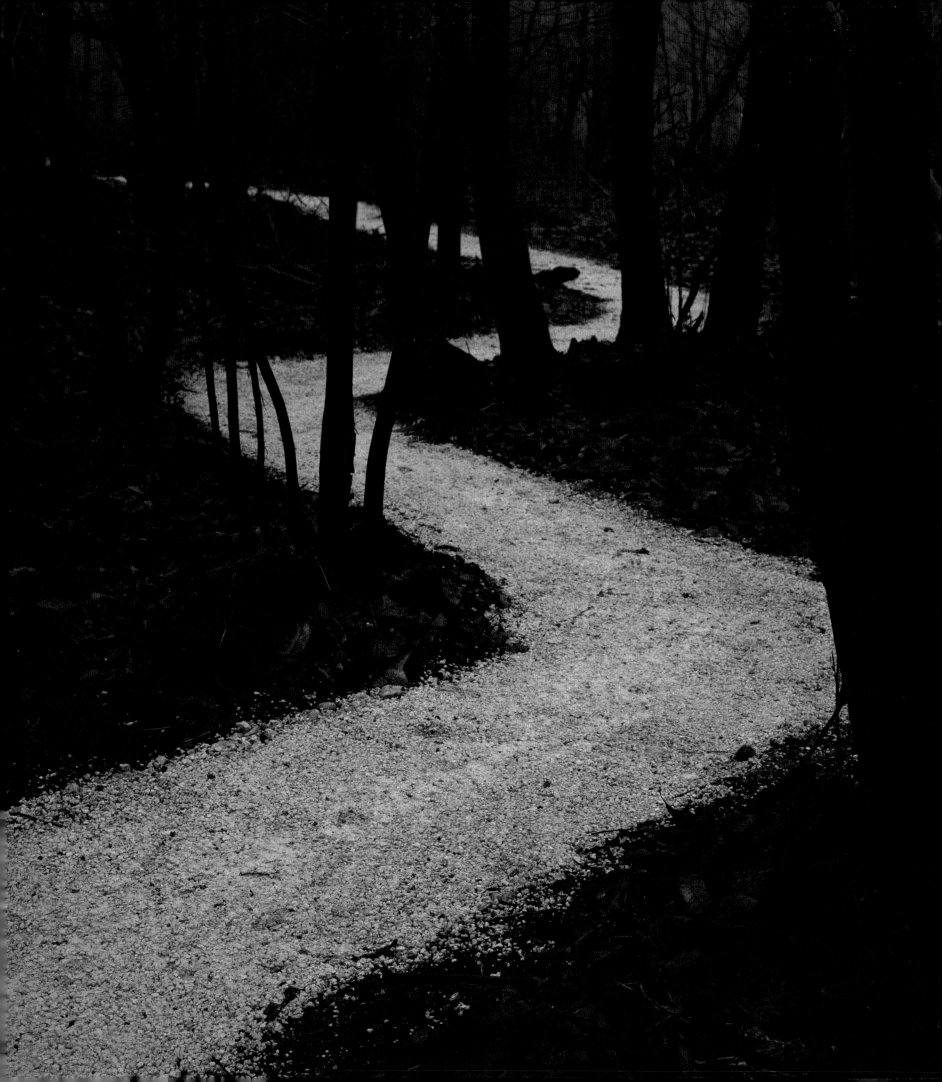

Acknowledgements

I am grateful to Eric Sawden and Jacob Ehrenberg who have done a great job organising projects in the UK and the United States.

Large-scale projects are carried out with the support of many people in both their installation and their administration. In addition to the galleries that represent me, I would like to thank the following:

PENPONT CAIRN
Dumfriesshire
Stone supplied by Locharbriggs Sandstone
Excavator driver: Glen Davidson
Machines supplied by Lloyds Tractors
Stone transported to site by Walter Marchbank
Assisted by Andrew McKinna

GARDEN OF STONES
Museum of Jewish Heritage, New York
Museum staff: David G. Marwell, Ivy L. Barsky, Rina Goldberg, Abby Spilka
Public Art Fund: Susan K. Freedman, Tom Eccles, Richard Griggs, Anne Wehr
New York City Council: Robert M. Morgenthau
F.J Sciame: Paul Haydon, Montalee Hastanan
Forest City Ratner Co.: Eileen Weingarten
Cornell University: Gerri Jones, Tom Whitlow, Karen Edelstein, Miriam Pinkser

Joel and Sherry Mallin, Peter Del Tredici, Kevin Roche, Simon Schama, Porus Olpadwala, Inge Oppenheimer

Also: Ed Monti, Mary Sabbatino, Mark Hughes, Sue Wagstaff

Planters of trees: Ilana Abramovitch, Alison Anziska, Seth Anziska, Ivy Barsky, Jerry Bergson, Simon Bergson, Heather Bernstein, Bronia Brandman, Lou Bravmann, Elyse and Howard Butnick, Frank Camporeale, Tom Eccles, Elizabeth Edelstein, Jacob Ehrenberg, Jaffa Feldman, Susan Freedman, Norbert and Marilyn Friedman, Rina Goldberg, Angie Goldfeier, Muriel Goldsworthy, Anne Grand, Helene Kener Gray, Richard Griggs, Marina Kaufman, Edith Kaufthal, Judy & Uri Kaufthal, Rita Lerner, Samantha Lerner, Sherry Mallin, David Marwell, Judy Marwell, Mike Minerva, Amy Morgenthau, Lucinda Franks Morgenthau, Martha Morgenthau, Susan Morgenthau, Inge & Ernie Oppenheimer, Anne & Abe Oster, Avi Oster, Miriam Pinsker, Sari Reisman, Hannah & Bill Rigler, Marilyn Rosen, Mary Sabbatino, Fred Saporito, Deborah Schwartz, Nil Schiffman, Shari Segel, Abby Spilka, Michael Stafford, Mia Sussman, Michael Thompson, Deborah Tropp, Doris Urman, Eileen Weingarten

STONE HOUSES
The Metropolitan Museum of Art, New York
Museum staff: Anne L. Strauss, Philippe de Montebello, Kay Bearman, William S. Liebermann
Volunteers/supporters: Daniel Ehrenberg, Henrik Hammarlund
Cornell University: Bradley Borthwick, Alison Chung Kong, Tamara Dimitri, Michael Dosmann, Matthew Hirschtritt, William (Binx) Newton, MaryAnn OCampo, Sasha Shumyatsky

Also: Mark Hughes, Mary Sabbatino; Amanda Kirchgessner, Bob McGuire, Camilo Nascimento, Bob Potts, Jesse Sandvik
Funders and supporters: Cynthia Hazen Polsky, Leon B. Polsky, the Lita A. Hazen Charitable Trust, Joel and Sherry Mallin

POOL OF LIGHT
Bioussac, Charente, France
Philippe and Libby d'Hémery
Also: Yves Rondinaud, Serge Choisy, Bruno Gerbaud, Katie Budge

THREE CAIRNS
Des Moines Art Center, Des Moines
Museum staff: Susan Lubowsky Talbott, Chris Gilbert
Wallers: Steve Allen, Andrew Loudon, Andrew Mason, William Noble, Gordon Wilton, Jason Wilton, Darren Woolcock
Other: Jacob Ehrenberg, Valerie Knowles, Josiah Updegraff
Volunteers: Sam Chermayeff, Chad Elliot, Micah Hammac, David Pearson, Nick Manders
Funders/supporters: Edmundson Art Foundation Inc., the National Endowment for the Arts, Taylor Construction Group, Weber Stone Company, Brian Clark and Associates, Manatts, Inc., Star Equipment, Ltd

PRAIRIE CAIRN
Grinnell, Iowa
Faulconer Gallery, Iowa, Center for Prairie Studies at Grinnell College, Dr. Jon Anderson, Dr. Vince Eckhart, Larissa Mottl, Lesley Wright, Andrew Voss

EAST COAST CAIRN
Neuberger Museum of Art, Purchase, New York
Museum Staff: Lucinda H. Gedeon, Dede Young, Jacqueline Shilkoff,
Volunteers: Johnny Way, Jacqueline Silk
Cornell University: Anna Johnson, Bret LeBleu
Funders/supporters: Roy R. Neuberger Endowment Fund, the Klein Family Foundation, Sherry and Joel Mallin, Douglas Maxwell, Neuberger Berman Foundation, Friends of the Neuberger Museum of Art, the Andy Goldsworthy Patron Circle

EAST COAST SEA CAIRN
La Rochelle, New York
Galerie Lelong, Mary Sabbatino, Anne Claudie Coric, Blanche and Bud Blank,

WEST COAST CAIRN
La Jolla, San Diego
Museum Staff: Hugh M. Davies, Stephanie Hanor
Funders/supporters: Mary Keough Lyman, Robin and Bill Comer, the San Diego Commission for Arts and Culture

WEST COAST SEA CAIRN
Pigeon Point, Half Moon Bay, California
Cheryl Haines, Gina Fairly, Phil Hayes

NIGHT PATH
Petworth, Sussex
Initiated by Pallant House Gallery, Chichester: Stevan van Raay and Andrew Churchill

Petworth House (The National Trust): Diana Owen, Crispin Scott and Ros Lee

Lord and Lady Egremont

Leconfield Estate: Simon Knight, Roger Wootton, Neil Humphries

Duncton Quarry: Rupert Philips

Footprints of Sussex: Vivien Lyth and Keith McKenna

Construction: John Baker, Hugh Dickenson, Neil Humphries, Tim Jemmet, Paul Kingswell, Mark Ralph, Jumbo Taylor, Nick Taylor, Steve Wadey, David Wort

Maintenance of path organised by Sue Wagstaff with help from various student volunteers including: Pat Stefanski, Debbie Zoutwelle, Chris Cook and Jill Francis of Northbrook College and Frank Jennings of South Downs College

Financially supported by Southern & South East Arts, Regional Arts Lottery Programme

Most photographs in this book were taken by the artist. Thanks are due to the following:

Tides
page 44: both photographs by Judith Goldsworthy

Stone Houses
page 54 (top): photograph by Mark Morosse, Photograph Studio, The Metropolitan Museum of Art
pages 55 and 56: photographs by Teresa Christiansen, photography © 2004 The Metropolitan Museum of Art

Garden of Stones
page 70: all photographs by Melanie Einzig

Three Cairns
page 93: photograph by Mike Crall, Des Moines
pages 96-99: photographs by Andy Goldsworthy and Lark Smothermon, Wolly Bugger Studios
pages 124-125 (top): photograph by Lark Smothermon, Wolly Bugger Studios